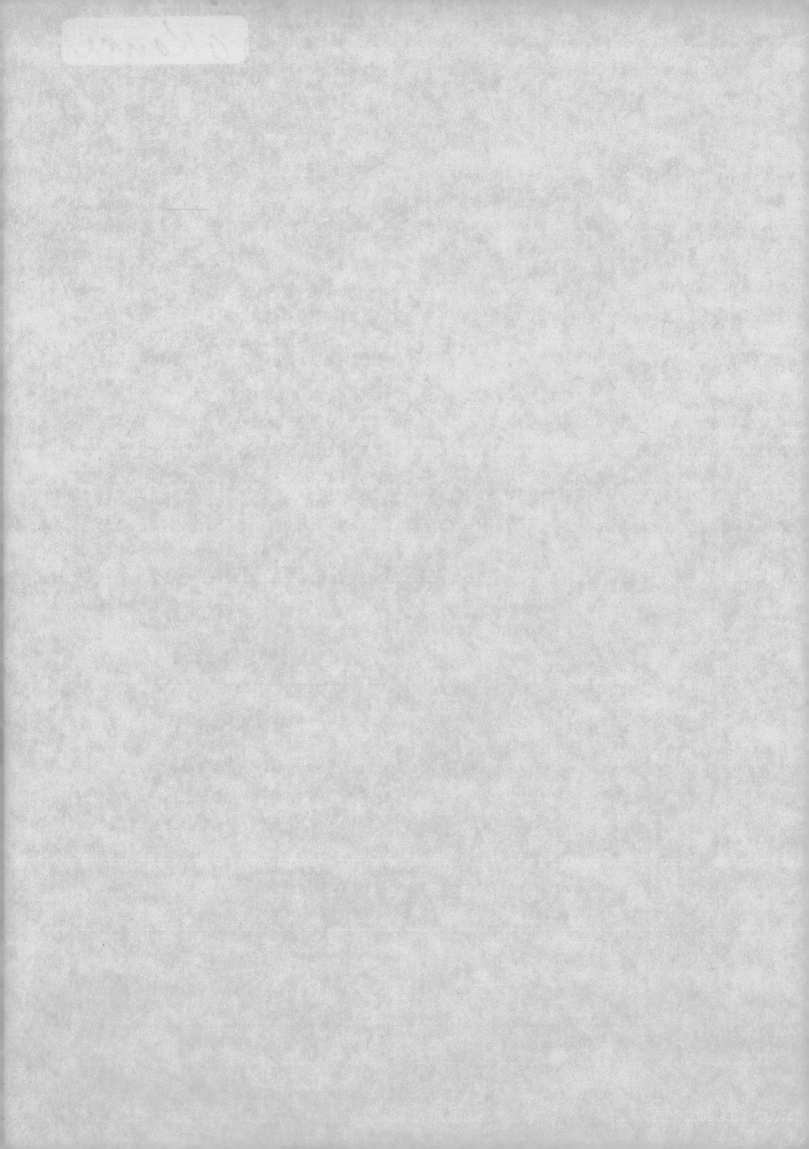

FLOWER PAINTING IN WATERCOLOR

FLOWER PAINTING IN WATERCOLOR

By Charles Reid

WATSON-GUPTILL PUBLICATIONS/NEW YORK
PITMAN PUBLISHING/LONDON

My thanks to Judy, Peter, Sarah, and Sam for their support
and encouragement. This book wouldn't have been possible without
them. My thanks also to Marsha and Connie for their perseverance
and to Bob for another beautiful design.

Copyright © 1979 by Watson-Guptill Publications

First published 1979 in the United States and Canada
by Watson-Guptill Publications,
a division of Billboard Publications, Inc.,
1515 Broadway, New York, N.Y. 10036

Published in Great Britain by Pitman Publishing Ltd.,
39 Parker Street, London WC2B 5PB
ISBN 0-273-01347-5

Library of Congress Cataloging in Publication Data

Reid, Charles, 1937-
 Flower painting in watercolor.

 Bibligraphy: p.
 Includes index.
 1. Flower painting and illustration. 2. Water-color
painting—Technique. I. Title.
ND2300.R44 1979 751.4'22 78-26535
ISBN 0-8230-1849-0

Manufactured in U.S.A.

First Printing, 1979

This book is for Judy

Introduction

Friends who have read other books of mine have expressed an interest in a book on flower painting in watercolor. Since there was a need for such a book, I decided to write one. I hope you'll have as much fun painting flowers in watercolor as I have had. Enjoyment is the key. If painting flowers or painting watercolors seems difficult, you should stop and think of watercolor painters you admire. Go to a museum and look at watercolors by Hopper, Wyeth, Sargent, or Homer. I think you'll be surprised. They found watercolor difficult too! They made mistakes. Their washes weren't always perfect. And they had to scrub, scrape, and use opaque white. It's frustrating, but it's still a great deal of fun. I hope this book helps you.

Contents

MATERIALS AND EQUIPMENT

There are many different kinds and brands of materials available for painting in watercolor. Some of you will already have your favorite brushes, palettes, easels, colors, and other miscellaneous equipment. Don't throw anything out just because it isn't what I suggest here. This chapter will simply give an overview of the basic materials you'll need, and, of course, I'll be suggesting the things I like and use myself. I'll discuss color and paints in the section on color in composition in Chapter 5.

Paper

Watercolor papers are made of different materials and come in various weights and surfaces. The best papers are made from linen. Cotton is also used, but I find it less satisfactory than linen because cotton seems to have a very absorbent surface. Some papers will have "linen" or "cotton" impressed next to the watermark, but if they don't, be sure to ask. With experience, you'll be able to tell just by the feel. Cotton paper feels softer than linen.

The weight of a paper is guaged by the weight of the whole ream. The weights range from 70 lb. to 400 lb. The 70-lb. type is really too light for anything but relatively small paintings, and the 400-lb. kind is unnecessarily heavy, unless you plan to have a real battle. For half- to full-sheet watercolors, I'd suggest paper of 140 lb. to 300 lb. The 300-lb. weight will stand up the best for a larger painting, but your choice really depends on how much punishment you plan to give it.

Watercolor paper is sold in several surfaces: rough, cold pressed, and hot pressed. You'll have to decide which surface you like best, but I find the rough-surface papers pretty rough and prefer either the hot pressed or the cold pressed. The cold pressed has a fairly rough surface but probably is the best all-round paper. Many painters find hot-pressed paper too smooth. I hate to recommend particular paper makers, since paper is such a personal thing. The most important consideration is finding a paper you like that is readily available.

Some papers contain a good deal of sizing and tend to fight the paint. This problem can be reduced by first stretching the paper on a board, securing it with paper tape around the borders, and sponging it down before painting. Heavier papers such as the 300 lb. type can be sponged off in a bathtub without stretching them. In fact, it isn't really necessary to stretch your paper unless you have a sizing problem. It is helpful to stretch the lighter papers to avoid buckling if you're doing a full-sheet painting. I don't pay too much attention to the right or wrong side of a paper. The right side is the side with the watermark, but I find both sides of good papers equally acceptable.

Brushes

Good watercolor brushes cost a fortune, especially the larger sizes, which are the most useful. Of all the things you'll need for painting in watercolor, brushes are the most important; so I feel you should stint on everything else if necessary but buy the best brushes you can afford.

Watercolor brushes are made from red sable (the best brush by far), sabeline (a form of oxhair), oxhair, white nylon, and camel hair, squirrel hair, and numerous other hairs. I'd suggest avoiding any of the brushes labeled "camel," "squirrel," etc., unless you like to paint with a mop. They get floppy and lack rigidity. The red sable is the best, but if you can't afford one, the sabeline or oxhair brushes work quite well. Nylon brushes aren't expensive and are also acceptable.

Watercolor brushes come in two shapes: round and flat. I've always used a round brush just because I'm used to the shape, and I still have some big round sables that I bought years ago before they were outrageously expensive. Because large rounds are so expensive, get a larger flat instead. It will cover just as much area as a large round for much less money. You can also try the 1½ inch to 2 inch commercial bristle brushes that you can find in any hardware store. They work well for large areas.

Different manufacturers number their brushes on different scales, so be careful about ordering without knowing the actual size of a particular brush. The brushes throughout this book are Winsor & Newton, and the number 8 I mention so often is about 1 inch long. I think it is the best all-round size in a round sable. When you're buying a brush always remember to test it by dipping it in water to see how it points. It should always point well when dampened. Also, never put your brushes away damp. It's not good for the brushes, and it will cause the handles to flake.

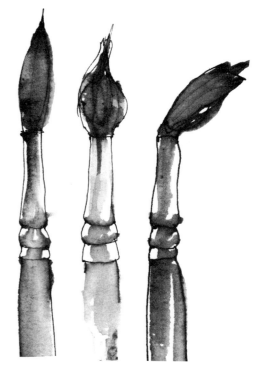

A good brush should always point well when dampened, as does the brush on the left. It shouldn't look like the one in the middle after a stroke. It should bounce back to its original shape. Also, a good brush shouldn't balloon out and become floppy like the one on the right.

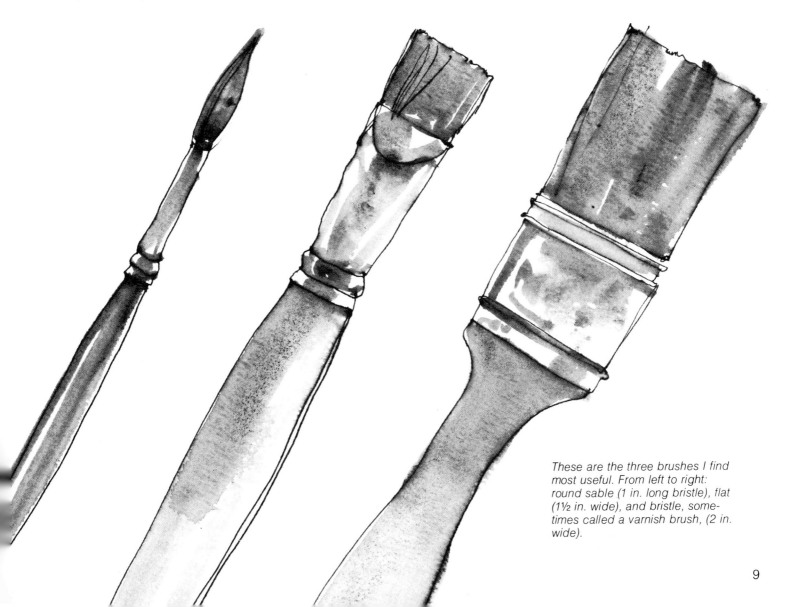

These are the three brushes I find most useful. From left to right: round sable (1 in. long bristle), flat (1½ in. wide), and bristle, sometimes called a varnish brush, (2 in. wide).

Palettes

You should avoid cheap metal or plastic palettes and shouldn't rely on dinner plates. My favorite palette is the folding metal type shown below with a little finger hole. Two other covered palettes I recommend are the metal O'Hara watercolor box and palette and the heavy-duty plastic John Pike palette. Another very simple and inexpensive palette is a porcelain tray known as a butcher's tray. You can put damp paper towels over your paints to keep them moist.

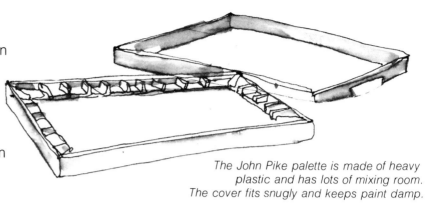

The John Pike palette is made of heavy plastic and has lots of mixing room. The cover fits snugly and keeps paint damp.

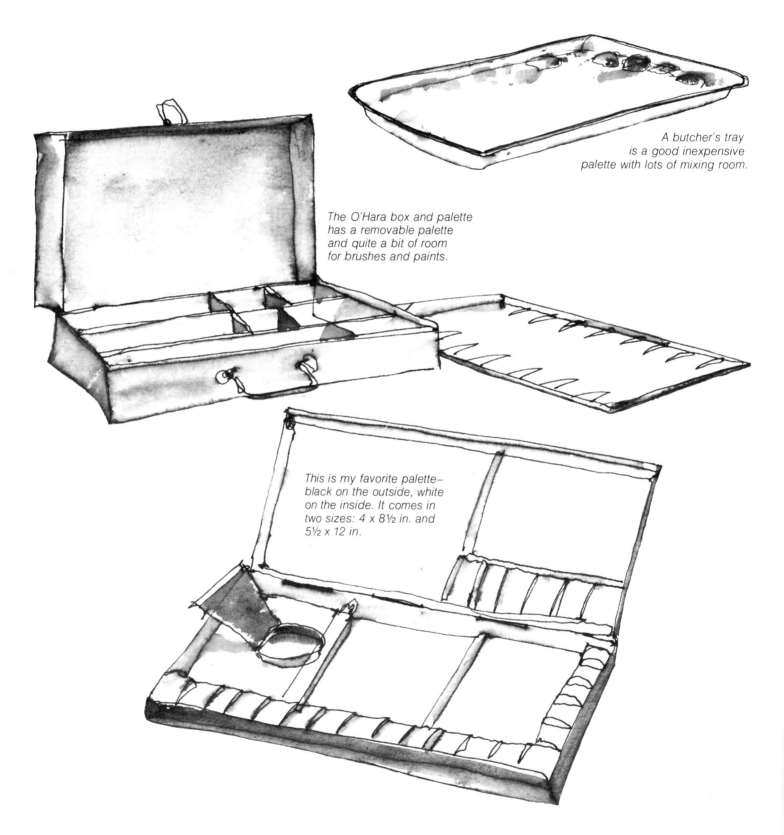

A butcher's tray is a good inexpensive palette with lots of mixing room.

The O'Hara box and palette has a removable palette and quite a bit of room for brushes and paints.

This is my favorite palette— black on the outside, white on the inside. It comes in two sizes: 4 x 8½ in. and 5½ x 12 in.

Easels

Watercolor easels come in many sizes and forms, and I'd recommend any easel that you're able to operate. But when you buy one, insist on putting it up first—the simpler the better. In fact, you can prop your paper and board on a rock, chair, or table for a while until you're sure watercolor painting is for you. You'll need some fairly firm board to support the paper. I wouldn't buy an official drawing board, since they're either too small for a full sheet or too heavy. Any piece of Masonite, ½-inch plywood, or even styrofoam board will work fine. You can even have two: one for half sheets and one for full sheets.

You might find—as do many people—that working on a flat surface is best for you, in which case you won't even need an easel. You can be wet and loose without fear of the wash flowing down the paper as it can do, when the board is tilted. Also, you can decide whether you like standing or sitting best. You should get used to both, especially if you're working in a large group such as a class or workshop where sitting on the floor may be the best place to see what you're supposed to be seeing.

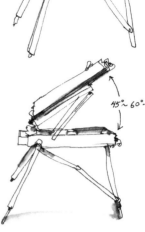

French easels are very good, but they're expensive!

You can use the French easel with your board almost upright (top), but you'll get lots of drips. Most of the time I keep my board at an angle as shown in the lower drawing.

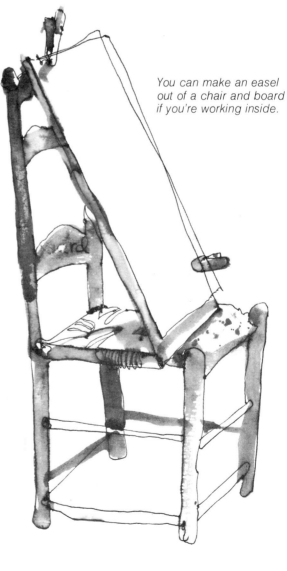

You can make an easel out of a chair and board if you're working inside.

Miscellaneous Materials

In addition to the materials and equipment already discussed, there are a few other items you'll find useful.

Water container. Almost anything that doesn't leak can be used. Plastic containers offer numerous possibilities, but an old surplus canteen and cup also work well.

Tissues. You should never paint a watercolor without having a tissue at hand. You can use toilet tissue or paper towels, but should avoid old towels and rags.

Tape, thumb tacks, or clips. Any of these work well depending on what kind of board you're using.

Erasers. The best eraser is the kneaded rubber eraser and is made by Eberhard Faber. It's very useful in getting rid of pencil lines as well as cleaning soiled and smudged paper. You should avoid hard red and white erasers, as they'll destroy the paper while erasing a line.

Brush carriers. Brushes shouldn't be put away wet; so before you put them away, be sure they're dry, or at least dry them when you get home if you're painting outdoors. A good carrier is a wicker or reed table mat. These are sold in art supply stores, but you can make them yourself. Don't use cloth carriers, since they retain moisture. There are also metal boxes made especially for carrying brushes.

A surplus canteen and cup are always handy for water.

Kneaded rubber erasers are a necessity with pencil drawing.

Paper tape

Clamp-type clips from the hardware store

Clips will secure your paper to your board.

Push pins if your board is soft enough

A wicker table mat will keep your brushes dry. Thread a shoe lace or fine rope or twine through the holes to keep your brushes in place. Knot this at each end to keep it from slipping out. The whole thing can be rolled into a neat package.

13

DRAWING FLOWERS

Drawing can be anything from a quick first sketch to an involved and careful preliminary drawing. Different problems call for different solutions, and there will be times when you will want to do a quick sketch and then develop the drawing with your brush as you paint, and there will be other times when an involved preliminary drawing is best. But don't let a careful drawing become too precious or you'll be afraid of losing it, and you'll get tight and stilted paintings. However, in the right hands, definite boundaries can make for beautiful paintings.

Drawing is a very personal form of expression, and it should be like your handwriting—strictly yours. It's all right to get ideas from others, but relax and let your own style develop. Also, you should separate ways of learning about drawing from drawing in your own style. For example, the form of contour drawing that I'll demonstrate later in this chapter is just a tool. You can incorporate it into your own work, but you should see it as distinct from your own style and not be bound by it.

Most important, don't go through your painting life saying, "I can paint pretty well, but I just can't draw." This is a bad premise and will prevent you from really improving your drawing. If you can paint, you can draw. Also, if you don't try to learn to draw, you're missing a crucial part of the art experience, and you might get away with it in certain styles of painting, but you'll always be limited.

Drawing Media

The most commonly used drawing materials are graphite pencils, charcoal, and pens. Brushes as a drawing medium will be discussed in Chapter 3.

Graphite Pencils are most useful if you want a preliminary drawing that will be a guide rather than an important part of the picture. The softer graphites (4B and 6B) are dark enough to stand out in a watercolor, but they tend to smudge and can cause unpleasant effects if not used well. My favorite is a 2B—not too hard and not too soft. A number 2 office pencil is really the same thing and is what I usually use. The harder graphites tend to dig up the paper when you try to make a dark line. You'll need a rubber or kneaded eraser when working with graphite pencils.

Charcoal and Charcoal Pencils are useful if you want a drawing that plays an important part in the watercolor. Although there is always the problem of bleeds and smudges, you can get some very interesting effects. Compressed sticks are more stable than vine charcoal and should be used with paint. Don't "fix" a charcoal drawing with a spray—the watercolor won't take. But you can use acrylic paint as watercolor over a "fixed" drawing.

Pen and Ink is useful for making preliminary planning drawings which you don't paint over. But however you use it, it should reflect your own approach. I'm partial to contour line drawings, but this is only one of many possibilities.

Types of Pens

The handiest pens are fountain, felt tip, and ball point pens. Quill and other "dip and draw" pens are fine and inexpensive, with a wide variety of points available; but they aren't very handy. I prefer fountain pens, but they are expensive. There are two types: the sketching type with a standard style point, which is my favorite drawing pen, and the technical or rapidograph pen, which has a rigid tube for its point and is really too rigid for much flexibility in sketching. Neither type will take waterproof ink, which contains shellac and causes clogging. I recommend water-soluble ink even though you'll get some bleed when you paint over it. The bleed often improves the drawing. Finally, felt tip or Pentel pens are cheap and fun to draw with, but I find ballpoint pens a bit rigid.

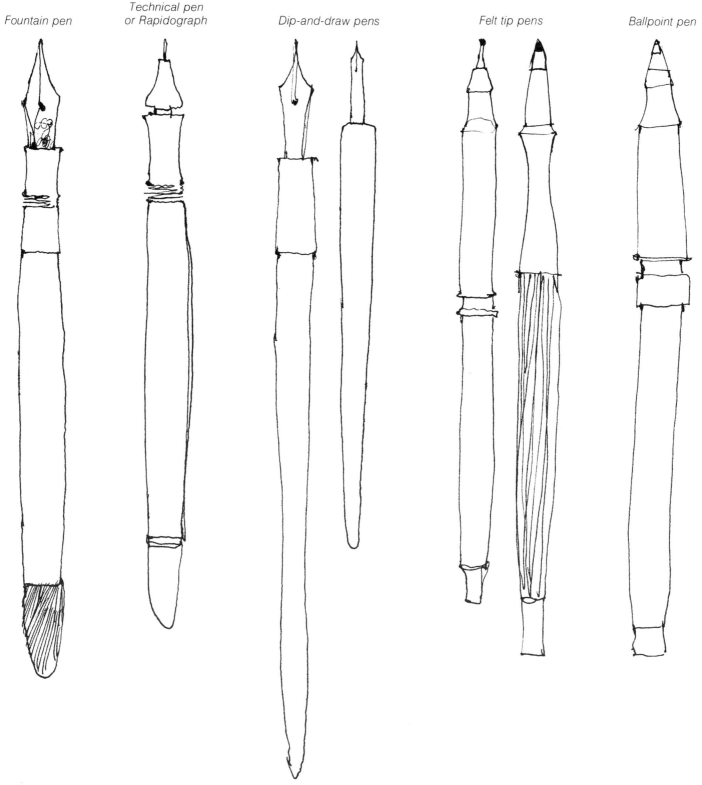

Fountain pen *Technical pen or Rapidograph* *Dip-and-draw pens* *Felt tip pens* *Ballpoint pen*

Contour Drawing

One good way to break out of "formula" compositions is to start with a contour drawing. I use this approach in class, although many people find it annoying, since it's possible to come up with some very strange compositions. The trick is not to worry. Your drawing may look odd to you, but to do this properly you shouldn't plan it out. Just start anywhere and let things happen.

In true contour drawing you're never supposed to look at the paper when the pencil is moving. I often don't bother with this rule, but there are a few requirements you should try to follow. (1) Keep your pencil on the paper at all times until you get to a border and can't go any further. (2) Don't sketch little scratchy lines; your pencil should move in a continuous direction. (3) The pencil should move slowly with frequent stops to check and see how you're doing. Don't lift the pencil at these stops; leave it on the paper. (4) Work both within the form and around the boundaries. This will be shown in the demonstrations that follow. (5) Try not to erase. If you make a mistake, make a new line, using the old line for reference. This is one of the hardest "rules" to follow, so don't worry if you can't resist reaching for the eraser. I find that too much erasing disturbs the paper and we often merely redraw the old line anyway. Don't worry about proportions. They're bound to be a little off.

The best reason for this approach is that you come up with a clear and definite set of boundaries to work with in the painting stage. Sketching so often results in a confused collection of scratchy lines that are difficult to follow. Sketching also often produces too many lines that tend to make the watercolor look dirty. Aside from this, contour drawing gets you closer to your subject. Ideally you're thinking that the pencil is actually on the subject, tracing the subject's contours rather than being on the paper. If things go well, it's often easier to catch the essence and truth of the subject even though the proportions might not be literally correct. Sketching often produces a watered down idea of what is being drawn.

In the next three pages the two step-by-step demonstrations show you a modified contour drawing and a drawing using both line and wash.

Pen and Ink Contour Drawing

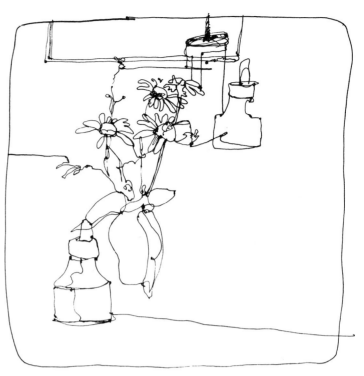

Using a Pelikan fountain pen with an extra fine point, I first establish my picture border. Never start in the middle of a page and think you'll solve the problems of outlying areas later. Starting with the daisy, I work slowly out into the petals then down the stem and into a section of the leaves. Dots are where I stop to check the section I'm working on. I then go on to the vase and a neaby ink bottle. I don't lift my pen between the vase and the ink bottle, but make a bridge between the two objects. Finally, I pick up a grain in the tabletop which connects my objects to the border.

I now go back into the flowers and pick up a new direction. I go back to the center, draw in new flowers and add some objects above the flowers. Here I connect my drawing with two other picture borders at the left and at the top, but I don't necessarily finish statements before going on to adjoining areas. I also introduce some shading, using short pen strokes.

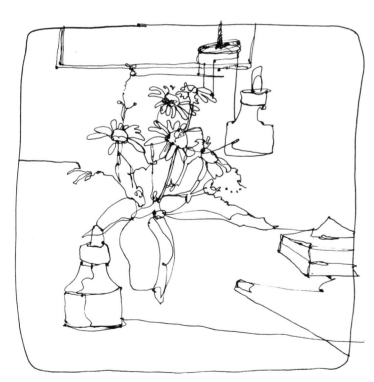

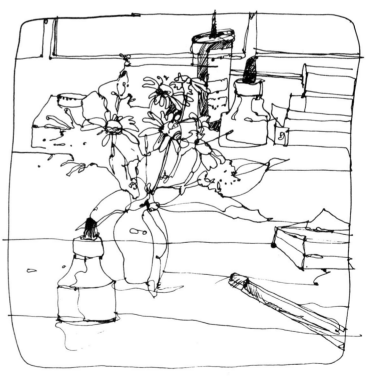

Here I work more in the flowers and add a book and the beginning of a pencil. My major concern is shape here, but nothing is exact since this type of drawing is one of exploration. The hardest part of the process is to accept the mistakes and inaccuracies and not worry about them.

I add more shading in the background and the ink bottles. It's a good idea to get most of the line work done before you put in darks. Notice that I've carried lines right through objects; this is called "drawing through." As a drawing, this is confusing and would be more clear if wash were added. But this is only a foundation for a painting and I would ordinarily use a pencil. But pen is easier to see here. The few tones I have added are meant to balance the composition.

Ink and Wash Contour Drawing

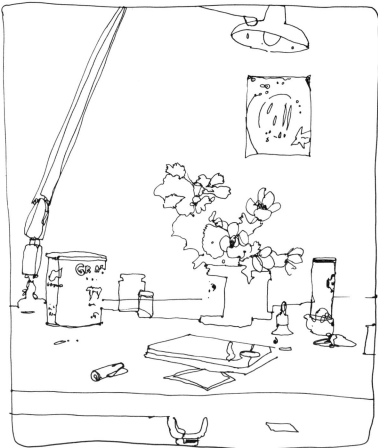

Using an extra fine Pelikan fountain pen, I start by establishing my picture boundaries so that I know the space I'll be dealing with. I then begin with the top lip of the vase since I find it helpful to start within a form rather than around the boundary of an object. I thus avoid outlining objects and think of their substance. I draw the contours within the flowers as well as their outside boundaries.

Now I mass objects together, leaving separating boundaries unstated. The objects themselves aren't as important as their shapes, which will become boundaries of value and color masses that will make up the final painting.

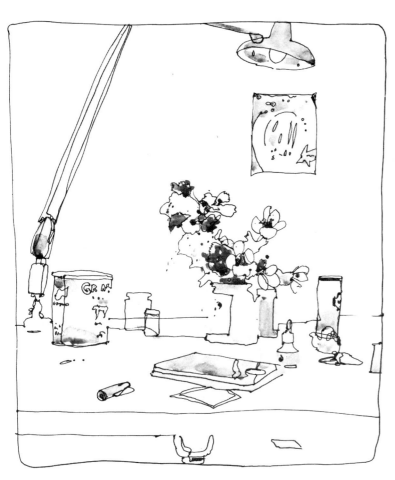

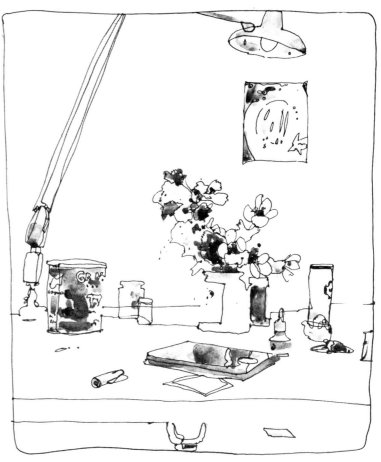

I now start adding tone with diluted ivory black watercolor, using my number 6 round sable brush. A wash drawing like this is a planning step only and is not intended to be a finished work. I'm using it mainly to plan my darks, developing a road map of darks to lead the eye through the picture. I make no attempt to fill in all the areas, and at this point, I don't commit myself with values that might be too dark.

I now add my darker darks. Notice how these lead the eye around the picture from the flowers at the right, down to the paintbox below the vase, over to the left to the tobacco can, over and up to the light, and down again to the flowers. There could be any number of possibilities; the important thing is to keep the eye moving.

USING THE BRUSH

When beginning a painting, many people enjoy starting right out with a brush rather than doing a preliminary pencil drawing. I think this is a wonderful practice, since it allows you to be free from the fear of losing what you think is a good drawing. In Chapter 1, I discussed the kinds of brushes I feel are the best.

The most important thing to remember in using a brush is that you're painting a picture and not a wall or a house. I'm a terrible painter of walls or houses, partly because I don't like painting them, but mostly because the whole objective behind painting walls and houses is very different from that behind painting pictures. I'm not an expert, but it seems to me that to paint a wall well your main concern is always smoothness—keeping all the strokes going in one general direction, smoothing out the paint as you go. You can't just slap it on any old way. I'm not suggesting that when painting a picture you should just put the paint on any old way either, but generally your strokes should not all go in the same direction. You shouldn't smooth out the paint with your brush once it's on the paper. You should use a variety of strokes. *Variety* is the key word in painting pictures.

Also, don't think only of the tip of the brush when you paint. Use the center section and the base of the brush much of the time.

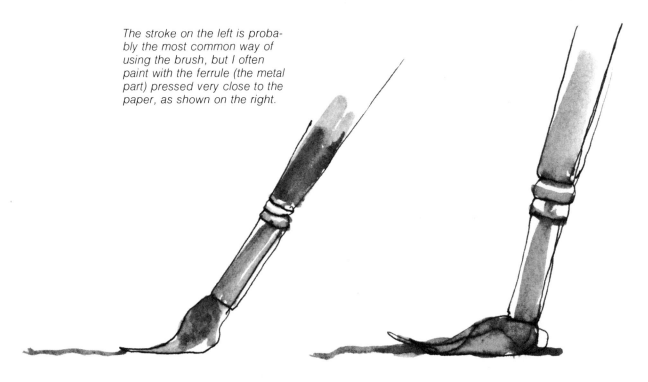

The stroke on the left is probably the most common way of using the brush, but I often paint with the ferrule (the metal part) pressed very close to the paper, as shown on the right.

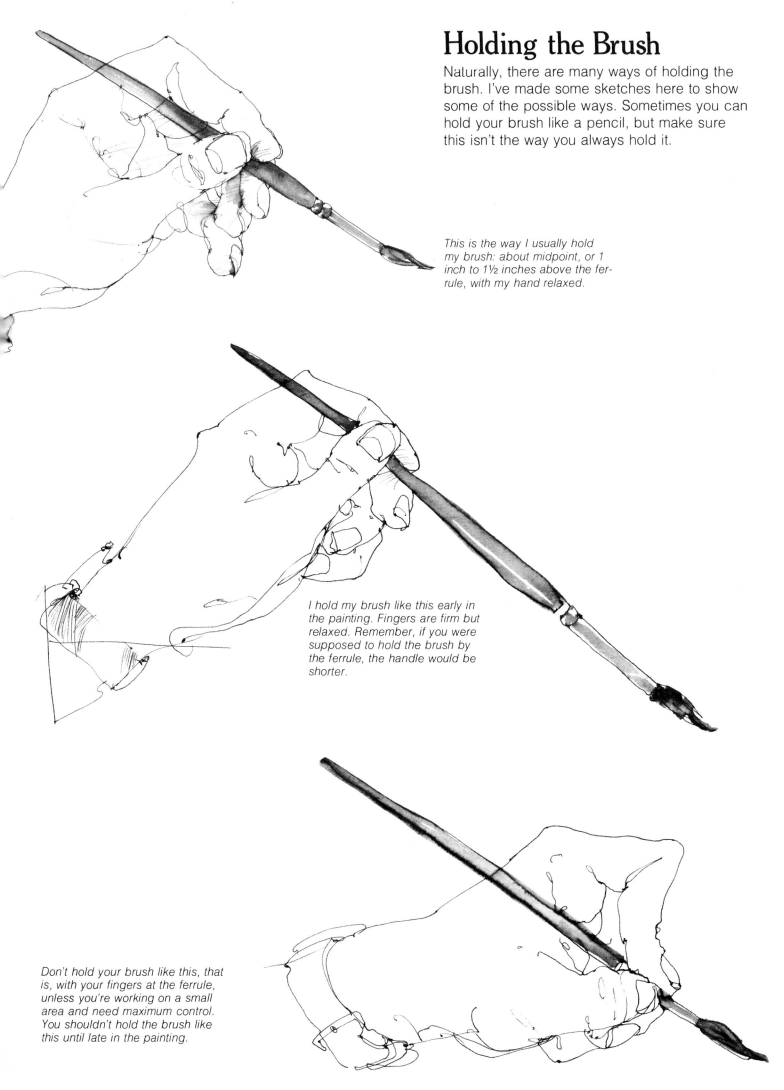

Holding the Brush

Naturally, there are many ways of holding the brush. I've made some sketches here to show some of the possible ways. Sometimes you can hold your brush like a pencil, but make sure this isn't the way you always hold it.

This is the way I usually hold my brush: about midpoint, or 1 inch to 1½ inches above the ferrule, with my hand relaxed.

I hold my brush like this early in the painting. Fingers are firm but relaxed. Remember, if you were supposed to hold the brush by the ferrule, the handle would be shorter.

Don't hold your brush like this, that is, with your fingers at the ferrule, unless you're working on a small area and need maximum control. You shouldn't hold the brush like this until late in the painting.

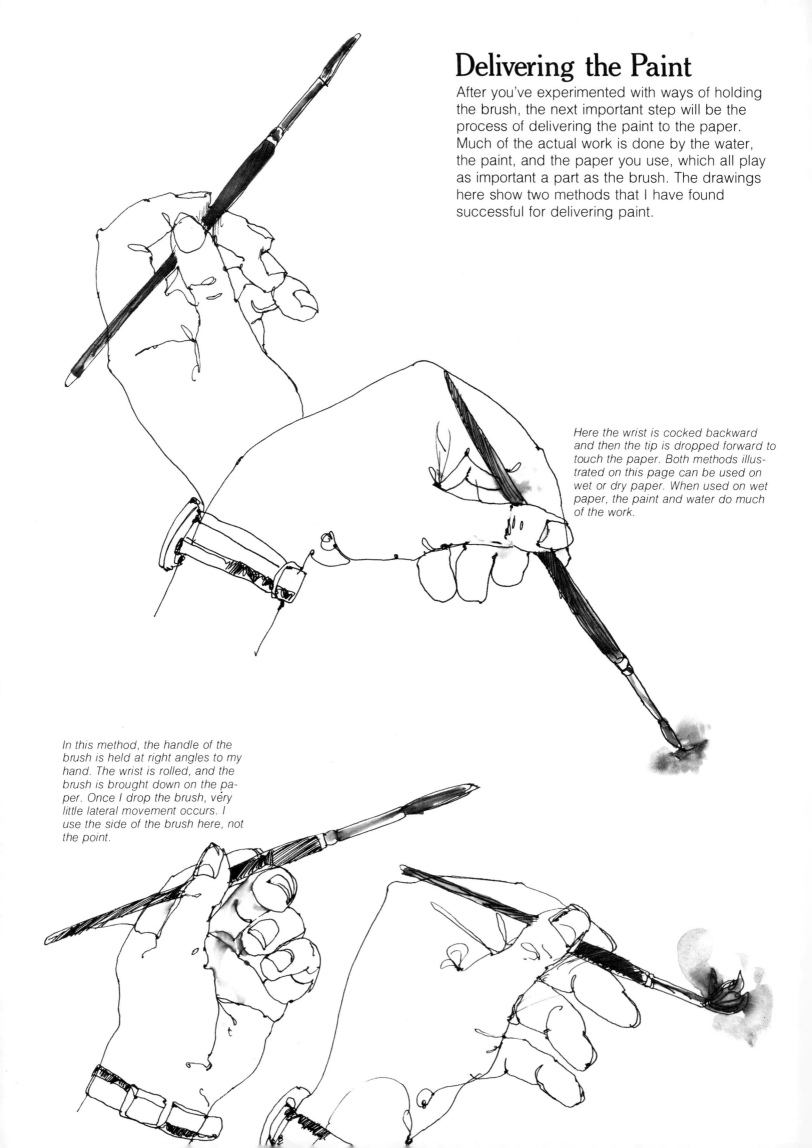

Delivering the Paint

After you've experimented with ways of holding the brush, the next important step will be the process of delivering the paint to the paper. Much of the actual work is done by the water, the paint, and the paper you use, which all play as important a part as the brush. The drawings here show two methods that I have found successful for delivering paint.

Here the wrist is cocked backward and then the tip is dropped forward to touch the paper. Both methods illustrated on this page can be used on wet or dry paper. When used on wet paper, the paint and water do much of the work.

In this method, the handle of the brush is held at right angles to my hand. The wrist is rolled, and the brush is brought down on the paper. Once I drop the brush, very little lateral movement occurs. I use the side of the brush here, not the point.

Wet-in-Wet

There are many times when paint shouldn't be stroked onto the paper, and wet-in-wet is one of these times. But wet-in-wet shouldn't be thought of as a unique approach in watercolor painting. It *is* watercolor painting. I use wet-in-wet constantly. It is also important to realize that wet-in-wet is not just dampening a large area with clear water and then dropping in color. Actually, you should be using wet-in-wet any time you go back into any wash, and you should never correct a stroke without using it. To correct a wet wash, it's necessary to have new pigment on the brush, not just plain water, which will dilute and muddy the paint already down. When I'm working wet-in-wet, I usually use the tip of the brush rather than the side, but there is no real stroking. The work is done by the paper, the water, and the paint.

The longer we can keep a painting wet looking, the better. When a painting starts to look dry and scratchy, we're in trouble. Some artists soak their paper completely before painting, but for the drawing here I only dampened with clear water the surface I planned to paint on. I then dropped paint onto the damp paper with the tip of my brush. I also used some spatter work, which I did by filling my brush from the palette and then knocking the brush against the forefinger of my free hand. While the washes were still wet, I lifted out lights with a tissue. As the paper dried, I sketched in stems and small details, but I did so before the paper was completely dry in order to keep the wet look. It's important not to make these details too dark or they'll seem out of place.

Basic Long and Short Strokes

For both long and short strokes the wrist and lower arm are held firm. Most of the movement comes from the elbow and upper arm. The hand isn't rigid, but there shouldn't be a lot of excess finger movement. To make either long or short strokes successfully, it's important to have enough paint and water on your brush. So if you're in doubt, try some practice strokes first to make sure your paint and water are all right. The drawings on this page show the procedure for making long strokes, and those on the opposite page illustrate short strokes.

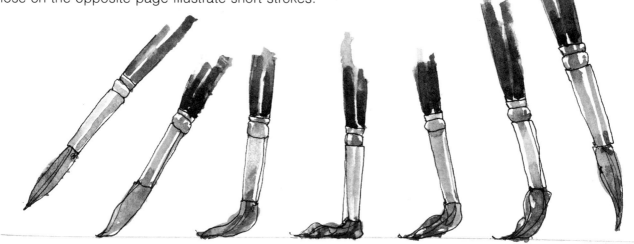

The motion of a long stroke is shown here, proceeding from left to right. At the end of the stroke the brush is lifted from the paper while the arm is still moving – just like a follow-through in golf or tennis. The movement should be continuous until the end of the stroke. Don't go back for correction.

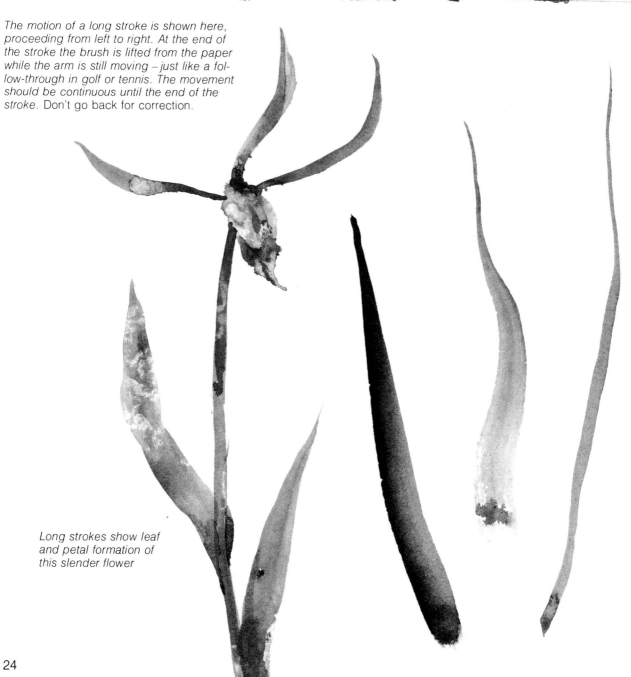

Long strokes show leaf and petal formation of this slender flower

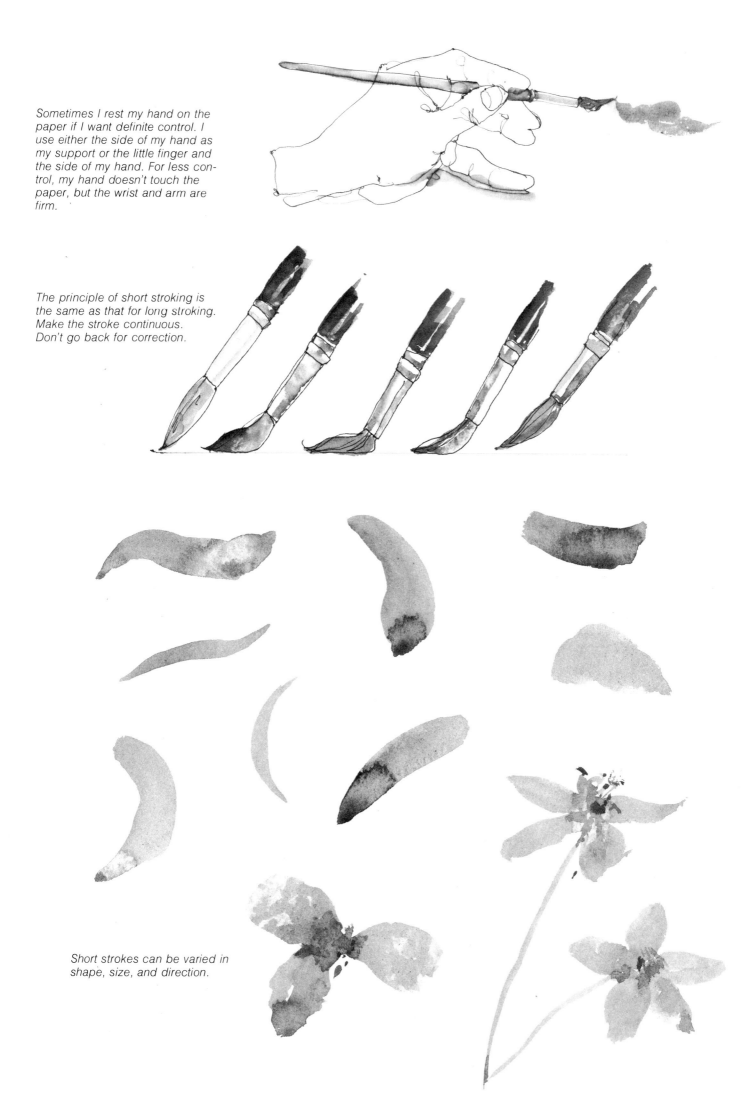

Sometimes I rest my hand on the paper if I want definite control. I use either the side of my hand as my support or the little finger and the side of my hand. For less control, my hand doesn't touch the paper, but the wrist and arm are firm.

The principle of short stroking is the same as that for long stroking. Make the stroke continuous. Don't go back for correction.

Short strokes can be varied in shape, size, and direction.

Broad Strokes

The principles for broad strokes are the same as those for long and short ones. Keep the wrist firm, with some movement in the hand but most of the action still coming from the upper arm. The brush should be in contact with the paper most of the time, since you're working for a continuous flow. Naturally, you must pick up the brush to get water and paint—not just water, since too much water only dilutes your pigment and gives you a watery, washed-out effect. But keep your brush on the paper as much as possible. When you need more paint, go back to the palette, load up the brush, and return to the spot where you left off. Don't go back into the part you've just done to make corrections. If you have a large area to cover, do a series of the kind of blocks shown below, connecting them as you go. Some artists would do the whole area at one time, but this method isn't good if you have a very large area to cover. For that I'd suggest wet-in-wet. A broad stroke can cover a very small area or it can be quite large, and its overall shape can be long and fairly narrow or a broad mass. The technique is the same in either case.

Here I'm working in a circular, meandering way, and the handle swivels around the base of the brush.

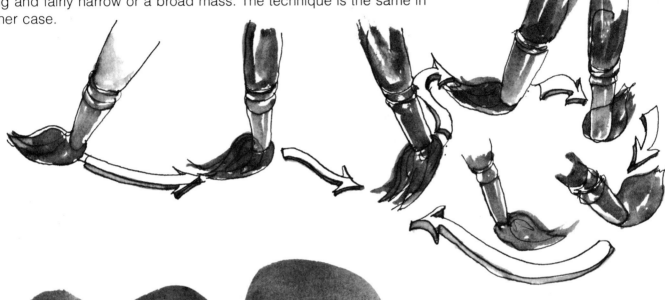

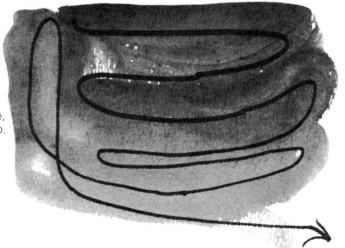

This is how the stroke would look. The hole left here on the right is just to show the stroke.

I would ordinarily connect the two strokes just along the edge, as shown in the middle, but not at the center of the top stroke.

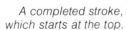

A completed stroke, which starts at the top.

Connecting Strokes

Throughout I've recommended keeping your brush on the paper. I realize that you can't always do this, as you must lift the brush to make new strokes; but work toward keeping the flow by connecting your strokes. There is no particular direction that the brush should take, so long as the strokes are not all the same.

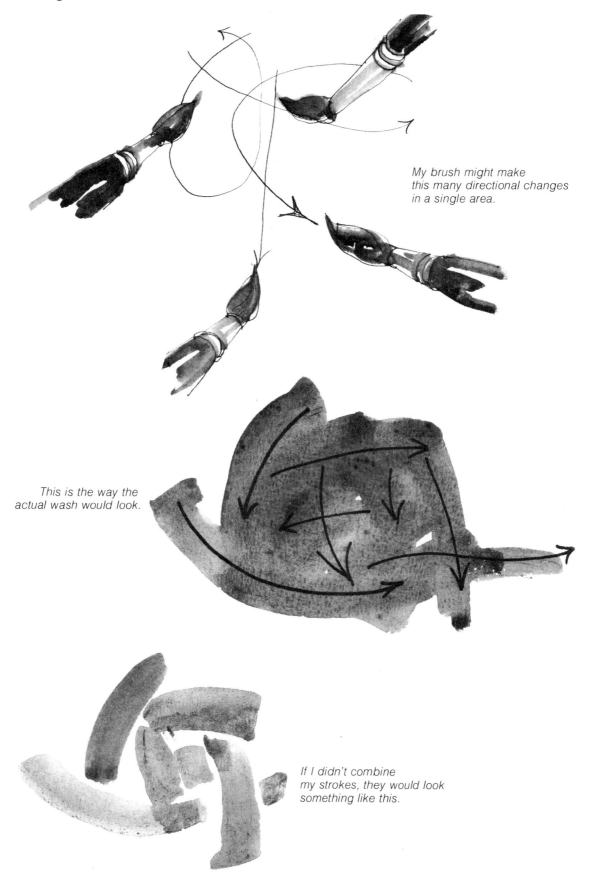

My brush might make this many directional changes in a single area.

This is the way the actual wash would look.

If I didn't combine my strokes, they would look something like this.

VALUES

In painting, the term *value* means how light or how dark a particular area is in relation to other areas. It's easy to get confused when you're looking at an area and trying to decide whether you're seeing value or color. Ideally, you should be able to look at any object and identify its value without considering its hue or intensity. This sounds easy, but I'm often surprised that people who have been painting for a long time have trouble figuring out the value of a bright red. You must start out by seeing in black and white. Your brain should have a switch like that on a color television, which allows you to turn your color pictures to black and white and back again to color.

Before you start any painting, study your subject. Force yourself to analyze every part of the setup to determine the value of each area. Everything you paint will fall somewhere between black and white on a value scale. Most of the things you paint will be in the gray range. You will seldom use pure black.

Value Scales

The value scale on the top row shown below is made up of nine values running from black to white. This is considered a full value range. The bottom row is much more limited, with the nine values condensed into five. This might be the best scale to start with. If you can paint a picture with a range of five specific values, you won't have any problems. However, if a limited value range stifles you, then you should expand your value range. The main thing is to be in control and to know for sure which value you want. You can't just dip into a mound of dark paint, stick it on, and then expect miracles. Each value makes a difference.

Your scale could range from light to dark, but the five-value scale gives you more practice in arriving at values quickly without building numerous washes. It also gives you a chance to practice working wet-in-wet and blotting with tissues as discussed in Chapter 2. Don't worry if you have problems, and don't expect to get a perfect gradation (mine isn't at all perfect!), which takes practice. If it's hard for you to master the nine-value scale, you'll have trouble arriving at the values you want in the actual painting, so I suggest you start with a more limited value range. As you become more experienced, you can expand the number of values until you're using all nine.

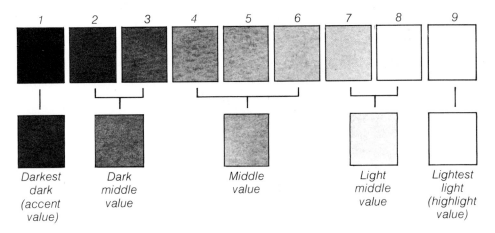

| | 1 | 2 | 3 | 4 | 5 | 6 | 7 | 8 | 9 |

Darkest dark (accent value) Dark middle value Middle value Light middle value Lightest light (highlight value)

Local Value

Local value is the overall value of a particular area in relation to other areas. Every matt surface—that is, a surface that's not glossy—has a local value. It's easiest to find local value when there isn't a light shining on the subject, but small details within particular areas can create the greatest problem because they become more obvious when a light shines on what you're painting. But remember that everything has local value—a white shirt is still white and a black shirt is still black no matter what kind of light you shine on them. It's helpful in defining local value to compare each area with two other areas to make sure you clearly understand just how light or dark each area is *relative* to other areas. In the drawing here, a light is shining on the subject. But notice that even though the values change because of the light, the flowers in the light are still lighter than the leaves in the light, and the shadow side of the flowers is lighter than the leaves in the light, and the shadow side of the flowers is lighter than the shadow side of the leaves. Keep your value pattern simple. Squint and compare when necessary. Remember that the darker the value, the less it should be affected by light on it. For example, the light and shade on a white daisy might be more obvious than they would be on a dark purple iris.

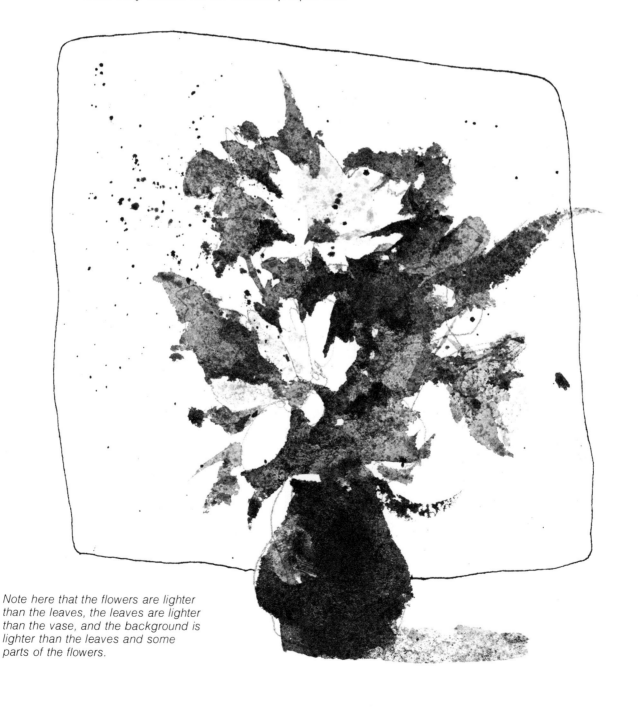

Note here that the flowers are lighter than the leaves, the leaves are lighter than the vase, and the background is lighter than the leaves and some parts of the flowers.

Values in Shadow

I never go very far in a painting without establishing some dark values, since one can't judge a light value against white paper alone. One of the biggest problems many students run into is making their darks too dark. If shadow areas are too dark, they have no depth, and the objects look lifeless because there is no atmosphere or air around them. If an object looks black and you paint it black, it creates a black hole in the painting. If you have trouble with shadows being too dark, you're probably using too much pigment with a brush that's too dry. I suggest avoiding drybrush in shadows until you have a good deal of practice. Instead, try working wet-in-wet to soften the dark-valued areas. Notice in the drawing here that the darkest section of the shadow area is most near the light side of the bouquet. Your darkest areas in any shadow are near the halftones, which are transitional values between light and shadow.

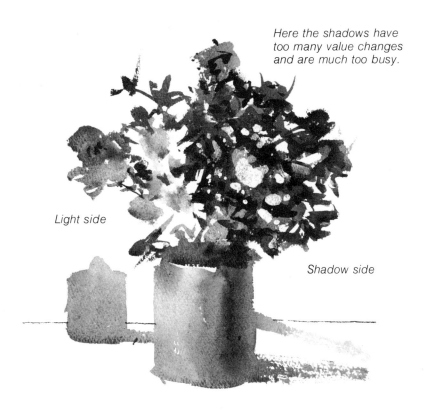

Here the shadows have too many value changes and are much too busy.

Light side

Shadow side

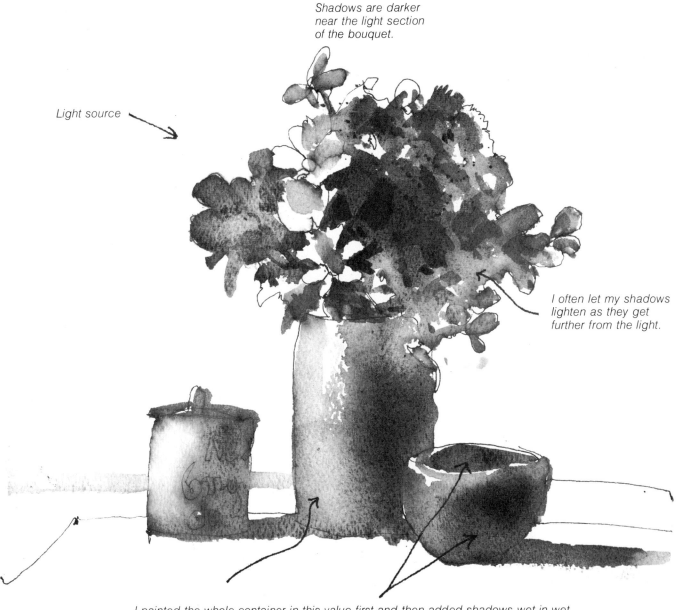

Shadows are darker near the light section of the bouquet.

Light source

I often let my shadows lighten as they get further from the light.

I painted the whole container in this value first and then added shadows wet in wet. Even if the shadow value is too dark, the damp paper takes the edge off.

Values in Strong Light

The main problem with painting in strong light is that middle and light values might appear washed out and lighter than they actually are. Another difficulty is that direct lighting often produces contrasts that are too harsh for the subtlety required in painting flowers. Flowers aren't made of steel, but too much value contrast might make them appear that way.

When starting a picture, I usually concentrate first on the light areas. In this sketch I used a pen line first and tried to show what happens when flowers of both dark and light values are affected by the same fairly strong light. Showing the smaller forms is very tricky and can cause you problems. Once you start working on small forms, putting in details and delicate lights and darks, it's easy to forget local value. Keep checking to make sure you're not losing the overall value of an area. Squint a lot. Get up and walk away from your work to take a fresh look at it. Try looking at the picture upside down. Try anything to avoid becoming too absorbed in a small area.

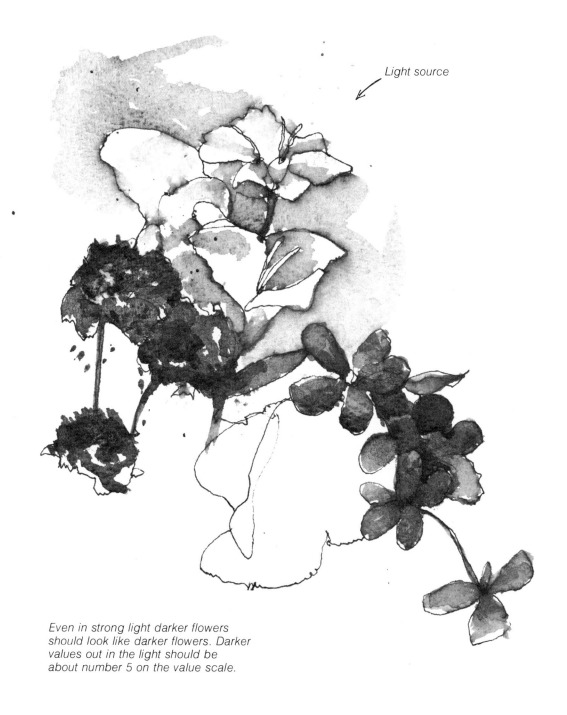

Light source

Even in strong light darker flowers should look like darker flowers. Darker values out in the light should be about number 5 on the value scale.

Highlights and Accents

A *highlight* is the lightest possible light in a picture, and an *accent* is the darkest possible dark. Highlights are, or should only be, found in glossy surfaces. Accents can be found in and around any surface. Highlights become a problem in middle- and dark-valued glossy objects. In a very light-valued object the overall light and the highlight are so close in value that you can't get into much trouble. With a darker object there can be a tendency to speckle bits of white paper all over and completely disrupt the local value of the object. Accents become a problem when you spot darks around objects to make them stand out and give the picture punch. Accents and highlights won't make a poor painting a good painting, but like spices in cooking, they'll make a reasonably good work better. Allow yourself one or two of each in a painting, and save them for the end. In the sketch here I wanted the white flowers to stand out, so I left out some of the highlights that were actually in the vase and was careful not to have bits of white paper in the background. The only highlight I used was in the bottom of the base to add balance and interest in the lower part of the picture. Notice that I've used accents around the flowers because they're my focal point. Accents in the flowers would have destroyed their big, simple shapes.

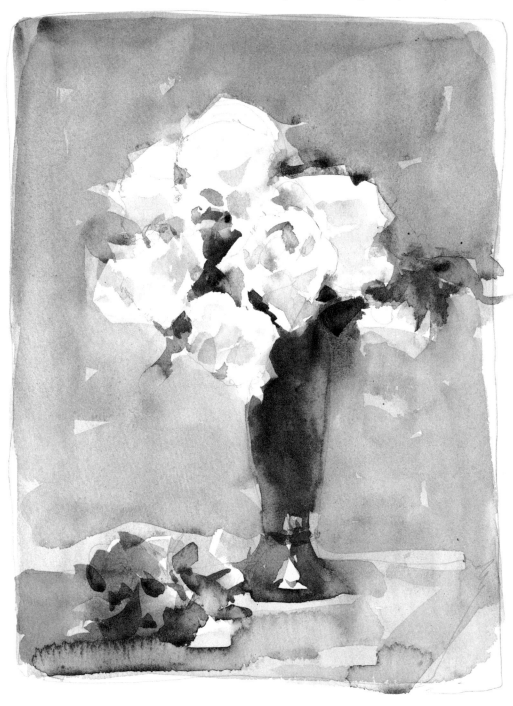

Reflected Light

Reflected light is very important. Without it, shadows would be leaden and dead. On the other hand, if the reflected light becomes too important, shadow values then become confused. At best, reflected lights should illuminate shadows without being noticeable themselves. They should never be confused with the main light, which should always be lighter. Look for color changes in shadow areas, which are often caused by reflected light. Try putting a white cup against a red background as shown in the drawing here. Shine a strong light on the cup and look into the shadow side of the cup. You'll see the red reflected into the shadow. The same thing will happen if the cup is sitting on a red cloth. Reflected light should be more of a color change than a value change. Shadows should be simple in value but complicated in color. It's best to have several colors of about the same value in a shadow area rather than several values of the same color in shadow.

The color of the background or table surface will bounce into the shadow of the cup.

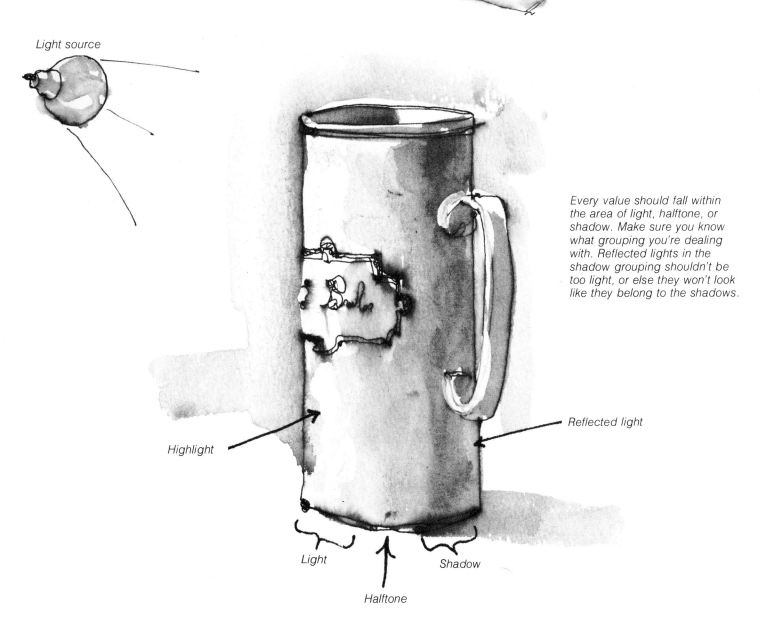

Light source

Every value should fall within the area of light, halftone, or shadow. Make sure you know what grouping you're dealing with. Reflected lights in the shadow grouping shouldn't be too light, or else they won't look like they belong to the shadows.

Reflected light

Highlight

Light

Halftone

Shadow

Chapter 5

COMPOSITION

We should all have our own ideas about what makes a good composition. I enjoy very casual setups, as you can see in my pictures in this book. I'm not an orderly person, and I'm often surrounded by clutter. I realize that I could accomplish more sometimes by working in an uncluttered environment, but it isn't in my nature to do so. On the other hand, I know many students and professional painters who are very orderly by nature, and their work should reflect this. I've seen people struggle to be "loose and free" when their real nature is to be controlled and careful. There is nothing wrong with "tight" watercolors or "tight" compositions if they are well done. Whatever way you organize your compositions, they should be natural to you. Don't stick ink bottles and coffee cans in your paintings if you don't like painting ink bottles and coffee cans.

General Principles

There are only a few things that I would consider to be "rules" or essential elements of a good composition. These relate mainly to the arrangement of objects within a picture's boundaries, and consideration of the way lights and darks and colors work together.

Picture Boundaries. The most important thing to remember about placement of objects in a composition is that they should always be arranged with the whole picture area in mind; so you must establish the size and shape of your picture area right at the beginning. If you're not going to use the whole sheet, then mark off the picture shape on the paper lightly with pencil. However, this doesn't mean you can't change your mind.

Backgrounds. Never start a picture without deciding what you're going to do in the background. Backgrounds are harder than foregrounds, so think of your backgrounds first. If you don't want to paint a lot of background, make your still life take up three quarters of the picture area.

Shapes and Values. Don't feel that your objects must be in a specific place in relation to the picture's borders. Generally, too much emphasis is given to objects. Actually, shapes are far more important than objects, and when we set up a still life, we should judge it by the pattern of lights and darks we see. Remember that values can completely change the balance of a composition, drawing attention from one place to another. Always squint and look for patterns of lights and darks caused by the objects and their shadows and cast shadows, which can dramatically change a composition by creating new shapes, connecting objects, and affecting perspective. Also patterns of color and value can be as important compositionally as shapes or boundaries of objects. To gain a real understanding of the way values, shapes, and colors interact, study the Masters for instruction. They are the best teachers. If you can't get to the originals, there are many good books with good reproductions available for study.

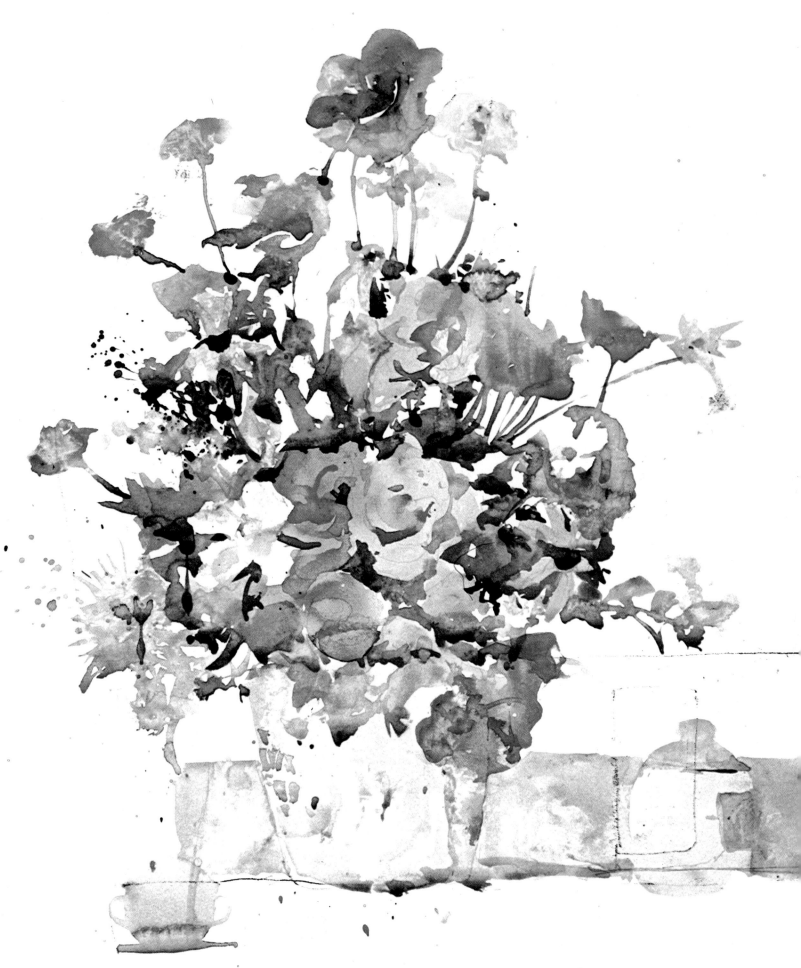

Big Bouquet, *14 × 11 in (36 × 28 cm). I often use white paper in my paintings. Sometimes the freshness of the paper is just the thing to set off the freshness of the flowers. I sometimes worry that using so much white paper is cheating; but if something looks good, I think it must be all right. Here there was so much activity in the flowers that any surroundings would have created a cluttered effect, and a darker background would have detracted from the picture.*

Arranging Objects

Here are two examples of arrangement of objects, one bad and one good (we are not considering values here). The problems in the drawing at the right are apparent. The objects are too evenly spaced, and such orderliness makes for an uninteresting arrangement. The shapes of the objects on either side of the vase are about the same size, the flowers are evenly placed between the window casings and the pencil is parallel to the bottom margin of the picture. The composition is static, and the eye isn't directed to anyplace in particular. The lower drawing is much more interesting and much more connected. I've switched the objects around a bit, grouping some things together to form a rather large single shape and separating a bottle and the pencil from this grouping. Now the shapes are of unequal weight. The pencil keeps the eye from wandering out of the left side of the picture. I've left out one of the window casings, thus making the upper part of the picture look less monotonous.

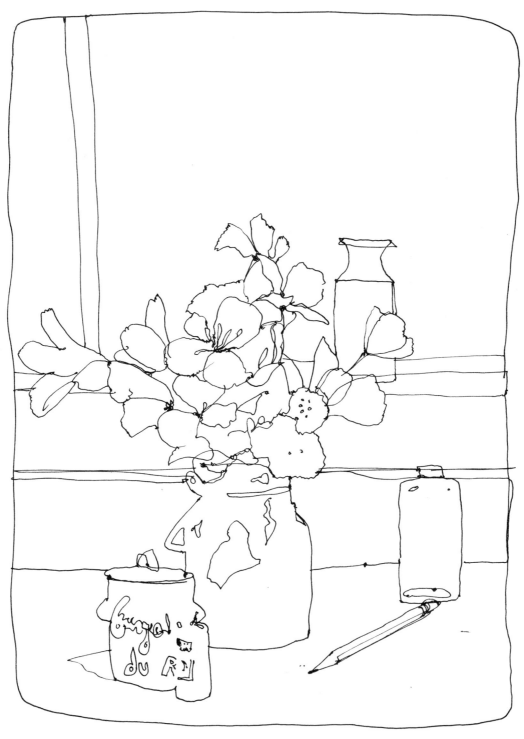

Establishing Values

These two drawings emphasize values and illustrate how important they are in making the composition come alive. The drawing at the right has some problems: two important darks are placed on the side margins, taking the eye away from the flowers; and the vase and the bowl next to it are so light in value that they can't compete with the surrounding darks. Thus the center of the picture looks empty. Also the darks in the flowers are concentrated just above the lip of the vase and capture the eye. The darker flowers above help, but they don't really direct the eye in any particular direction. The lower sketch has more dominant darks. Notice that the eye follows the dark window casing down into the picture, picks up the darks around the base of the flowers, and then continues down to the dark herb container in front of the vase. The surrounding lights and darks create enough interest and variety to keep the eye moving.

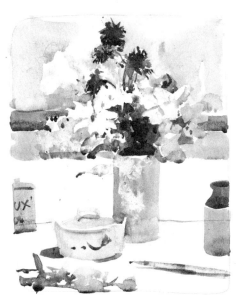

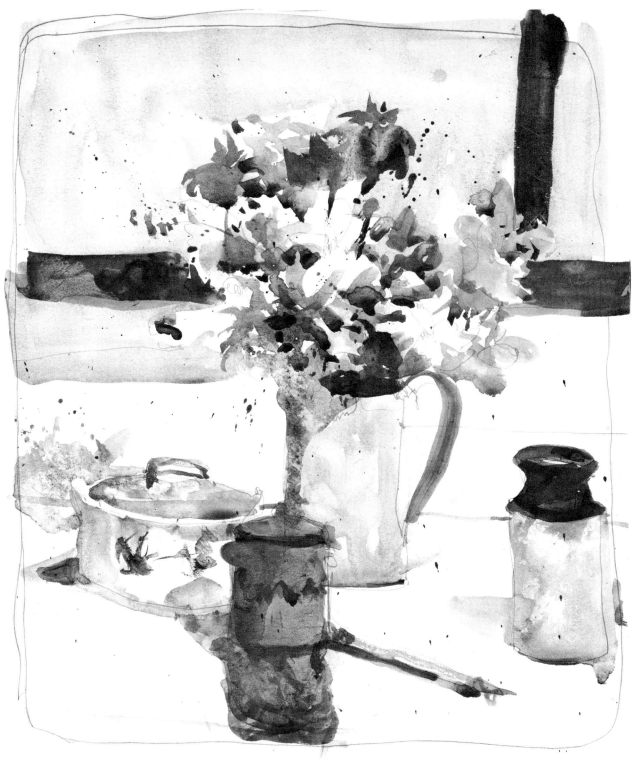

Color in Composition

Although I think good value patterns are the most critical element in composition, color is also very important. But color and values are not really separate considerations, and you need to think of both while painting. Think of where you'll place your stronger colors and where you'll place your more neutral ones. You can direct the viewer's eye around a painting by placing stronger colors along a specific path. Sometimes you'll find that a strong color in a bouquet is not in the right place. For the sake of the composition, you can mute the offender. Similarly, a section may need some strength, but that part of the bouquet may only contain dull grays or browns. So you may have to use colors more intense than those actually there. I've used a fairly limited palette in this book, but this doesn't mean I believe in a limited palette—rather, I seem to be using fewer colors these days. You can get along nicely without a lot of exotic colors, but part of the fun of painting is trying new colors. So in no way feel bound by the colors I've selected as basic.

Alizarin crimson. I find this a necessary color; it is very useful with cerulean blue, phthalo blue, and ultramarine blue (not cobalt blue) for mixing purples.

Cadmium red. This is the only other red I use, but check a color chart for permanency of other possibilities—vermilion is fugitive.

Cadmium orange. I use this color a lot. It makes nice grays when mixed with blue, and it freshens up light washes.

Cadmium yellow. I would find it hard to do without this color. It's warm and rich and almost a necessity for mixing greens. Some manufacturers label this cadmium yellow medium.

Cadmium yellow pale. Also called cadmium yellow light, this is a lighter version of cadmium yellow. It's warmer than the other lighter yellows and is very useful by itself. It is an excellent mixer.

Cadmium lemon. This light yellow, considerably cooler than cadmium yellow pale, is also an excellent mixer. You need at least one warm and one cool yellow on your palette.

Lemon yellow. Also a light, cool yellow, this color is more opaque and less rich than cadmium lemon and not as good a mixer.

Other yellows. There are many other yellows, but check the permanency chart before you try any of them.

Sap green. I like this green very much; but as it's only moderately durable, I'd suggest you avoid it.

Hooker's green. This color comes in both light and dark, but the light is only moderately durable, so I usually use Hooker's green dark. This is really the only green I use, since I prefer to mix greens using other colors.

Cerulean blue. My all-time favorite blue, it's gentle and comes out of the tube at a light value and quite cool. It's somewhat opaque but never a bother in better grades of colors. Cheaper ceruleans can be loaded with white, so buy a professional grade.

Ultramarine blue. A warmer blue, which I use more than any other blue (with one exception, cerulean). Winsor & Newton sells only French ultramarine blue in tubes. Apparently this isn't a true ultramarine, but it seems fine.

Phthalo blue. This clean blue is much cooler than ultramarine and really very necessary. It's strong but mixes nicely with alizarin crimson for delicate purples. Winsor & Newton labels this Winsor blue. It's full name is phthalocyanine blue.

Cobalt blue. A favorite color of many artists. I also have it on my palette, but I don't use it much because it doesn't mix as successfully as other blues. It's, a good color, however, and you should try it.

Manganese blue. This is a more transparent light blue, similar to the more opaque cerulean. I prefer cerulean, but this can be a substitute.

Prussian blue. I never use this color much, but many artists favor it.

Yellow ochre. I've always had this color on my palette but seem to use it much less these days. In watercolor it's similar in value and color to raw sienna but a bit lighter and more opaque.

Raw sienna. This and yellow ochre are quite similar, but I use raw sienna much more because of its transparency. You should try both.

Raw umber. This is a darker version of raw sienna, leaning toward green. I use it often.

Burnt umber. Darker than raw umber, this color is warmer and tends toward a reddish brown. I often mix it with a blue for a warm gray. I find it more useful than sepia or Van Dyke brown.

Burnt sienna. This color can be overused, and is unpleasant and raw if used alone. But I think it's necessary as an important ingredient in several mixtures. It goes nicely with phthalo and ultramarine blues for darker washes and makes a nice dark when mixed with Payne's gray. I rarely use it in lighter washes.

Ivory black. This is the only black I use, although I have bought blue black by mistake and found it all right but cooler than ivory black. People disagree on black, but it's an asset if used with care. Every dark color shouldn't have black in it. It's much better to have the experience of mixing dark tones and then to use black when you really want it.

Buying Colors

Watercolors, like oils, come in several grades in both tubes and cakes. The best are usually of the "professional" or "selected" grade. You should buy the best colors you can manage, but the quality of colors you work with is not as critical as the quality of your brushes, which should be superior. I prefer tube colors, since they are the easiest to find and the most useful. If certain cake colors dry up, it's hard to make them workable again; but you can always squeeze more paint from a tube. When choosing any color, check the color chart in your art store. But only those with an "extremely permanent" (AA) or "durable" (A) rating. There are so many good colors in these categories that there is no reason to buy questionable ones.

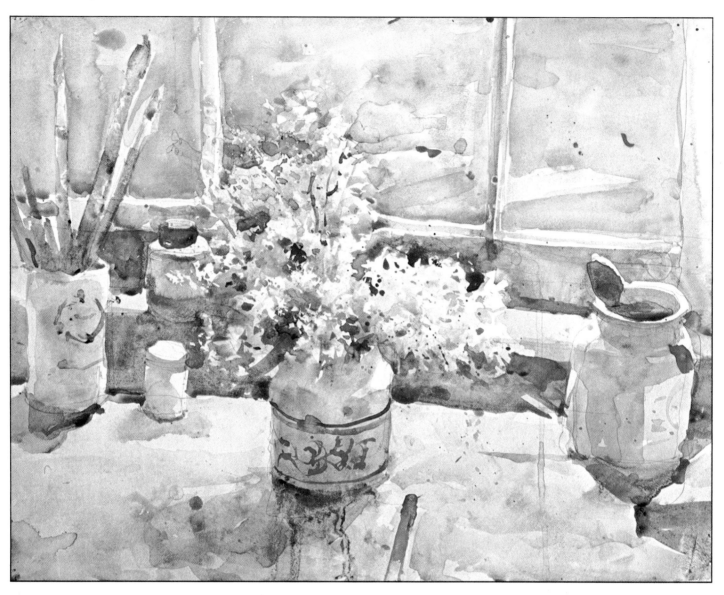

Queen Anne's Lace, *(above) 11 × 14 in. (36 × 28 cm). I wanted to use values that would complement the light, airy feeling in the flowers. There was a fairly strong light coming in the window, and the shadows were actually darker than I've shown here. I purposely kept my values high in key. You shouldn't be bound by the actual values and colors in front of you. Notice the warm yellows in the table. These are exaggerated – the table was actually a dull brown, but I added more yellow than I saw.*

Afternoon Sun, *(right) 14 × 11 in (36 × 28 cm). Because of back lighting, shadows and cast shadows are more important in this composition than the objects themselves, especially in the foreground where the cast shadows make such a strong pattern of lights and darks. Notice that the flowers themselves are very close in value to the background. This is a good example of how a painting can depend more on lighting than on the objects painted. If I had used front lighting, this would have been a totally different painting.*

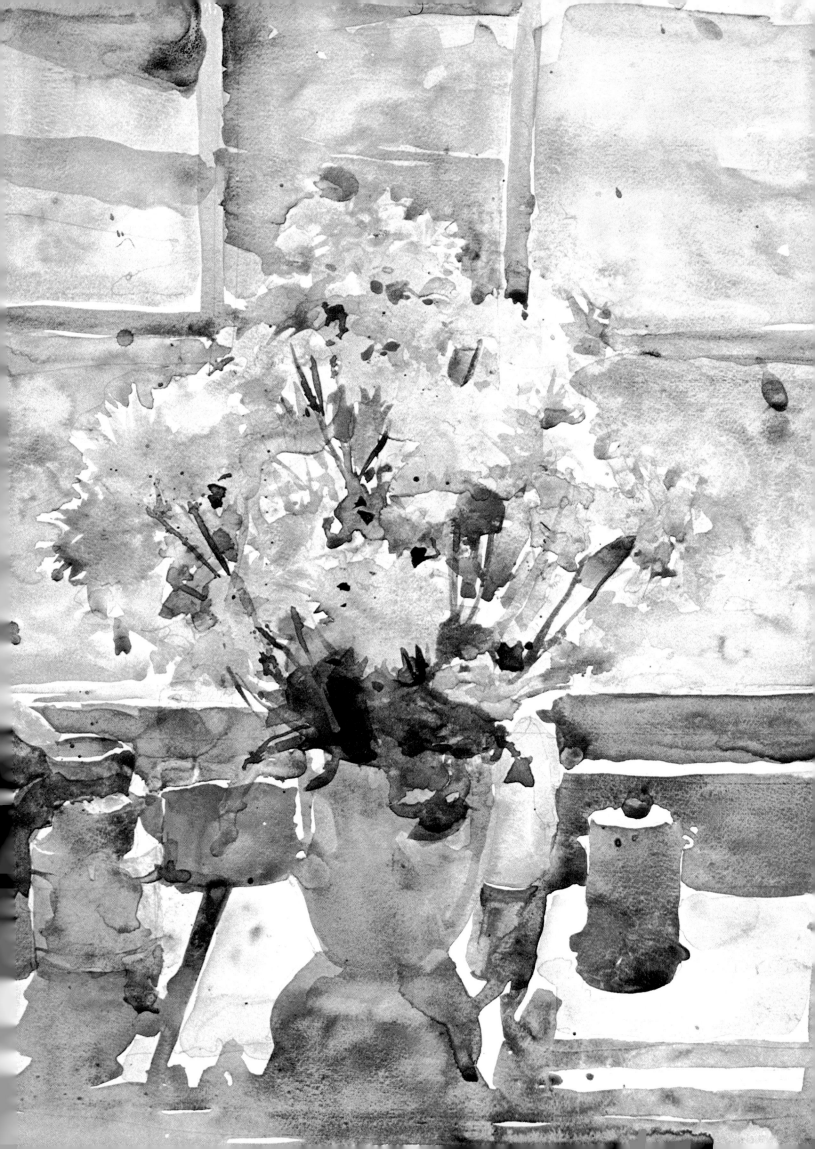

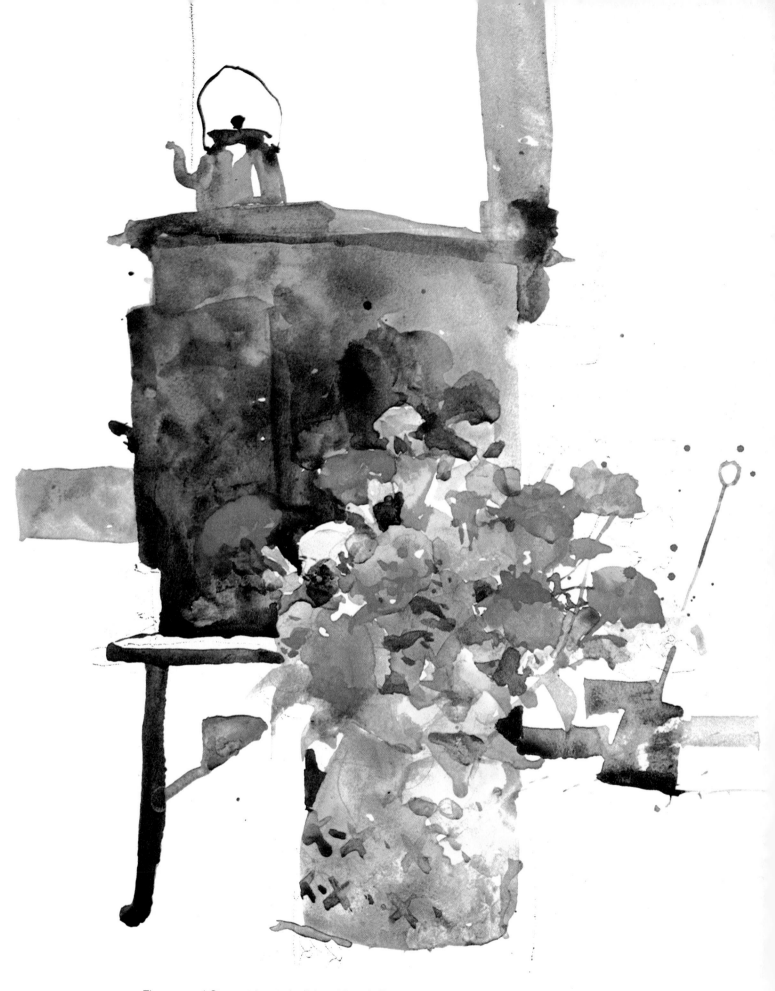

Flowers and Stove, *14 × 11 in (36 × 28 cm). The stove here is very dark, and the temptation is to paint it as dark as it actually is. But very dark values should be treated with great respect and should rarely be made as dark as they seem. It's better to make a dark just a bit higher in key than it should be. You can always go back when you're finished and restate the dark. When I do this, I usually wet the area, in this case the stove, with clear water (making sure I don't dampen the flower area) and then drop in dark color wet-in-wet.*

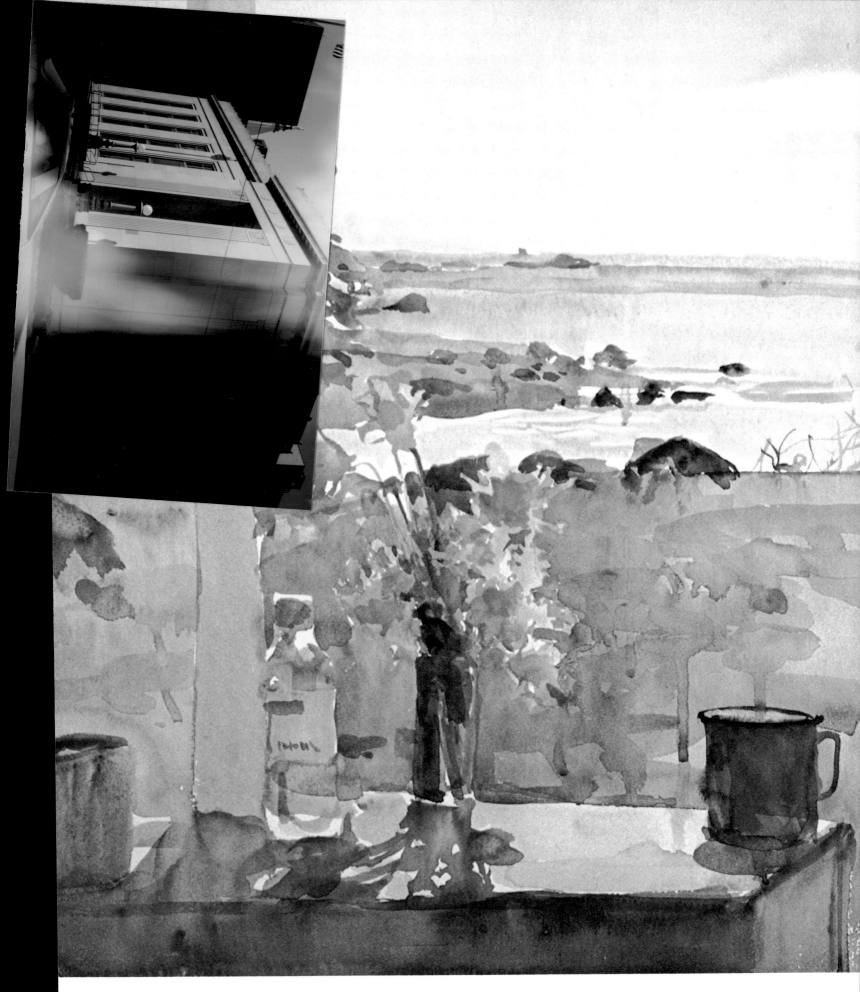

Flowers in Boccaro, *11 × 10 in (28 × 25 cm). This isn't really a flower painting – it's half still life and half landscape. I liked the distant view but felt the grass in front of the house needed some help. Since I think that flowers can make almost any painting a bit better, I put them in here; but generally the landscape or the still life should dominate.*

GALLERY

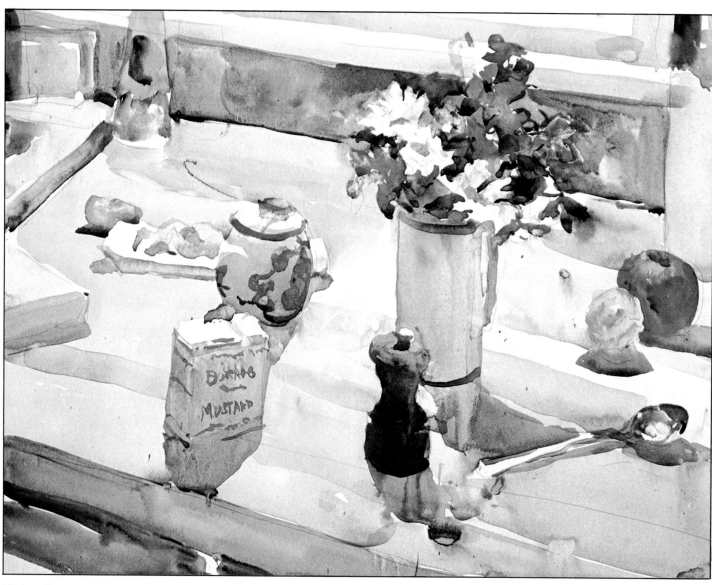

Kitchen Counter, *13 x 16 in (33 x 41 cm)*

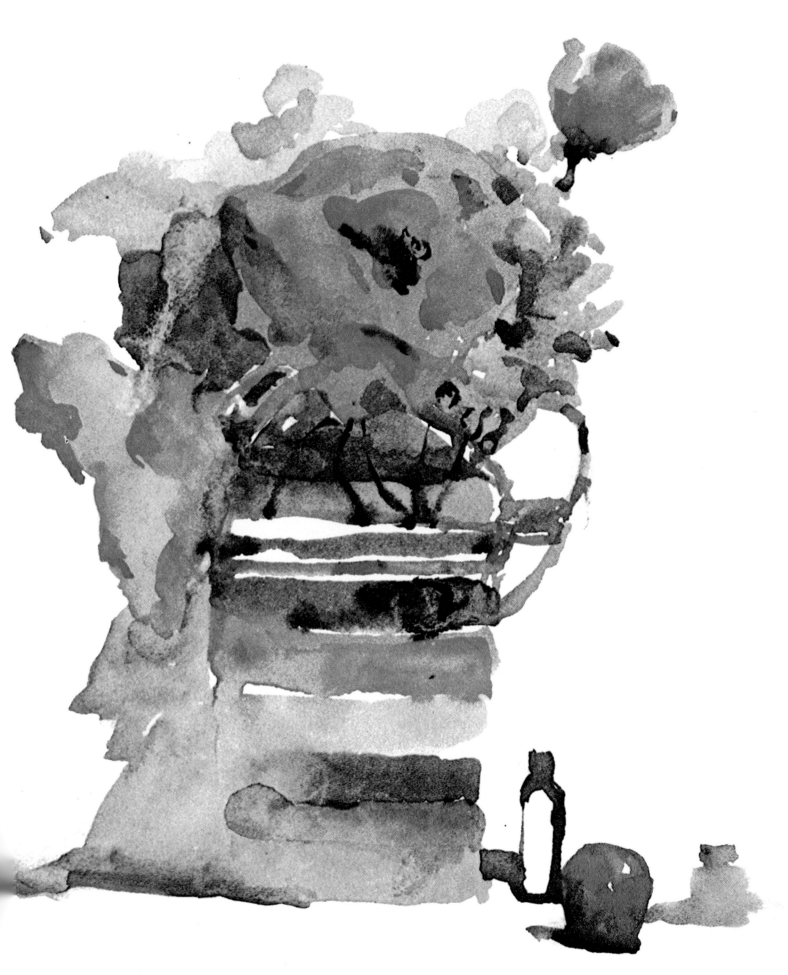

Paper Flowers, Rhea's Studio, *16 x 13 in (41 x 33 cm)*

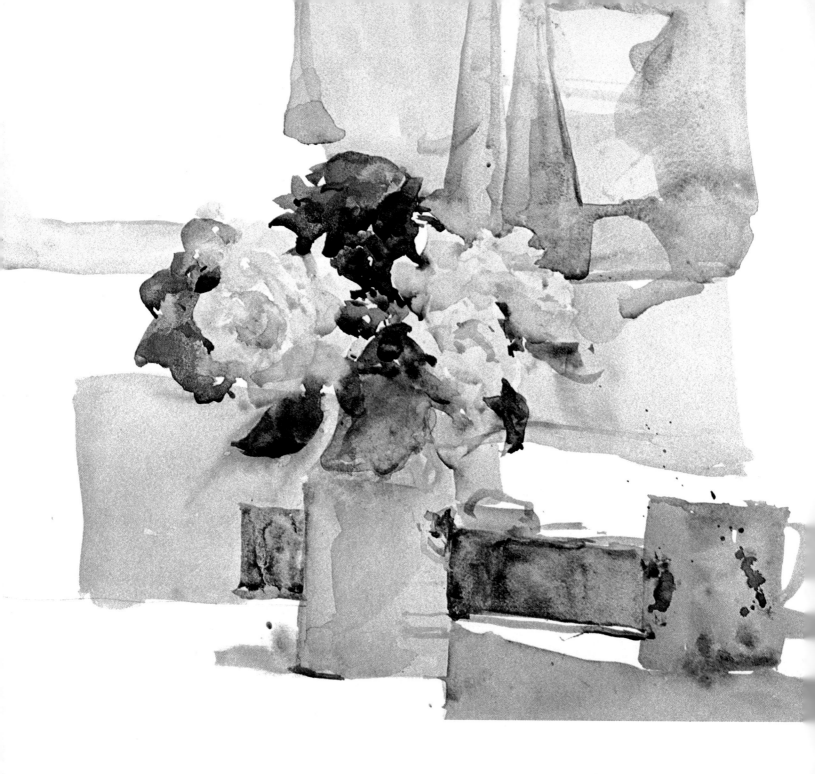

Roses, *13 x 16 in (41 x 33 cm)*

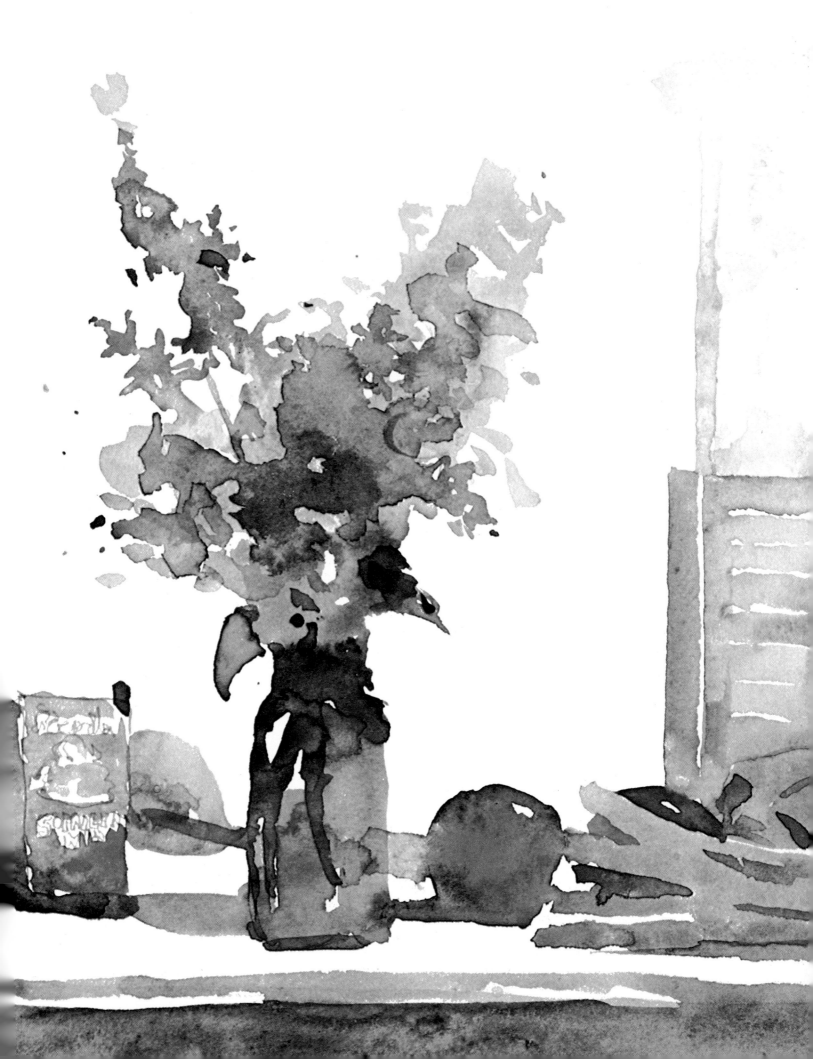

Lilacs on Kitchen Counter, *16 x 13 in (41 x 33 cm)*

Blue and White Iris, *16 x 13 in (41 x 33 cm)*

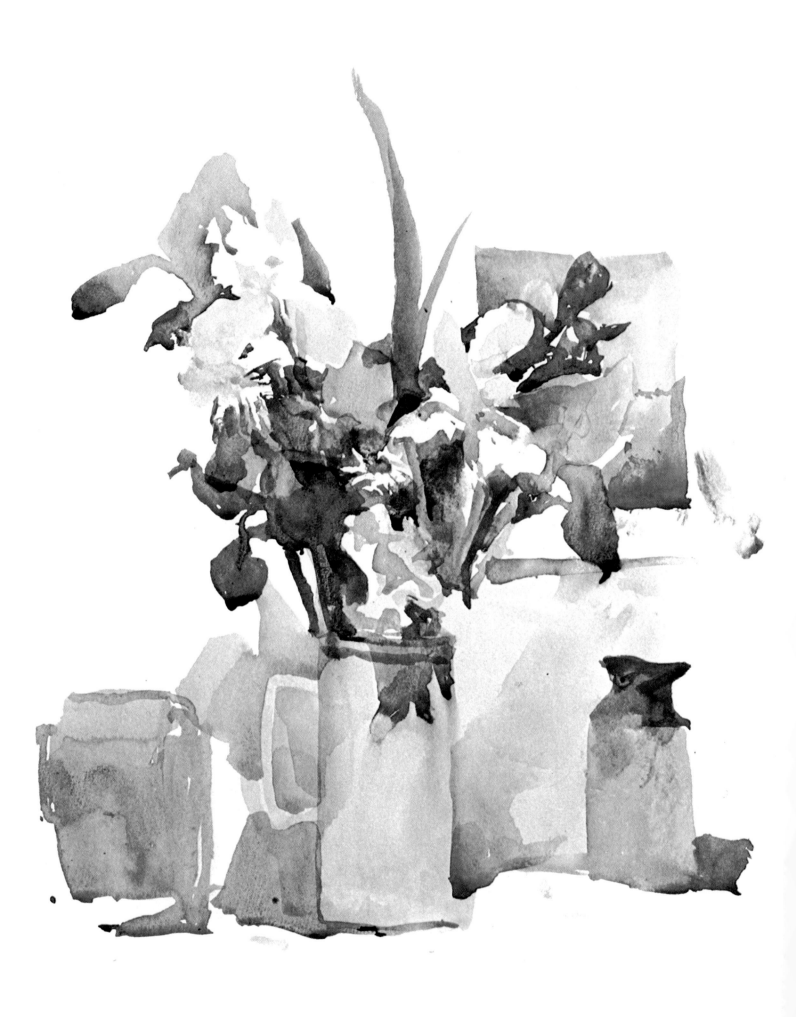

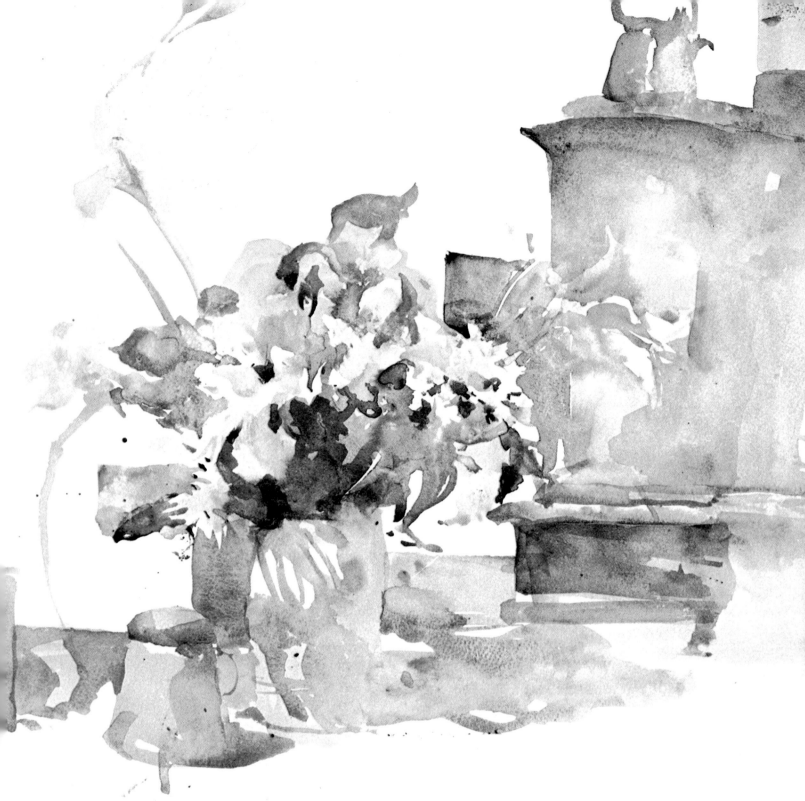

Flowers from the Garden with My Stove, *16 x 13 in (41 x 33 cm)*

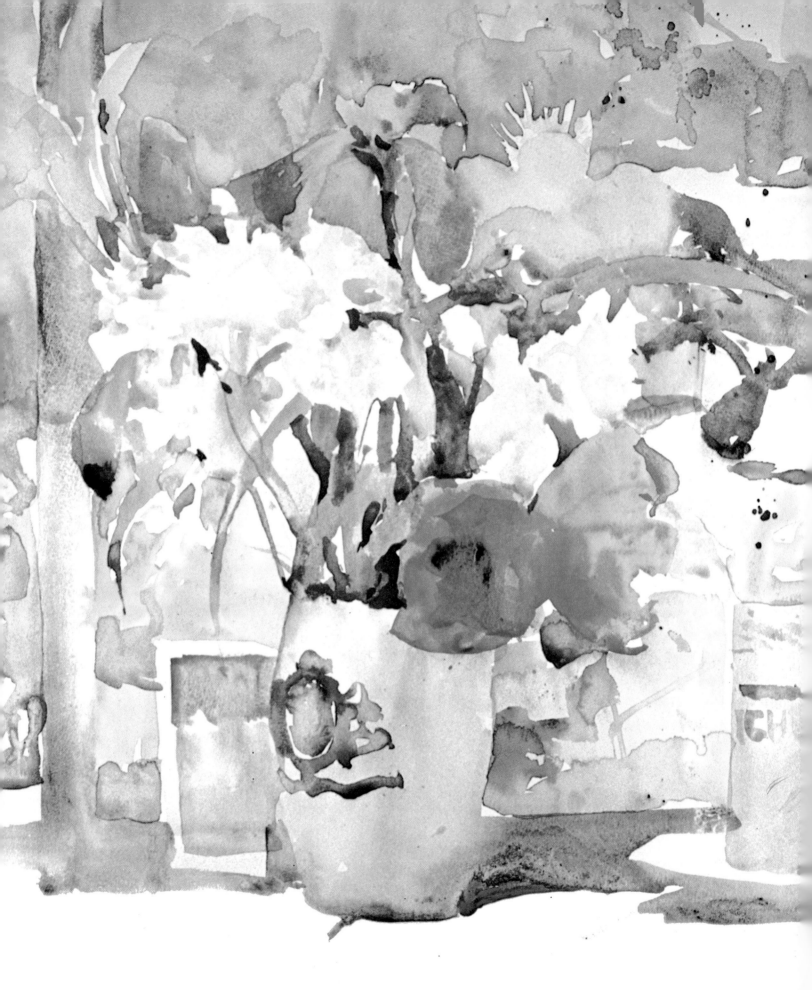

Morning Light, *16 x 13 in (41 x 33 cm)*

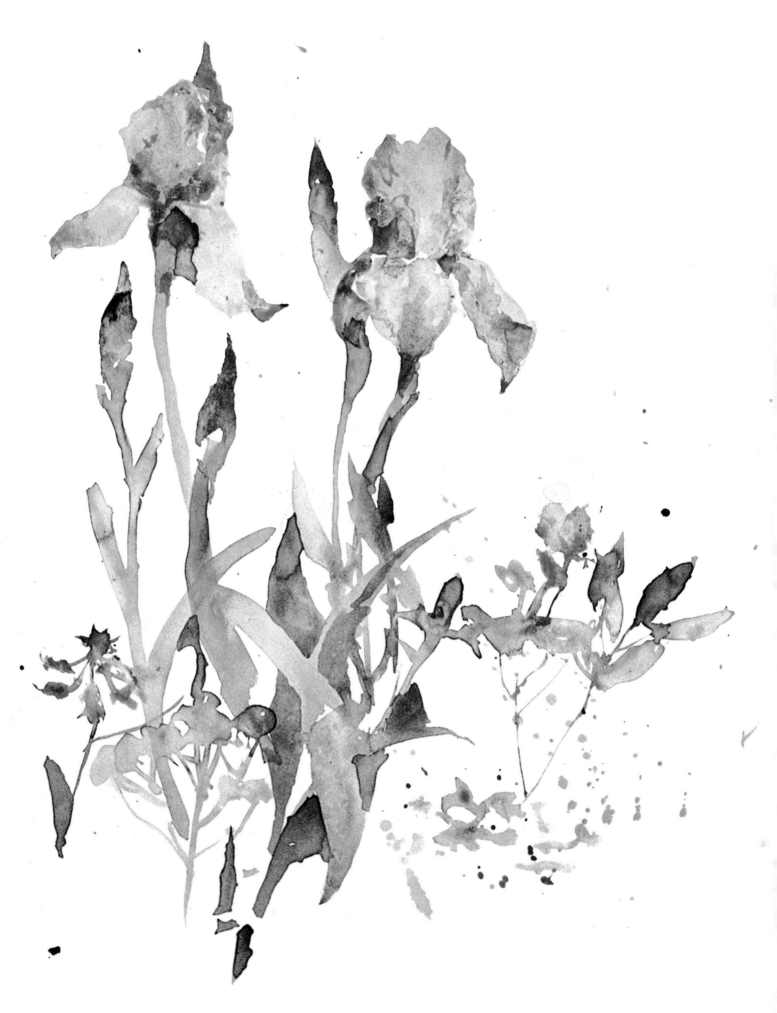

Yellow Iris, *16 x 13 in (41 x 33 cm)*

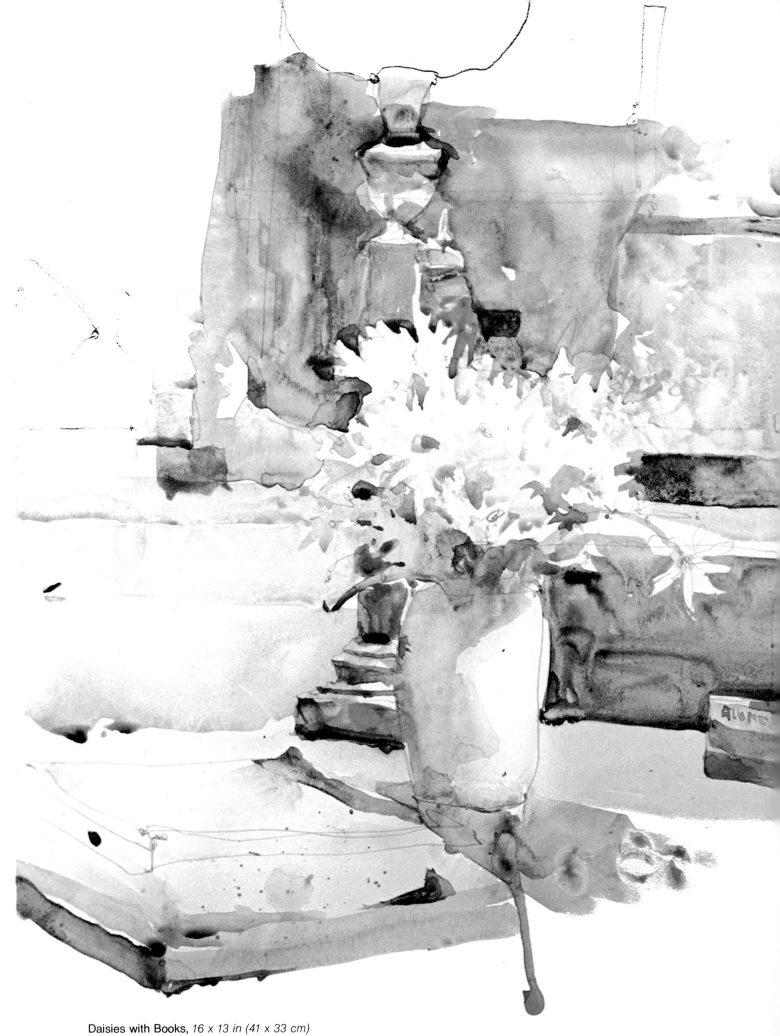

Daisies with Books, *16 x 13 in (41 x 33 cm)*

TECHNIQUES

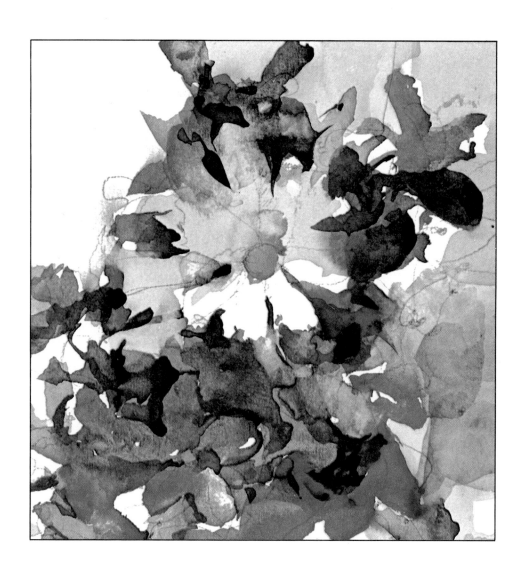

DIRECT PAINTING

I'm painting a little clutch of Star of Bethlehem flowers in this demonstration, and in this series I'll be concentrating on simplicity. Almost all the areas in the painting are done as broadly as possible; there's very little refining of forms. I try to get what I want the first time around. Obviously, this is not always possible or even desirable, but in this early stage I think it's a good idea to be as direct as I can be. I'll be using only a few colors and working in rather large, single areas with very few blending problems.

In this demonstration I'd like you to notice the way I use blues. I'm very fond of grays made with a blue, such as ultramarine, mixed with alizarin crimson combined with cadmium yellow or yellow ochre. In some places I use cerulean blue instead of ultramarine blue, since it makes a cooler gray than does the warmer ultramarine blue. I also use cerulean, cobalt, or ultramarine blue mixed with cadmium yellow to make a green and then mix it with cadmium red light to make a warmer gray. Frankly, I switch around among my blues for the sake of variety and often don't have a definite reason for choosing one over the other.

I'm working on 140 lb. cold-pressed paper, 16 × 13 in (41 × 33 cm). I start the drawing in my usual manner with a continuous contour line, using a number 2 office pencil. I don't do any preliminary sketching, and I keep my pencil moving fairly slowly from one object to another.

Brush
No. 8 round sable

Palette
Alizarin crimson
Cadmium orange
Cadmium yellow
Cadmium yellow pale
Sap green
Cerulean blue
Ultramarine blue
Raw sienna

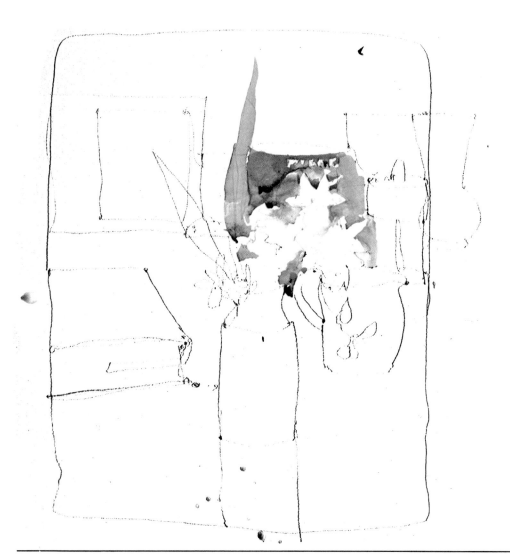

1

For a cool green I mix cadmium yellow and cerulean blue. With my number 8 brush I make a single downward stroke, increasing the pressure to show the broadening of the leaf. I then work around what will become one of the flowers, but I don't go back and correct with my brush. If I wish to lighten a leaf I blot it lightly. I allow the leaf to dry; then, adding a little sap green and cadmium red to my green mixture, I paint in the dark middle-value green under the central flowers. I now paint around the lettering of the blue can with ultramarine blue and allow it to dry before painting the yellow-brown label with raw sienna and cadmium yellow. Before painting the label I first wet the paper in several places where I will paint flowers with a very light, cool mixture of alizarin crimson, cerulean blue, and a touch of yellow ochre. Notice the soft edge around the little section of the flowers. I only dampen the flower area in a few places and keep hard edges and careful flower shapes in others. The very warm spot in the lower right area is a bit of pure cadmium orange.

2

Again using sap green and cadmium red light, I put in the fairly dark green under the flowers and then work down into the top of the vase using the same colors, but this time with more red and much less sap green. I paint the "brown" vase top to reflect the round shape it describes, leaving a little white paper on the lower left for a highlight and adding a touch of cerulean blue on the right to suggest a cool reflected light. I paint the pitcher with the same cool gray I discussed in the introduction: a mixture of alizarin crimson, ultramarine blue, and yellow ochre. I allow this to dry before I paint in the rim and the darker inside section at the top. I then add a slightly darker overwash on the left side of the pitcher, leaving a bit of the original wash untouched to suggest reflected light. I paint the L-shaped section of the tabletop with cadmium orange and raw sienna.

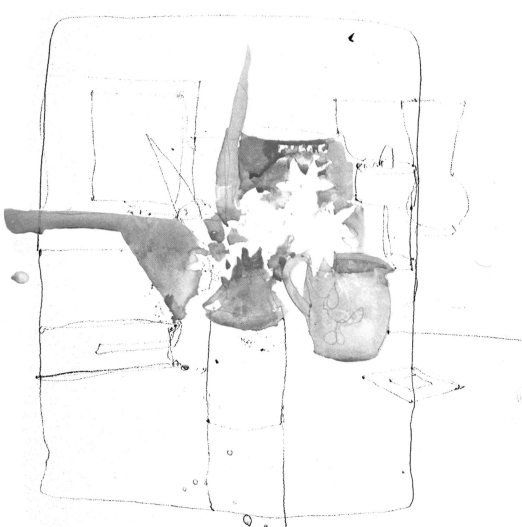

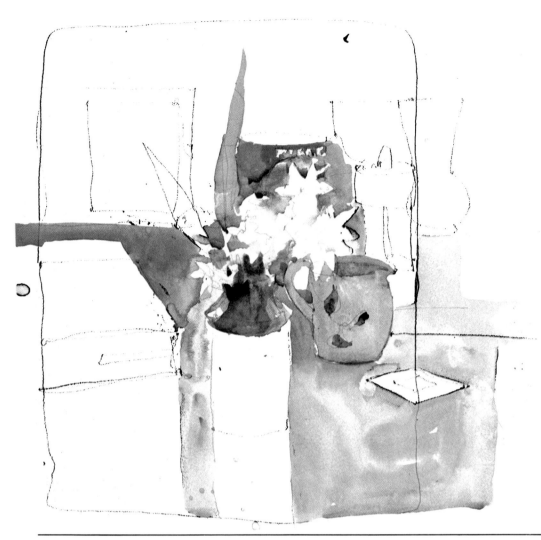

3

Next I add the table section to the right of the vase. Starting with raw sienna, I put in a touch of cadmium red light at the top. I then work my way down with my raw sienna, this time adding a touch of cerulean blue. Still working quite wet, I add some alizarin crimson to the table. I'm applying these colors directly to the paper, mixing very little on the palette. I paint around the slide lying on the table, leaving this little piece dry. I don't prewet the paper but start right out with colors such as the raw sienna and cerulean blue, on dry paper. I then add more colors to this initial wash. Instead of continuing right into the vase and its cast shadow, I leave hard edges on the washes. I could have painted the whole table and vase with a single wash, since all the colors and values are so similar. But there are always several possibilities, and we should try different things at different times.

4

I finish painting the table and add colors wet-in-wet. Notice the big blob of alizarin crimson in the lower left area. This is a bit strong, but I leave it, knowing I would only get in trouble if I try to correct it. I paint right up around the book, leaving a hard edge and using more and more raw sienna with a touch of cadmium orange. At the same time I paint the vase and its cast shadow with the same colors and values. I don't like the hard edge together with an extreme color and value difference between the dark vase top and the lighter lower section, so I introduce some cadmium red light and a little sap green along the upper back side of the vase. The grays in the cover of the book are a mixture of cadmium red light and sap green. I combine cerulean blue and cadmium yellow to make a green for the second leaf and the salt grinder, which you can see through, to the right and behind the pitcher.

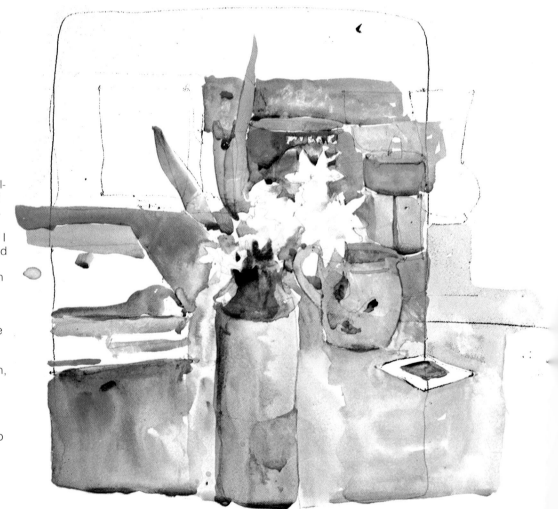

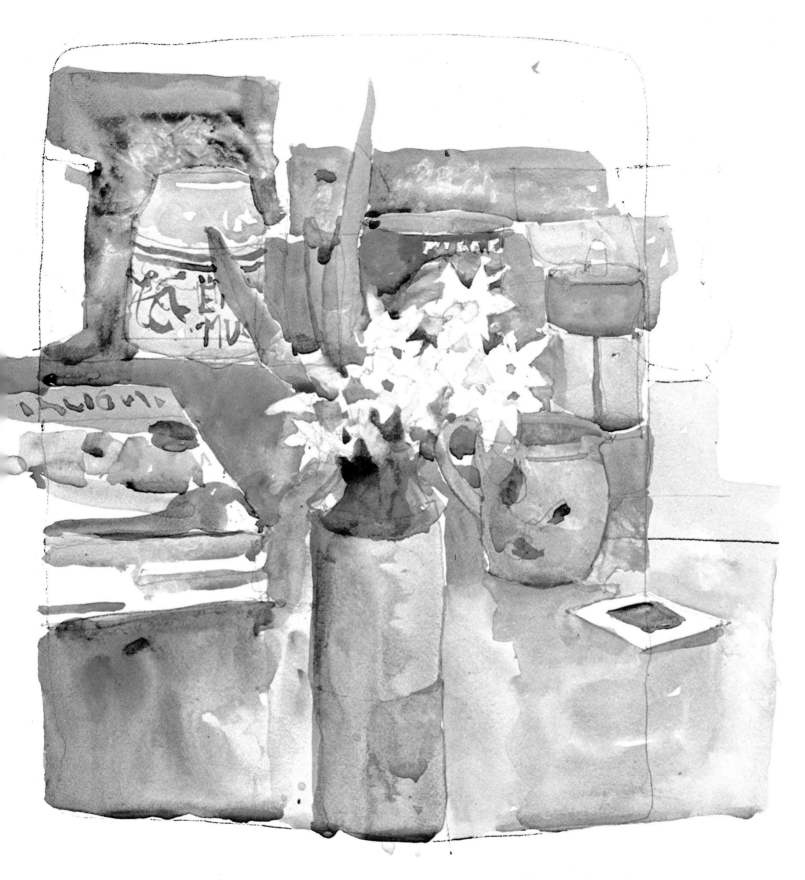

5 Here I "lift out" several flower petals. "Lifting out" is much harder with some colors such as green than with others. To lift out, I take a clean, damp brush and scrub lightly the area of color I wish to lighten. I then clean the brush, blot the brush with a tissue until it's only damp, and then work at the area until I have it light enough. I now turn to the book cover which I paint with a very watery wash of yellow ochre and cadmium orange, adding a pale wash of cobalt blue when the first wash dries. The book lettering is done with a combination of sap green and cadmium red light. The mustard jar behind the flowers in the upper left area is cerulean blue and alizarin crimson with a little yellow ochre at the top, cooler section. Then, with more yellow ochre and less alizarin crimson and cerulean blue, I paint the lower section. When this is dry, I add the lettering and the stripes. Finally, I go back to the flowers, adding cast shadows (cerulean blue, alizarin crimson, and cadmium yellow pale), some color in the centers (cadmium orange and yellow ochre), and lifting out and softening edges. The shadows in the flowers are not terribly important, and if you overdo them, you'll end up with a mess.

Demonstration 2

WET-IN-WET

I'm painting a bouquet of peonies, daisies, and daffodils here. Usually I work on dry paper, but for this demonstration I dampen the paper first to get it as wet as possible. I actually don't soak the paper to get it wet; rather, I simply pass a clear wash over it with my number 14 round sable brush. My studio is quite dry and, as you will see in step 1, the paper is already beginning to dry by the time I begin to apply color to the drawing. Your wet paper will dry at varying rates of speed, but if you find that sections have gotten too dry before you've had a chance to work on them, you can always redampen the paper. If you want to redampen a section you've already worked on, you must be careful. Make sure your previous wash is *completely* dry before adding your overwash.

Brush
No. 8 round sable

Palette
Alizarin crimson
Cadmium red light
Cadmium orange
Cadmium yellow
Cadmium yellow pale
Yellow ochre
Sap green
Cerulean blue
Cobalt blue
Ultramarine blue
Raw sienna

The decision to predampen paper is personal. Some painters always predampen because it enhances their painting style. Also, some watercolor paper has a sizing on it that tends to repel the paint; but "washing down" will make this kind of paper much more receptive. Whatever your reasons for dampening your paper, you should usually first secure it to a board by taping around all the edges with masking tape, which will give you a stretched-paper effect. I don't do that here, since I'm using a small piece of paper. Had I chosen to work with a half or full sheet, taping would be necessary.

My preliminary drawing is done with a number 2 office pencil on 140-lb. cold-pressed paper, 16 × 13 in (41 × 33 cm). The drawing is not particularly complete. Actually, it's merely a rough-in. I'll do most of my drawing with my brush in the painting stage. At this stage I just want a general idea of where my big forms are. This is my usual approach, but here I really want the picture to evolve, and I don't want to worry too much about losing a good drawing. If you find that a complete drawing works better for you, then that's what you should do.

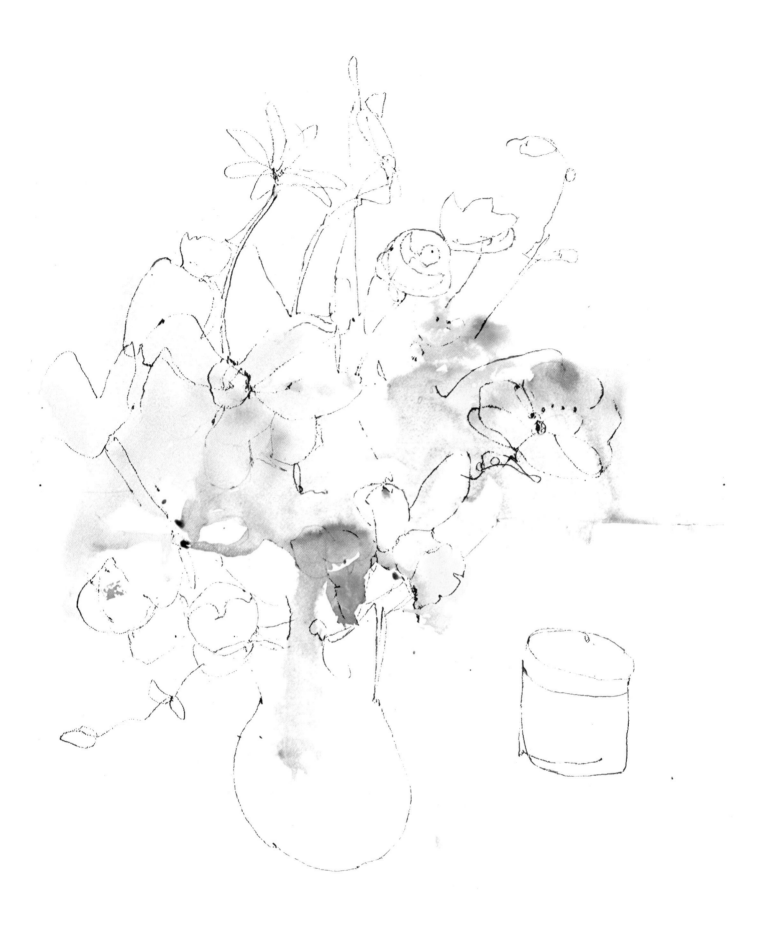

1 The very high-key yellow on the left is cadmium yellow pale. I put this in first. Then I mix alizarin crimson with a lesser amount of ultramarine blue on my palette, applying this wash to the paper where it blends with the yellow. I then add diluted ultramarine blue. The paper is drying fast, which creates a somewhat hard edge. Next I mix my greens on the paper using cerulean blue and cadmium yellow. The paper has almost dried, so I paint around some areas that will eventually be white flowers. I again dampen the paper to the right with clear water and then add more flowers, using cadmium yellow and a little cadmium orange. I also drop ultramarine blue and alizarin crimson directly onto the paper and they are absorbed fairly well. Don't go back to correct even if the new colors are too dark. I put in the cadmium red light flowers and more ultramarine blue and alizarin crimson to show the beginning of the vase.

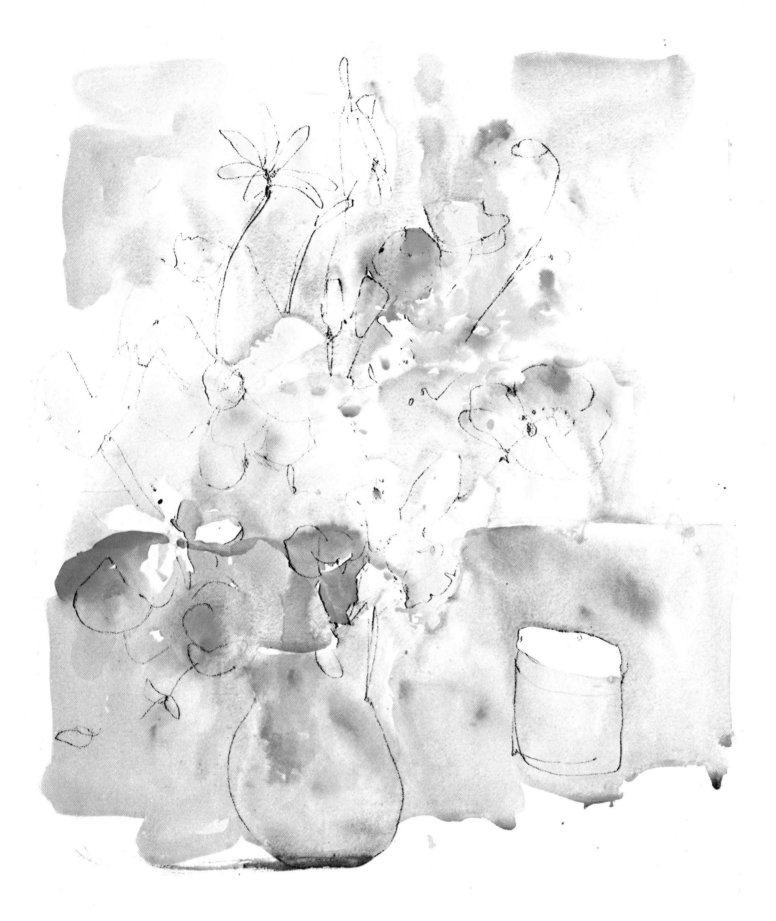

2 The paper is dry, and there are some places where I'd like fairly definite edges, so I don't dampen the whole paper again. I mix a cool wash of cadmium yellow pale, cerulean blue, and alizarin crimson and work this mixture over large areas in the upper section of the picture. As I work, I add cadmium red light and cadmium yellow directly into this wet, cool wash. Some bits of white paper show through. I'm slowly beginning to "find" various flowers by painting around shapes with an overwash. Working into the lower section of the picture, I return to my cool wash of alizarin crimson and cerulean blue, carrying it right across the vase and into the left side of the picture. I apply some of the new colors wet-in-wet and others onto the dry paper. For the most part I keep things as fluid as possible. I don't want to get into a drybrush type of dark accent yet. Things must be kept light and airy.

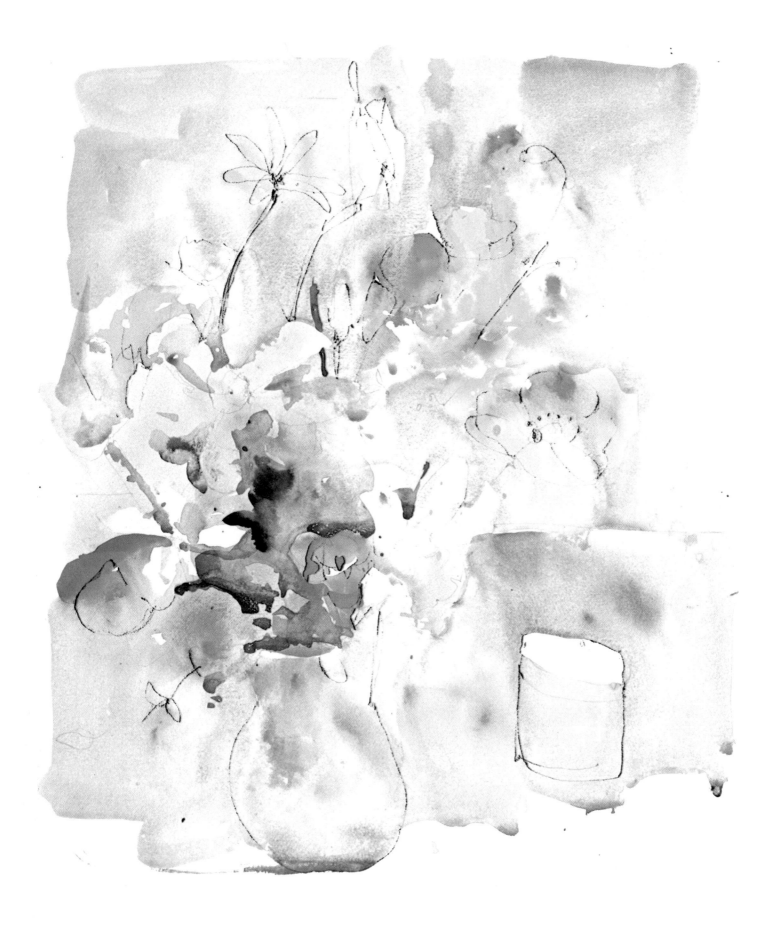

3 This is the first step where I really add darks. Using ultramarine blue and cadmium yellow, I begin to work on some of the greens in the center of the flower mass. They don't cover a very large area, and I'm ready to blot and lighten with a tissue if they do seem to be getting too heavy. I do this right above the red flower in the center left area. Using cadmium yellow pale, I start to work around a light purple flower on the right. I pick out one or two details with ultramarine blue, cadmium yellow, and a touch of alizarin crimson. The cadmium yellow from the yellow flower flows into this combination, but I don't correct, allowing the paper, the water, and the paint to do the work.

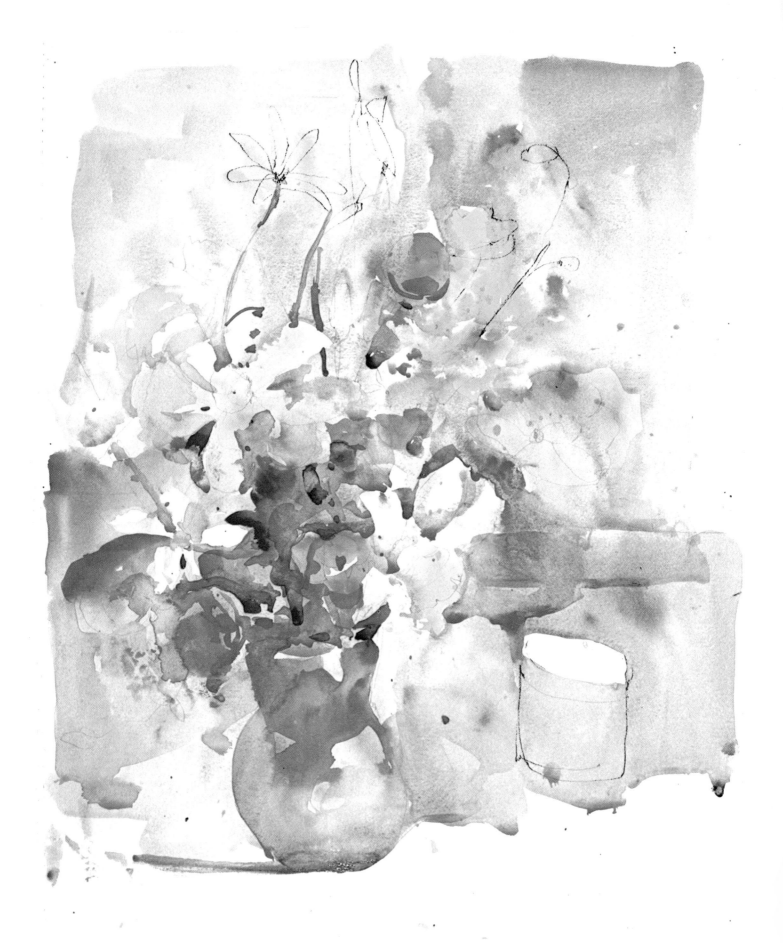

4 Here I add background and bring the flowers into focus by finding the left boundary of the vase with a cool gray wash of ultramarine blue, alizarin crimson, and cadmium yellow. Using sap green and cadmium red, I show the warm dark on the vase, giving the vase a variety of hard and soft edges. I then work down into the left side where my darker wash blends with the cool gray. Using my green combination of ultramarine blue and cadmium yellow, I define more of the flowers, developing lots of hard edges. But I also blot a lot and never outline with the darker background value. I almost paint in spots, just hitting some of the areas around the flowers with darks, allowing the flowers breathing room. The darker areas on the red flowers are done with cadmium red light and a small bit of alizarin crimson.

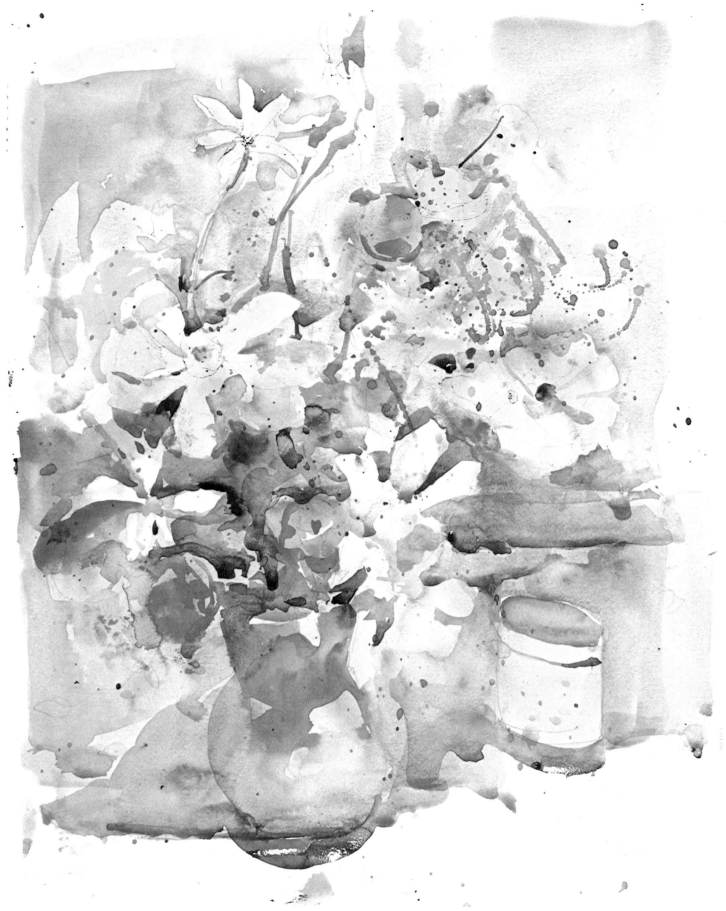

5 In this final step I continue finding flowers with my warm and cool background color, but I don't introduce any new colors. You can make any gray combination either warm or cool by using more warm or cool colors in combination. If I wanted a really warm brownish gray, I wouldn't use alizarin crimson, a yellow, and a blue; rather, I'd go to a green and red, or a blue and burnt sienna, or one of the umbers mixed with blue. I continue to work around color areas to create flowers. In this kind of painting you need not be a slave to your subject. The painting should take over and dictate what is to happen. Be sure to vary colors. Never settle on one green or blue and keep using it over and over. Remember, you can use the same color combinations varying the ratios and come up with quite a different feeling in each.

DRYBRUSH

I rarely use drybrush in my own work, probably because I don't use it very well and so have gotten out of the habit of working with it. When drybrush is executed properly, however, it can give life and interest to a painting. When I do use it, I mix my paint and water on a palette. I try to keep my colors light and use the drybrush in light areas. In the kind of paintings I do, darker drybrush usually seems to look out of place.

In this demonstration I'm painting a close-up of an arrangement of beautifully variegated tulips. Since the flowers are so delicate, I must be careful not to overdo the drybrush work, lest the painting become scratchy and hard looking. However, the fine striations of a tulip provide me with a subject well suited to the drybrush technique.

I start with a brief drawing using a number 2 office pencil. I'm working on 140 lb. cold-pressed paper, 13 × 16 in (41 × 33 cm). Since both the flower and the arrangement are simple, the drawing is also simple. The shape is the most important element here; the painting will have no meaning if the shapes are sloppy and generalized.

Brushes
No. 8 round sable
No. 14 round sable

Palette
Alizarin crimson
Cadmium red light
Cadmium orange
Cadmium yellow
Cadmium yellow pale
Sap green
Cerulean blue
Ultramarine blue

1

Since the flower is very delicate, with pink edges changing to a light warm color toward the center, I begin by mixing on my palette cadmium yellow, a bit of cadmium orange, and a little alizarin crimson with quite a bit of water. My puddle of paint is diluted, but the wash will dry lighter; therefore, I make sure the puddle still has a feeling of definite color. Using my number 8 round sable brush, I begin with the petal in the center and to the left, washing in the whole petal at once while making sure that I keep the definite shapes. Then I mix alizarin crimson and a little phthalo blue, which I drop wet-in-wet around some of the edges of the petal. The center of the flower is too washed out, so I drop in some slightly diluted cadmium yellow wet-in-wet. I don't want to go back over the lighter washes of this delicate flower with an overwash, so I try to complete each section as I go. I use a tissue to lift out color if it gets too dark. I continue using the same color for new petals, but I add more blue. I again drop in some cadmium yellow wet-in-wet.

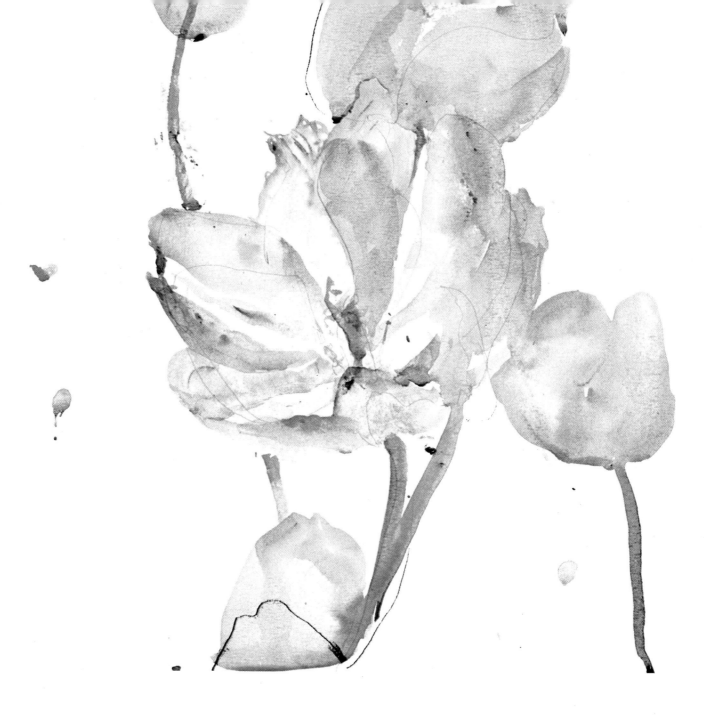

2

Throughout this early stage I allow each petal to dry almost completely before going on to the next. I want some firm edges, but I also want a little bleed on some edges so that the flower won't look like a cutout. I'm still using my number 8 brush and the same colors. As I mentioned earlier, I don't want to go over light values with overwashes; but some overwashes in darker sections are necessary. You can see this in the top petals where a darker pink is added over a lighter wash wet-in-wet. I start to use a bit of drybrush in this top section of the flower. This is not pure drybrush, since the paper is wet, but I give my brush a good shake before picking up some slightly diluted alizarin crimson. Then I blot the brush lightly with a tissue before I add the small strokes for the small details. The green in the center is a mixture of ultramarine blue and cadmium yellow. I now add more flowers, using the same colors. Notice that I do quite a bit of mixing on the paper. You can see this clearly in the flower at the right, which I first paint wet-in-wet with a combination of alizarin crimson and phthalo blue. Then, while it is still wet, I drop in bits of blue that I have diluted slightly on the palette. I also add some alizarin crimson, again in slightly diluted form. The green stems, painted in with my number 8 brush, are ultramarine blue mixed with cadmium yellow.

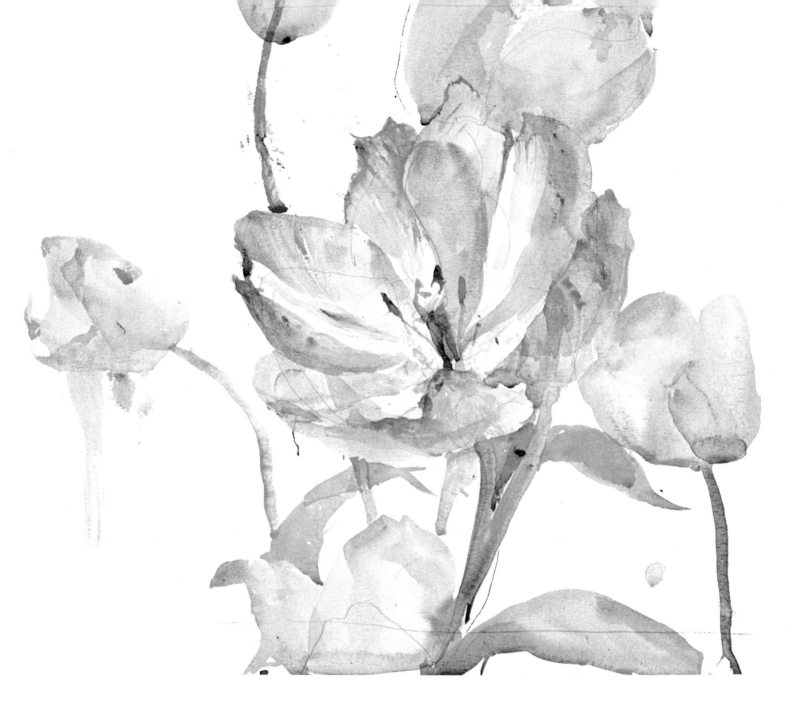

3

Notice that so far I haven't used any pure drybrush. I want the flowers to remain fresh looking, so in this final step the drybrush must be subtle and understated. I continue to use my number 8 brush. I mix up a puddle of alizarin crimson and a little phthalo blue and blot my brush with a tissue to get rid of excess water. I then take this "dry" brush back to the palette and pick up some paint from my light pink puddle. I again shake the brush, as I don't want it too wet. You might also blot the brush lightly with a tissue if it's still too wet. Next I make very delicate, light strokes, showing the texture of the petals. It might be necessary to make these strokes several times to get the right values and the right amount of dryness in the brush. It does take practice. I'd suggest trying the whole procedure on another piece of paper first until you get the hang of it.

Demonstration 4

USING OPAQUE

Crocuses are a sign that winter might finally be over, so in this painting they appear still in the ground. Although I do work with opaque white here, opaque actually plays a very small part in my paintings because I find it difficult to use for anything other than corrections and small details. When I try to work with opaque, the results often have a dry and labored look. I think the trouble arises when I try to do larger areas with opaque, thus creating a picture that is partly transparent and partly opaque—a combination I find unpleasant. For example, if, in this demonstration, I paint the ground transparently and the flowers opaquely, I will have a picture with two separate painting ideas, and I'm unable to manage this successfully. To make this a successful opaque watercolor, I would have to paint much of the background and the flowers with opaque washes—which isn't my way. That I don't use opaque comfortably is my own failure and doesn't mean that opaque watercolors cannot be used successfully by someone who likes using them and uses them well.

The opaque white used here is Luma designer's white, and I work directly from the bottle when I want pure white. However, as I don't like the cloudy water that results from rinsing a brush containing opaque, I either have a separate container of water used only when I paint with opaque, or I don't use the opaque until the very end when all the transparent work is done.

I'm working on 140 lb. cold-pressed paper, 12 × 12 in (30 × 30 cm). Using a number 2 office pencil, I sketch in a rather rough idea of the flowers. My first thought is to start developing a connection between the flowers and the surroundings. Thus I carefully show the boundaries of some sections of the flowers, while in other places I allow the flowers and the background to merge. Throughout most of the painting, that is, until close to the end, I do most of my mixing on my palette, but I'm careful not to overmix. I want the different colors to show on the painting.

Brush
No. 8 round sable

Palette
Alizarin crimson
Cadmium orange
Cadmium yellow
Phthalo blue
Ultramarine blue

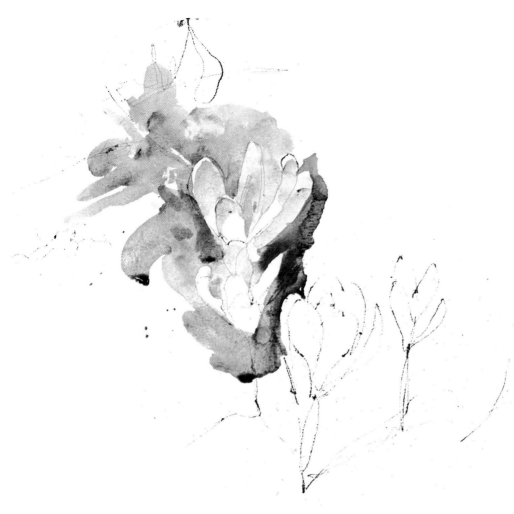

1

Once I have drawn in the crocuses, I then slowly begin to add some shadows to them and work more into the background with a quiet green made up of raw sienna, cerulean blue, cadmium yellow, and alizarin crimson. The values in the top flower are very similar to adjoining background values, but I don't isolate the flowers with dark surrounding values. Rather, I just spot darks to set off the lighter flowers. I'm still using the same colors I started with for the background, but I don't use them all at the same time. In some places I use only the blue and yellow when I want a stronger green. I also allow definite color to show. For example, you can see pure cerulean blue in the left side of the lower crocus. I mix a little cadmium yellow, alizarin crimson, and cerulean blue on my palette and then work up from the pure cerulean blue to make the rest of the shadow section of the crocus. I use mostly my number 8 brush until step 5.

2

I'm trying to create the effect of soft edges here by varying the value contrasts between flowers and background. A strong contrast between the values of two adjacent areas will give the impression of a hard edge, whereas two adjacent areas of similar value will give the impression of a softer edge. As I add darker values around the flowers, I'm still careful to let the flowers breathe. I don't want to mummify them in surroundings of heavy darks. Notice that there is often a lighter strip between the flower and the darker values in the background and that I've introduced some light pieces of detail that run into the flowers. When overpainting, I leave these light pieces untouched.

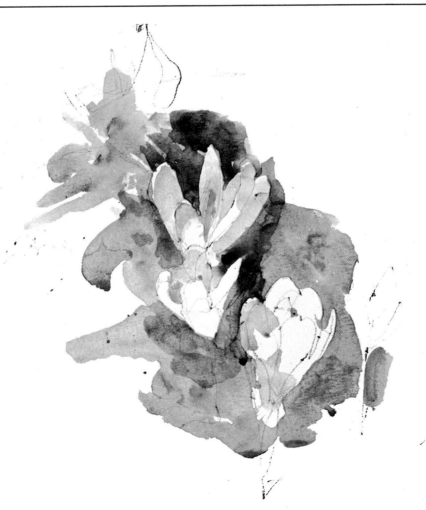

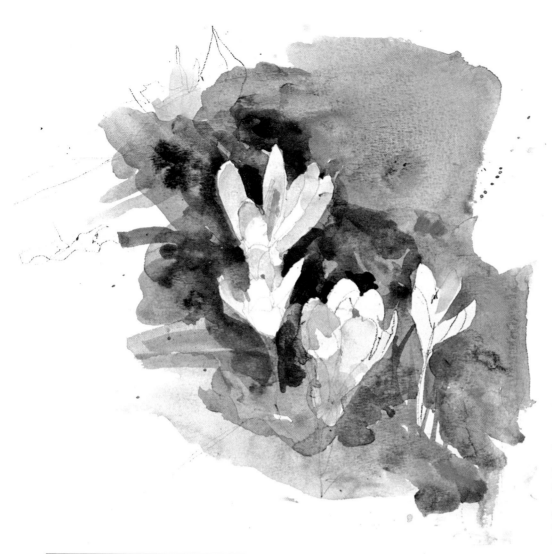

3

I add another crocus on the right and more background around the flowers. The ground is quite dark, and I squint often to keep the big value shapes in mind. I also look at the picture from a distance or turn it upside down. If it looks good, I know I'm on the right track. If you get into trouble with too many details, switch to a bigger brush rather than a smaller one. Simplify even if you destroy the freshness of an area. I try to keep my color in the background as fresh as possible by adding new color directly, actually mixing on the paper. You can see the ultramarine and cerulean blues and the alizarin crimson, and as I add cadmium yellow, the background in the upper right area becomes a warm gray. I also mix the blues with cadmium yellow to get a relatively strong green. These color areas often don't blend perfectly but do retain their own identity. The values are, however, all about the same. In the lower right area I also add a bit of cadmium orange wet-in-wet, mixing it into the wet color on the paper. I don't work in the new color; rather, I gently place it.

4

I haven't yet used any opaque since I'm still working with my transparent washes. In this step I add some cool shadow wash to the two flowers in the lower right area, using mostly cerulean blue, a little quiet, unobtrusive cadmium yellow pale, and a little alizarin crimson. Cadmium orange mixed with a blue would work if carefully diluted. Alizarin crimson must also be carefully diluted when used in light areas. Cerulean blue, however, comes out of the tube in a relatively quiet state and can be used a bit more freely. I paint the stamens with cadmium orange, to which I add very little water plus a bit of raw sienna and cadmium yellow. I use my number 6 brush for small areas like this but quickly go back to my number 8 brush. In painting the foreground grass, I start with the mass in the lower left area, using ultramarine blue and cadmium yellow. Then, with the color that's already on the paper, I draw upward strokes to form the individual blades of grass. If I need new color, I add it to the original green section wet-in-wet and continue drawing this color upward to form more blades of grass.

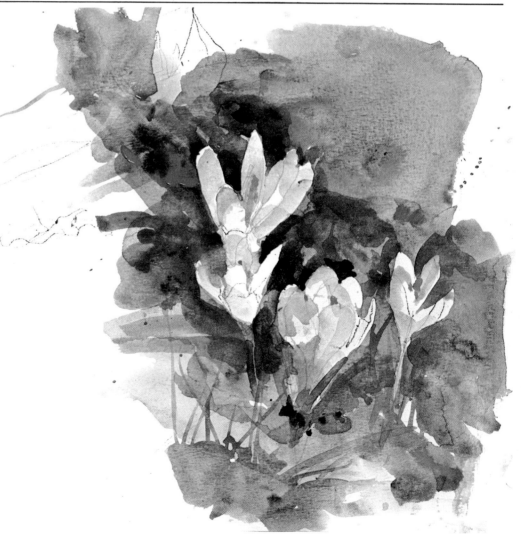

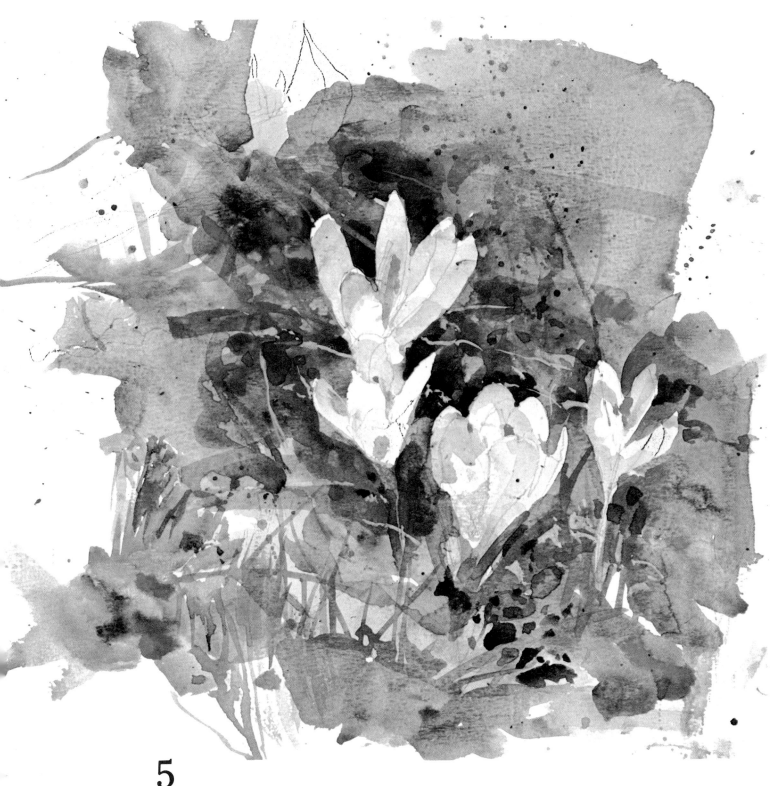

5

To finish up, I use opaque to correct some errors and add details. I occasionally switch to my number 9 brush for broad areas. They don't make a very dramatic difference in the painting, but the minor corrections and details help the overall effect. I expand the background around the flowers using the same color but painting with both the number 9 and the number 8 brushes. I'm still spotting color about the painting in fairly limited areas, mixing most colors right on the paper and keeping all new areas in the same general value range. I add only a few really dark accents—and even these aren't as dark as they could be—which help direct the eye in a diagonal direction through the painting. I want a covering white for the flowers, so I don't add water to the opaque white. I restate some white areas in the flowers, without overdoing it. With a number 6 round sable brush I add twigs and other small forms in the ground around the flowers. I mix white on the palette with other colors—some of the warm gray stripes are fairly apparent. I don't want chalky color that looks out of place. The opaque stripes help connect the light flowers with the background. In the lower right area, I use my opaque mixture to show some lighter ground through some blades of grass. In other places I combine the opaque with the green that I mixed from cerulean blue and cadmium yellow.

Demonstration 5

WASH-OVER-WASH

Wash-over-wash is the technique probably used most often in water-color painting. It implies starting with light beginning washes and building toward darks with successive overwashes. The term *overwash* means exactly what it suggests: applying a new wash over the old with a very light pass of the brush. Most watercolorists use a modified version of this procedure. They build up many areas with overwashes but paint in darker values right away, since it's a bother to build toward a dark with six or eight overwashes if you already know from the beginning that an area in the painting is going to be dark. In my own work I paint all darker values in the middle-value range with my initial washes. (If you have questions on what I mean, please look again at Chapter 4 on "Values.") As the painting develops, I might add darker overwashes to reach the desired value. This demonstration illustrates this process.

I'm painting anemones, working on 140 lb. cold-pressed paper, 16 × 13 in (41 × 33 cm). I do the initial drawing with a modified contour line, using a number 2 office pencil. I've discussed this type of drawing in Chapter 3 on "Drawing Flowers." I try to keep it minimal, since I want to establish only the placement of the major parts of the painting at this point. This is my way of working, but every artist must decide how complete a drawing he or she needs.

Brushes
No. 8 round sable
No. 9 round sable

Palette
Alizarin crimson
Cadmium orange
Cadmium yellow
Cadmium yellow pale
Cerulean blue
Ultramarine blue
Raw sienna

1 I begin with raw sienna and cadmium yellow pale on the left, since I need a darker value to set off the boundaries of my white flowers. Then on the palette I mix up a light puddle of alizarin crimson, cerulean blue, and ultramarine blue. I load my number 8 brush and give it a good shake before painting in the very light purple values above and to the right of the white flowers. I let some of this mixture seep into the white flowers, adding a little cadmium yellow pale wet-in-wet and blotting it with my tissue to keep it from being as dark as the surrounding colors. The raw sienna mix is still wet, so I get a blend. I keep adding new color to the puddle and work my way down into the darker purple values in the lower right area, adding color wet-in-wet as I work. Some of the work is quite broad, but I'm careful to show some of the petals of the purple flowers. The really dark spots in the center area are also alizarin crimson and ultramarine blue with very little water. This is an example of starting out with a dark value in an area that I know should be fairly dark. Normally, I wouldn't go this dark, but the flowers look so dark I know I can't be too far off.

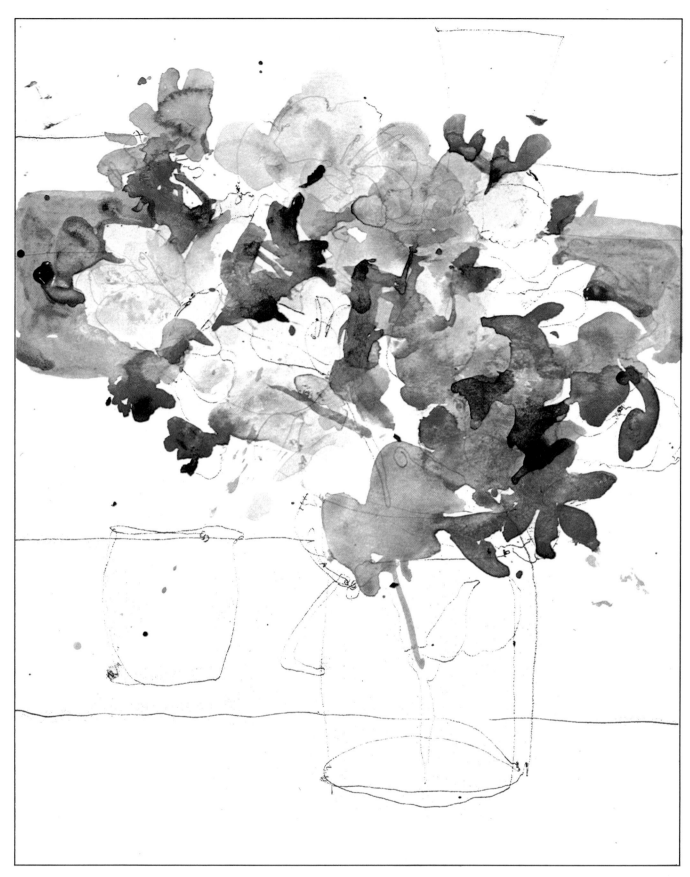

2 Using raw sienna, I darken the yellow browns on each side of the flowers. Using the same combination of cerulean blue, ultramarine blue, and alizarin crimson that I used in step 1, I paint more of the purple flowers. I use darker values in an overwash to pick out the contours of the lighter flowers. Some sections of my first wash are still damp, and the overwash blends with the underwash. I want some edges firm and some soft. I wait about two minutes before adding my second wash. It takes experience and luck to get the harder edges and the blends where you want them. Sometimes I blot the first wash with a tissue in the places where I want a soft edge. This helps the painting to look less rigid and tight. Blotting usually makes a dry spot, but it also lightens the blotted section. I also mix up some color for the green leaves, using ultramarine blue, cadmium yellow pale, and sap green. With this mixture I pick out the contours of the lighter flowers. These greens are about as dark as they'll ever be. I don't build them up but state them as I think the greens should look in the final stage.

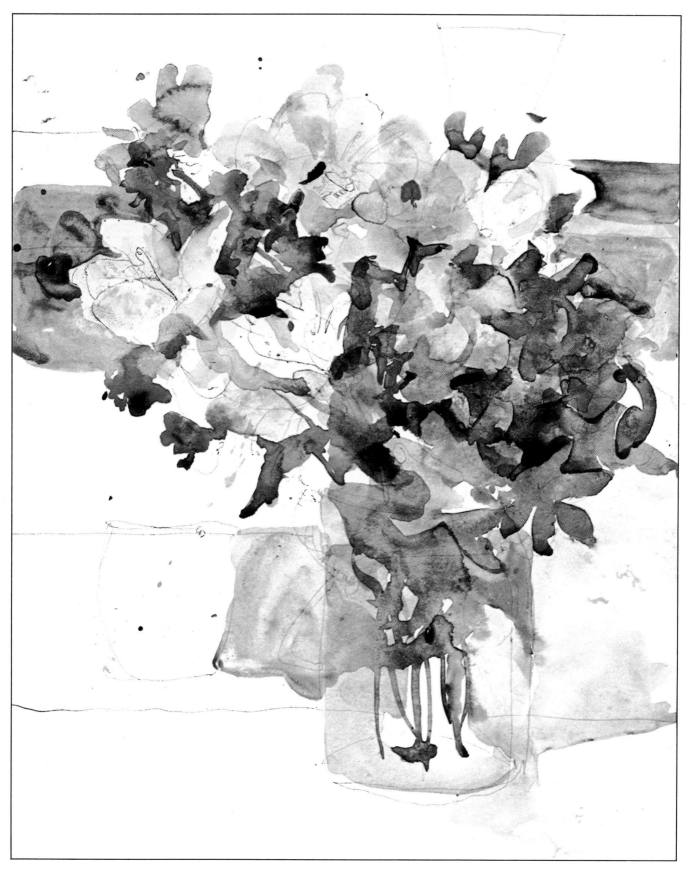

3 At this stage I add the vase, some flower stems, and more greens. It's important to tie together new areas with those already painted. The vase and parts of the table are the same color and value, so I paint them at the same time. Since the vase is glass, I can see the greens and stems around the base of the flowers. I paint these using my mixture of ultramarine blue, cadmium yellow pale, and sap green. In painting forms like these, be sure that your brush points well, or else you won't be able to show the delicate forms of the stems. If you're having problems, it's better to switch to a smaller brush. Next, with a mixture of raw sienna and alizarin crimson, I begin at the left of the vase and then paint into the vase, where I get a blend with the greens. When everything is dry, I gently pass an overwash of alizarin crimson and cerulean blue over the vase and the stems, leaving some white paper showing. You won't disturb the underwashes if you pass the new wash over just once. But remember, it's important to have a light touch. Don't rework the overwash as it's drying, and don't scrub!

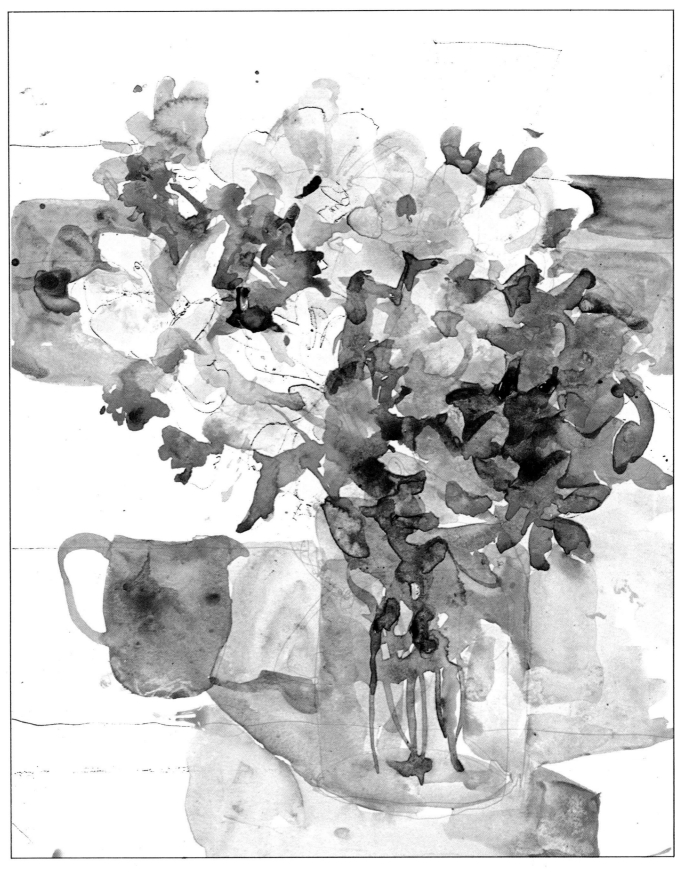

4 For the cast shadow to the left of the vase I use alizarin crimson, ultramarine blue, and raw sienna. It's a bit too cool and doesn't have the same color feeling as the table. This doesn't bother me too much, but, technically, a shadow or cast shadow should have the same local color as the object on which it lies. I allow this to dry before painting adjoining table areas. I add the shadow of the film box using cadmium orange and raw sienna, painting it soon after I put in a section of the table so that I get a blend. I'm using quite a bit of pigment in the shadow, but the table color has taken over and worked its way into the shadow. In a case like this, don't correct. Let things take their course. I add some light, warmer overwashes to the table using cadmium orange, and make sure that the underwash is dry before painting over it. I then paint the small pitcher with alizarin crimson, ultramarine blue, and raw sienna, making it completely one value, then blotting it lightly before adding another slightly darker wash to the middle section.

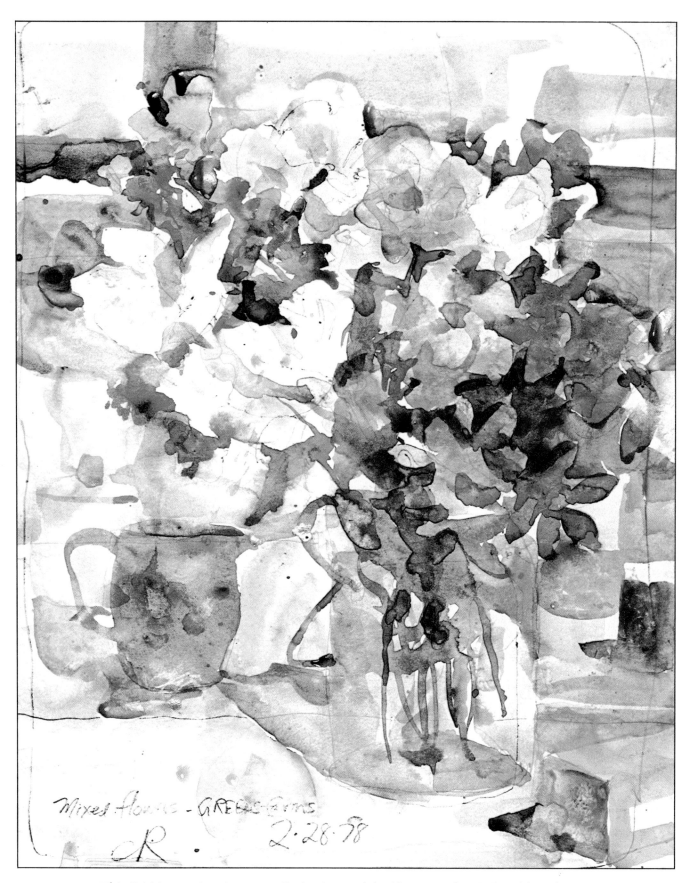

Mixed Flowers - GREEN-forms
2·28·78

5 In finishing up, I work more on the background. I add more washes to the table, using alizarin crimson and cerulean blue to the left of the vase. On the right I add cadmium yellow and cadmium orange to my raw sienna. It's important to give this rather dull tabletop some interesting color variations, so I use overwashes in fairly small blocks. Next to the pitcher I use more raw sienna and cadmium orange. I leave a line of lighter color to make some smaller shapes on this side of the pitcher and then continue above this line with my raw sienna and cadmium orange. I don't necessarily limit myself to just those two colors. I often slip in a little alizarin crimson or cadmium yellow pale, or both. I paint the light section of the film box with pure cadmium orange. The top boundary of the box has already been established, so I continue the orange wash up and out of the box, making an overwash on the light, cool color which has dried by now. Notice the triangle formed with this overwash.

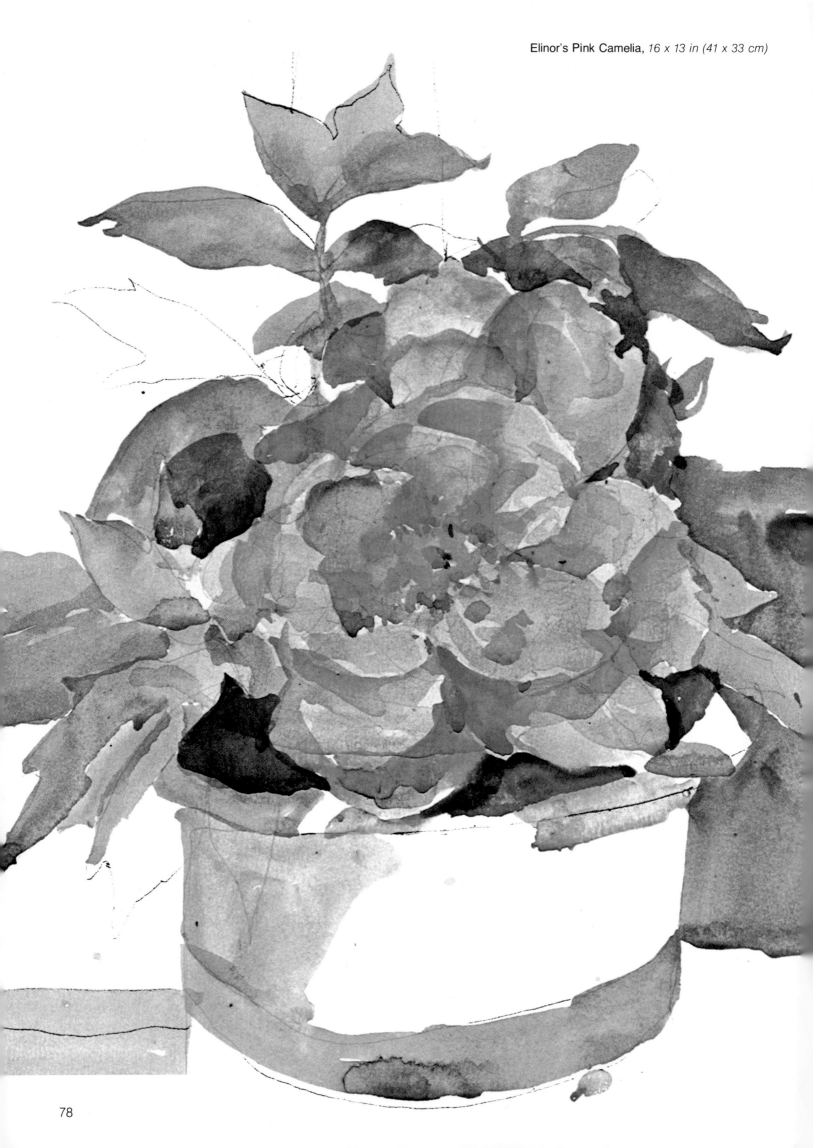

FORMS

Demonstration 6

BROAD PETALS

I'm painting a rather exotic flower for this demonstration—calla lilies. As you can see, I do not include a background, since I'll be concentrating only on the flowers. Almost all my color mixing is done on the paper. This doesn't mean that I abandon my palette completely. I do some palette mixing, but most of the large leaves and flowers are made up of individual colors applied wet-in-wet. These individual colors are then allowed to blend on the paper. I don't dampen my paper first with clear water. I start out on dry paper with color statements. The trick is to work in relatively small areas that won't dry before you want them to.

In this painting I use my paint as rich and strong as possible, adding just enough water to make the paint workable. Make sure you have fresh paint; or if the paint is old, make sure it's nice and moist. Nothing is more frustrating than trying to get a rich color out of a dried piece of paint. You really can't be too rich in a painting like this, so make sure your puddle of paint has lots of pigment.

I'm working on 140-lb cold-pressed paper, 16 × 13 in (44 × 31 cm), and using a number 2 office pencil for my drawing. Starting in the center of the lilies, with a single pencil line—no sketching—I try to describe the very interesting outside and inside shapes of both the flowers and the leaves. This doesn't mean that I'll slavishly follow my drawing; changes will be made. Drawing doesn't stop when you put down your pencil. Drawing continues throughout the painting process, but with a brush instead of a pencil. Notice that my pencil lines continue out to the borders of the picture in several places. Always remember to connect your subject with at least two picture boundaries.

Brushes
No. 8 round sable
No. 10 round sable

Palette
Alizarin crimson
Cadmium red light
Cadmium orange
Cadmium yellow
Yellow ochre
Cerulean blue
Ultramarine blue
Raw sienna

1

Starting at the broad tip of the lily on the left, I mix a small puddle of cadmium yellow on my palette, making sure I have lots of juicy paint on my number 10 brush. I press the brush down to make a nice broad stroke, leaving it on the paper until I paint the whole flower. Putting less pressure on the brush, I approach the narrower part of the flower. While it is still wet, I add a stem of cerulean blue and cadmium yellow that continues down and out in the large leaf formation. I never go back to correct. I work over into the shadow side of the vase, switching to only cerulean blue and alizarin crimson with just a touch of cadmium yellow. I paint the other lily the same way and add cadmium orange wet-in-wet as I work toward the narrow section. Then my wash flairs out, and I work to the left, connecting the wash with the stem of the first flower.

2

I continue down the vase using the same colors I used in step 1. When I get down to the ashtray, I work out of the vase and suggest the shape of the ashtray. Then I switch over to the left side of the vase and show a definite dark and cast shadow under the leaves, using ultramarine blue. Happily, the ashtray is still damp, so that I get a nice blur when I add a touch of cadmium red light and ultramarine blue mixed with cadmium yellow. The shadow to the right of the vase is cooler and darker, so I add some of the mainly blue mixture already on my palette. I work to the right and down to show the shadow on the side of the block, using alizarin crimson, cerulean blue, ultramarine blue, yellow ochre, and cadmium yellow, each color added directly wet-in-wet. For the cool stripe above the block I start at the ashtray, using my fairly dark blue mixture, and work to the left until I hit the shadow on the block.

3

In this step I work a bit more in the lower section of the painting. I add an overwash in the base of the ashtray, leaving white paper for the rim, and paint the inside with cadmium red light mixed with yellow ochre, ultramarine blue, and a little alizarin crimson. I don't let the white rim go all the way around, however, since this would make the ashtray look too static. Starting at the bottom of the lily that overlaps the right rim of the vase, I paint a specific shadow shape of a third lily, using raw sienna and cadmium yellow. Switching now to cadmium yellow with very little water, I wash in around the shadow I've just painted. Look closely and you'll see a white paper rim running on the left of the shadow. This keeps my shadow from blending with the light wash I've just painted. I then take my raw-sienna-and-cadmium-yellow mixture and paint the shadow shape of two additional lilies.

4

I add an overwash of pure cadmium yellow, mixed on the palette, to a section at the right of the shadow painted in step 3. With this yellow I go on to the flowers to the right. Having first suggested the shadow sections with raw sienna and cadmium yellow, I wait a moment for the shadows to dry. Then I put in some leaves with cadmium yellow, cerulean blue, and ultramarine blue. Their greens blend with the still-wet shadow on the lily in the lower right side of the arrangement. I blot some of the leaf areas with a tissue when they seem too dark; when the leaves are dry, I add a darker green shadow value, which is in fact a darker version of the green combination already used in this step.

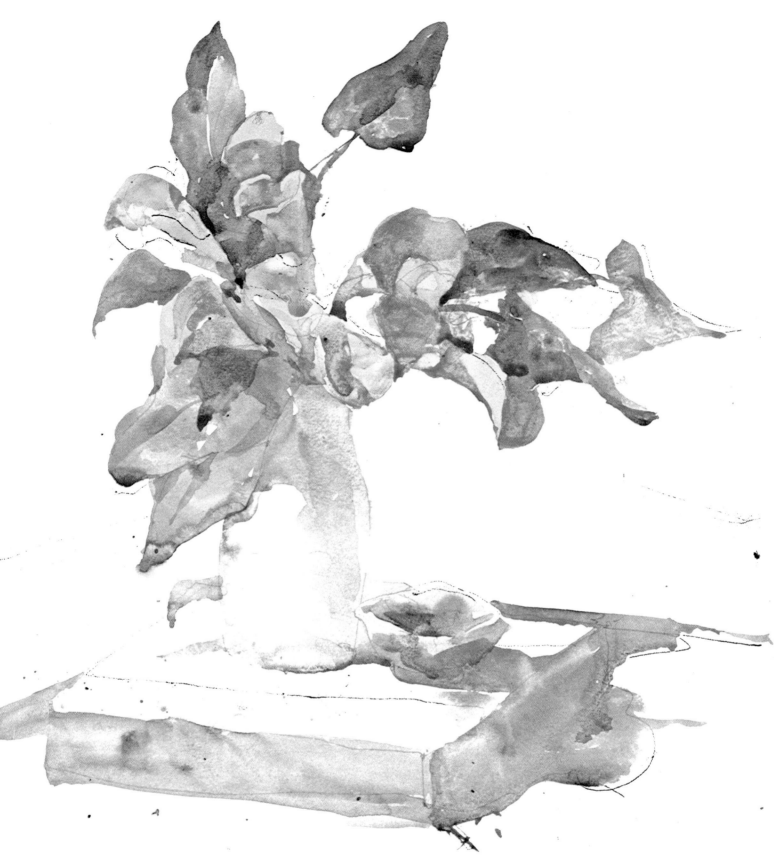

5 I add more flowers, starting with their leaves. My colors are still cerulean blue, ultramarine blue, a touch of alizarin crimson, and cadmium yellow. I begin the top left-hand leaf at its tip, working down the left side until I reach the lower boundary. I then go back to the top and work my way down the leaf with a lighter green wash, leaving a strip of white paper down the middle. Note that the two sides join part way down. I leave the leaf alone now and let things take their course. I paint the other leaf in just the same manner, but I don't leave any white paper showing. When the wash dries, I add a darker overwash to show the conformation of the leaf, being careful to get interesting shapes. Returning to the flowers, I paint the dark one on the left with one wash of cadmium yellow, raw sienna, and cadmium orange. I then paint the flower just below with cadmium yellow and allow it to dry before adding shadows. I add other shadows plus some darker accents to the upper flowers. Sometimes I paint shadows first and then add my lights. At other times I paint the lights first and add the shadow as an overwash. Both ways are all right. All the shadows and accents are done with cadmium yellow and cadmium orange mixed with raw sienna. Notice that I've got a nice blend where the flower shadows connect with the still-wet leaves.

Demonstration 7

SOLID FORMS

Silk flowers are the subject for this demonstration. They really could almost pass for the real thing. Naturally, it's more fun to paint nature's own product, but if nothing else is available, the artificial will do. Also, because silk flowers last a long time, it's pleasant to know that I won't meet a wilted bouquet when I go to the studio to finish a painting started several days earlier.

Note the way that I use colors and values here. For these purple-blue flowers I use both cerulean blue and ultramarine blue—and I find myself intermixing them. During the course of the painting, I often forget just which colors I'm using. I think you should always use a variety of blues where blue is called for, even though I seem to use a lot of ultramarine. At the moment, cobalt is seldom on my palette because it doesn't seem to have the richness of the other blues. But next month I may drop ultramarine and take up phthalo. I also try many yellows here. It doesn't really matter what yellow or blue you use. It's true that a cadmium lemon does not look the same in a mixture as a cadmium yellow, but you should switch between various yellows and blues to see what happens. I use cerulean blue and cadmium orange to make a good warm or cool gray, depending on how much of each I use, and alizarin crimson and ultramarine blue mixed with cadmium yellow pale produces another gray for me.

Notice the values in this demonstration, especially in my greens. I intentionally make some sections darker than others, and if you can show value changes with a single wash, it's all to the good. Naturally this isn't always possible, but always aim for the finished product the first time and don't assume you'll be back later with a second and third wash.

Also note that I rarely use black, burnt umber, or Payne's gray for dark accents. I prefer mixing darks with a blue and alizarin crimson or cadmium red light and Hooker's green dark or sap green. I like black as a mixer with a yellow, raw sienna, or yellow ochre to make greens. It also works well with sap green and a cadmium yellow. Burnt sienna and ultramarine blue make another good dark. Don't make drybrush accents—they give paintings a tacky and scratchy look. Always dilute your accents a little, not enough to lose the value but enough to take the edge off them.

I'm working on 149 lb. cold-pressed paper, 16 × 13 in (44 × 31 cm), and sketching with my usual number 2 pencil.

Brush
No. 8 round sable

Palette
Alizarin crimson
Cadmium red light
Cadmium yellow
Cadmium yellow pale
Cadmium lemon
Cerulean blue
Ultramarine blue
Burnt sienna
Raw sienna
Ivory black

1

I start the painting with a light wash of alizarin crimson, ultramarine blue, and cerulean blue mixed on the palette. Darker puddles of color gather in the lower section of petals. I work carefully around the shapes that will become my white flowers. Using the same blues and alizarin crimson with a touch of cadmium yellow, I show the very light sections of the flowers. I allow some darker purples to bleed into the shadow of the white flower to keep a connection between the two areas. Next, using a mixture of ultramarine blue and cadmium yellow, I paint a small section of light leaves. I continue to work around the white flowers, but my purple wash has become too weak, and I'll have to restate this area later. But I'm trying to keep some edges soft without completely losing the shape of the white flowers. Notice the combination of hard and soft edges, and the values, especially in my greens. I intentionally make some sections of the leaves darker than others.

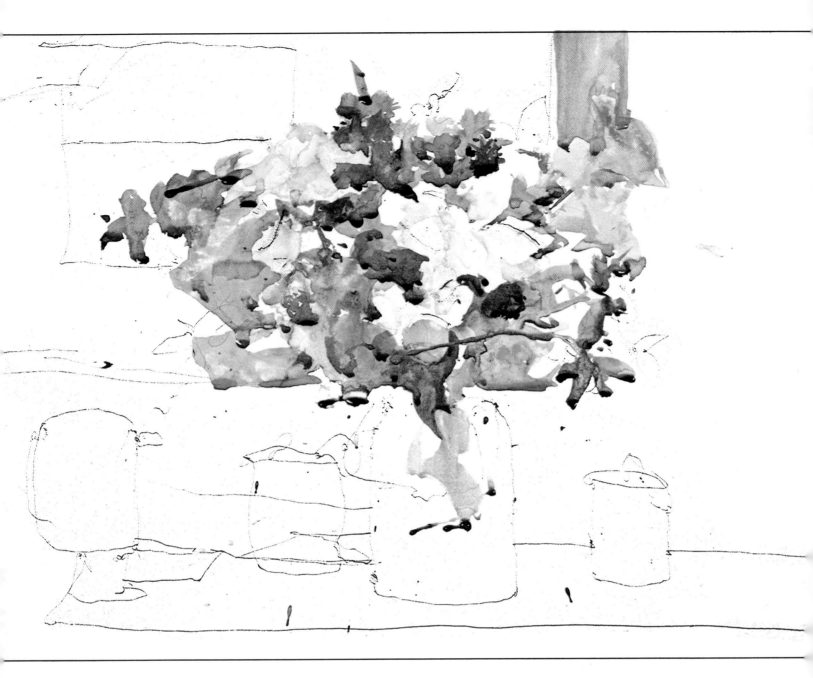

2

Quite a bit is happening here. I add more flowers and leaves as well as some darker values to sections already painted. The light pink flowers are mostly alizarin crimson, but I add a touch of cadmium orange and cadmium yellow pale for zest. I put in more purple flowers with my alizarin-crimson-and-ultramarine-blue mixture and begin to use a little sap green mixed with cadmium yellow in the darker green areas. For lighter greens I prefer mixing one of the blues with a yellow. I begin to work in some background details to help set off some of the lighter flowers in the upper right area. The warm browns are a mixture of cadmium orange, raw sienna, and cadmium yellow. Some of the purple flowers are washed out, so I add darker purple overwashes. In the purple flowers to the left of the white flowers, I make only a few darker accents, allowing some of the original washes to show through next to the boundaries of the white flowers. I don't outline the white flowers with darker color; instead, I spot the darker color around these flowers.

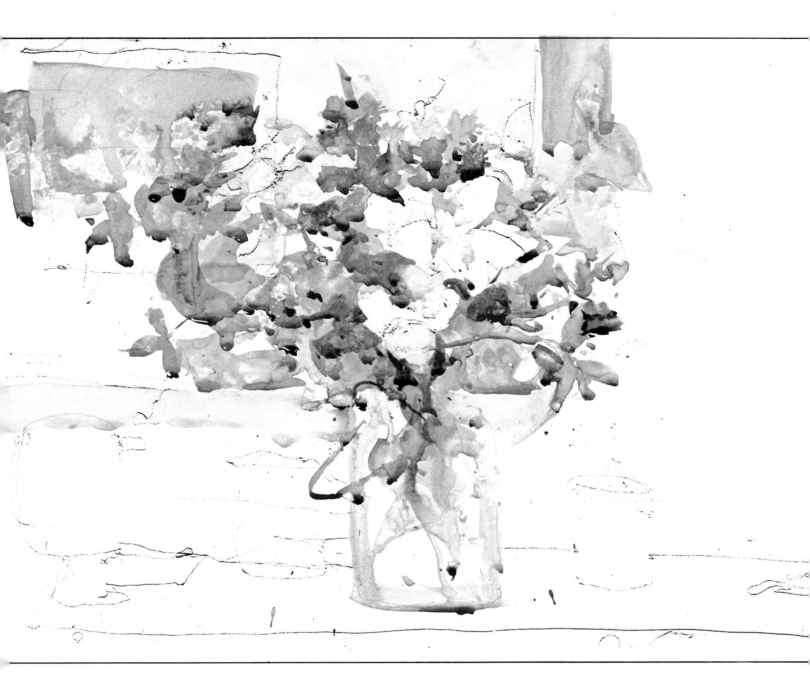

3

I don't do much with the flowers in this step. Instead, I develop more of the background and work on the jar containing the flowers. The flowers are sitting on a bookcase in front of a bulletin board. I paint in a couple of postcards, which I'm using to balance the composition and lend weight to the upper left side of the picture. Again I'm using ultramarine blue and alizarin crimson, but with cadmium yellow pale, which makes a very nice gray. The shadow under the bulletin board is ultramarine blue and cadmium orange. I continue it into the jar but switch to cerulean blue mixed with cadmium orange for most of the rest of the jar. I also use some ultramarine blue and cadmium yellow mixed with alizarin crimson. I add the bale of the canning jar using my ultramarine blue, alizarin crimson, and cadmium yellow.

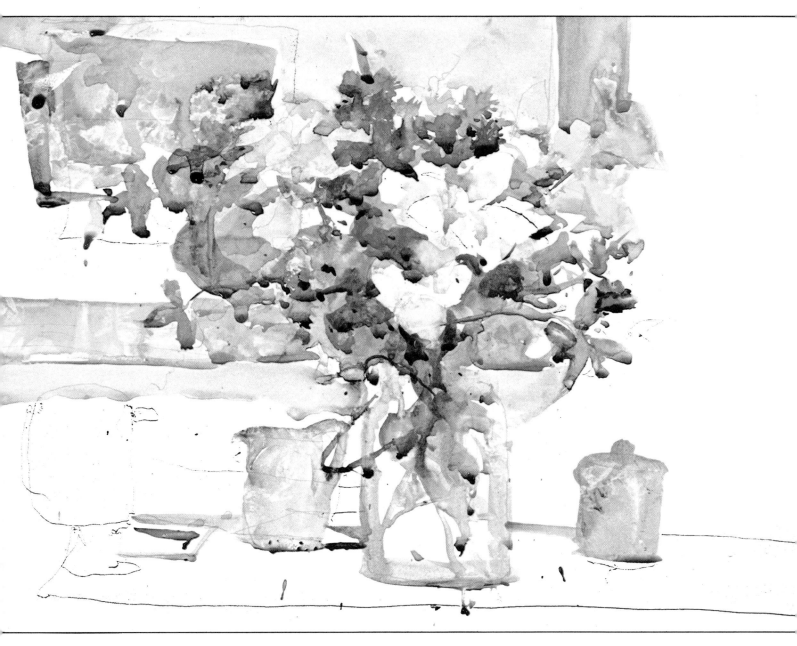

4

I add foreground objects in this step. There is a nice puddle of alizarin crimson, ultramarine blue, and cadmium yellow on the palette, but I keep adding touches of these colors so that I can always see color in the puddle. I use raw sienna on the little spice jar on the right, so I add this color to the puddle. I'm very careful to get the shape and the value of the spice jar correct. I want to paint it with a single wash. I add a bit more raw sienna directly to the paper and then quickly go back to the palette where I add new alizarin crimson and ultramarine blue to my puddle, being careful not to overmix. Working wet-in-wet, I work my way down the jar with a continuous back-and-forth motion, but without retracing my steps. The jar is a bit crude, but I don't try to clean it up. The lighter section in the jar is a happy accident. Using less raw sienna, I paint the other jar in the same manner. Notice that I draw out cast shadows with the same wash as that in the jars, adding a bit of new color to the cast shadows—with ultramarine blue, alizarin crimson, and raw sienna once again—where I want a darker accent.

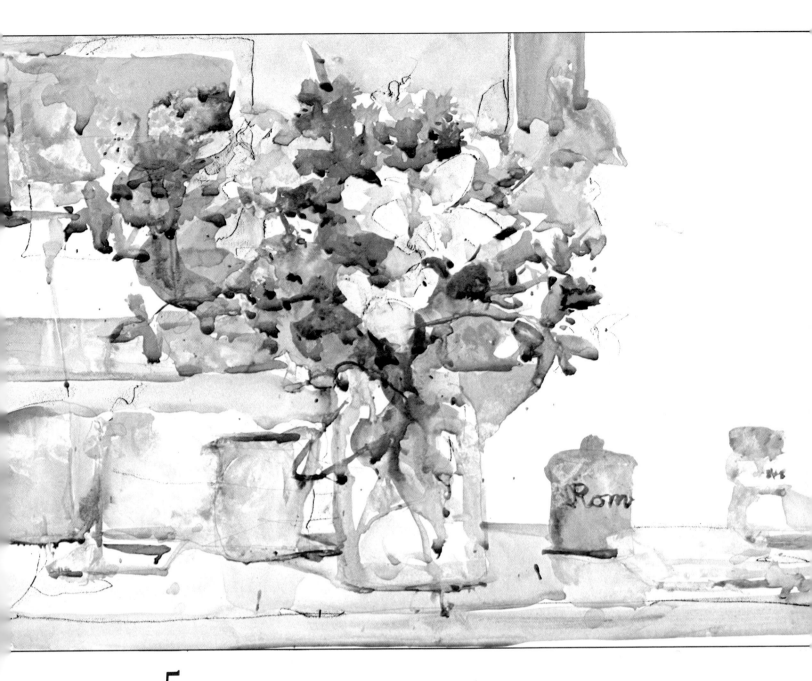

5

In this final step I continue to work mostly in the foreground—on the top of bookcase, some papers, and a couple of more objects. The top of the bookcase is somewhat glossy, so it picks up suggestions of color from the objects. Working mostly with raw sienna, I paint this reflection below the spice jar and allow it to dry before going on to the left. I indicate the papers with a mixture of ultramarine blue, alizarin crimson, and a little cadmium yellow. I vary the values around these papers and blot with my tissue to lighten certain areas. Using the same colors, I paint a small doll in the right corner. The ultramarine blue and raw sienna under the doll give a suggestion of green. The raw sienna reflection on the top of the bookcase has dried, so there is a firm edge where it meets a new wash of cerulean blue and alizarin crimson. I paint this wash to the left and use it to show the front of the bookcase where I add some raw sienna wet-in-wet. I'm rather splashy here and leave quite a bit of white paper. For the final jar on the left I'm afraid I don't do a very good job. I want to leave some lost edges, but I overdo it and make a mess. I use a touch of alizarin crimson directly on the paper at the point where I want an accent. I often prefer to make an accent with a color rather than with a heavy dark value.

Demonstration 8

SLENDER PETALS

Here I'm painting forsythia, which have very slender individual petals. At first I try to overlook this fact and concentrate on the overall shape of the bouquet to determine how it works in terms of design. I place the flowers against a white wall—an arrangement that I find very attractive. Now I must make them stand out against this light value. At the beginning I think there will be enough contrast, but as I get further along, I realize that I do need other objects, so I add some postcards. You should always try to plan your painting as much as possible in advance. But be prepared to make radical changes if they are needed. Don't feel you must stick to your original concept.

Note how much yellow pigment I use in the flowers painted here. Don't be fooled by the fact that they are very light in value. For flowers as bright as these you can almost use the yellow straight from the tube, with just enough water added to make the paint move freely. You don't want a drybrush effect, but you don't want weak, washed out yellow either. This painting is very high in key because of the light values. One combination I use in this painting is cerulean blue and cadmium yellow, which is an unusual choice for me because the result can be a bit pasty.

I'm working on 140-lb. cold-pressed paper, 16 × 13 in (41 × 33 cm), and drawing with a number 2 office pencil. It's a good idea to try to define specific shapes even at an early stage. Correction will probably be necessary later, but it's a good practice to do as well as you can with shapes in the original drawing.

Brushes
No. 6 round sable
No. 8 round sable
No. 9 round sable

Palette
Alizarin crimson
Cadmium orange
Cadmium yellow
Cadmium yellow pale
Cerulean blue
Ultramarine blue
Raw sienna

1

After sketching in the flowers and objects, I begin painting the flowers. I start out trying to get the combination of the characteristic slender petals of the forsythias while also trying to develop the flower mass. For the flowers I use cadmium yellow and cadmium yellow pale. Some raw sienna creeps into the left-hand section of the flowers, since I put the stems in while the flower areas are still wet. I try very hard to show the actual shapes of the flowers, and although they look rather quickly done, I am in fact working quite slowly.

2

I develop almost the whole bouquet in this step using the same colors. I use more raw sienna to indicate some of the darker sections. Cerulean blue and cadmium yellow go into the darker leaf accents, which I add after the yellows are dry. I could put in some leaves while the yellow is still damp, but I don't want a blend that would destroy the overall light shapes that I very much want to retain. The greens added at this point are quite light, even though they are dark in the actual bouquet. I add the vase and get a fairly hard edge, since the flowers have now dried. The colors in the vase are alizarin crimson and cerulean blue with a little cadmium yellow. I try very hard to get a specific shape. Since the vase is still wet, I get a blend without completely losing the boundaries.

3

Next I add color to the wall behind the flowers and paint in several of the foreground objects as well as more green leaves, which are ultramarine blue and cerulean blue mixed with cadmium yellow and cadmium yellow pale. Some of the leaves are fairly dark, while others are in the middle-value range. I'm working wet-in-wet in the wall, and although I mix the alizarin crimson and cerulean blue with a bit of cadmium yellow on the palette, I try not to mix too much. Actually, I don't see all these colors in the white wall, but I always make color decisions no matter what I'm painting. Note the variation in colors on the table top, which I paint after the three objects and their cast shadows have dried. The foreground ink bottle is burnt sienna and alizarin crimson, and the top is ivory black with ultramarine blue. The herb container is alizarin crimson, ultramarine blue, and cadmium yellow, the same colors used in the bottle to the right, but with less blue and more yellow to give more warmth to that object.

4

In this step I work all over the picture, putting in the cigarette lighter, the cup, and the mustard container. I mix the colors in the cigarette lighter on the paper, starting with cerulean blue at the top and adding cadmium yellow as I work to the right and down. The white strip of paper down the middle of the lighter indicates a highlight. I add cadmium red light wet-in-wet at the end and put in a cast shadow with alizarin crimson, ultramarine blue, and cadmium yellow. The cup to the left of the vase is painted with the same colors, with white paper showing the light-struck section of the cup. The mustard container above it is painted with cadmium yellow pale and cerulean blue. The darkest part is where the container meets the light. To get darker values in the background behind the flowers, I add a picture my daughter drew. Notice that there is still a rather large hole in the section to the right of the vase. Something will have to be done about this.

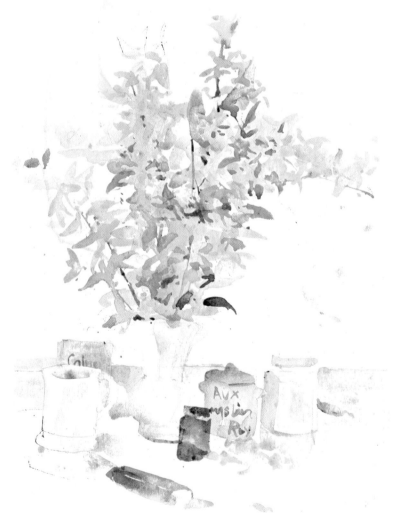

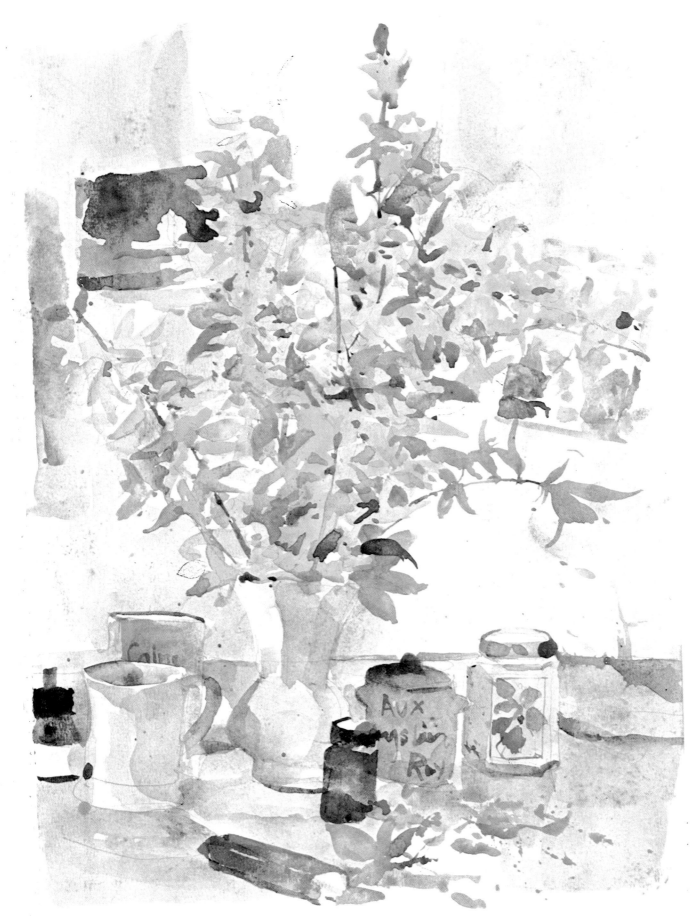

5 This final step is completely devoted to improving the composition, particularly the problems of the wall in relation to the flowers. I darken the values in the vase and add a black ink bottle to the left of the coffee cup to strengthen the lower section. I add another sprig of forsythia in the hole to the right, where I also put in an additional postcard. I don't want too much weight on this side of the painting, so the postcard is much lighter in value than the one on the left. At this point there is a mixture of very generalized masses of color. These masses don't really describe the particular flowers; but in other areas I do try to show the actual shape of individual petals. So there is a mixture of the specific and the general. Finally, notice the darks that I put in the flower area. I might have overdone them a bit, even though I was conscious of the danger of too many bits and pieces of dark value.

Demonstration 9

DIFFUSED FORMS

Here I'm painting apple blossoms. A setup like this is hard to paint since there is a tendency to look too closely at each individual flower. There are too many small darks within the mass of flowers, and we can easily overlook the big overall pattern. Another problem is the green vase. I always have trouble with it because of the color. For this painting I've placed it against a reddish-brown background. This sets up complementary colors which are more difficult to paint than analogous colors.

In this demonstration note that the overwashes I use are as strong as the underwashes they cover. Very pale overwashes tend to make an area look dull, and this is often the reason why watercolors look muddy as they progress.

I'm working on 140 lb. cold-pressed paper, 16 × 13 in (44 × 31 cm). I spend quite a bit of time on the drawing for this painting. Unfortunately, I often hurry through this drawing stage, which doesn't set a very good example, since I've found that many students have a much easier time if they have a good solid drawing to work with. I start by drawing the mustard container at the bottom. Then, keeping my pencil on the paper, I work up, moving from one object to another, connecting and overlapping as I go. I don't plan this composition in advance. Instead, I decide on the placement of one object, in this case the mustard container, and work from there. I draw the objects in just the positions I see them. I don't change things around on my paper to make a better composition. If what results is really unacceptable, I'll move an object and then draw it in its new position.

Brushes
No. 8 round sable
No. 9 round sable

Palette
Alizarin crimson
Cadmium red light
Cadmium orange
Cadmium yellow
Cadmium yellow pale
Sap green
Cerulean blue
Ultramarine blue
Raw sienna
Raw umber
Burnt sienna

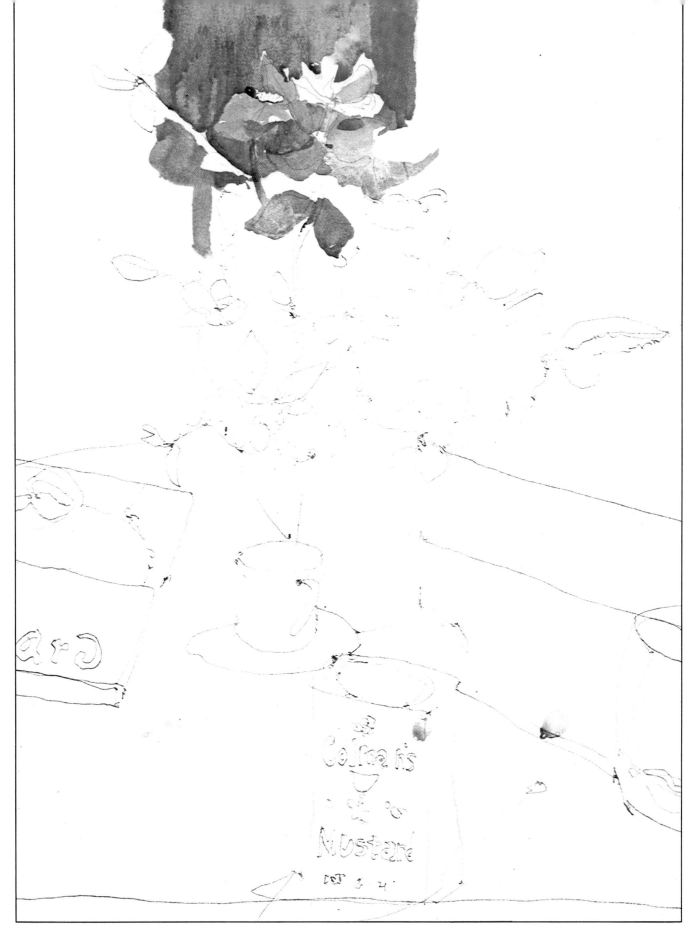

1 Using my number 8 round sable brush, I start with a darker value to set off my white flowers. The wall behind is a reddish brown, so on the palette I mix raw sienna, cadmium red light, burnt sienna, and a little sap green, making sure, however, that the individual colors show in the wash. I complete a very small area just around the flowers. Next I paint the leaves and some stems. The leaves are very cool, so I use cerulean blue and cadmium yellow pale. I'm careful to get some good shapes in the leaves and let them dry before continuing with the background. I have a lot of hard edges, since I don't want the browns to seep into the white flowers. I hope to give the impression of soft edges by using values as I get further into the painting.

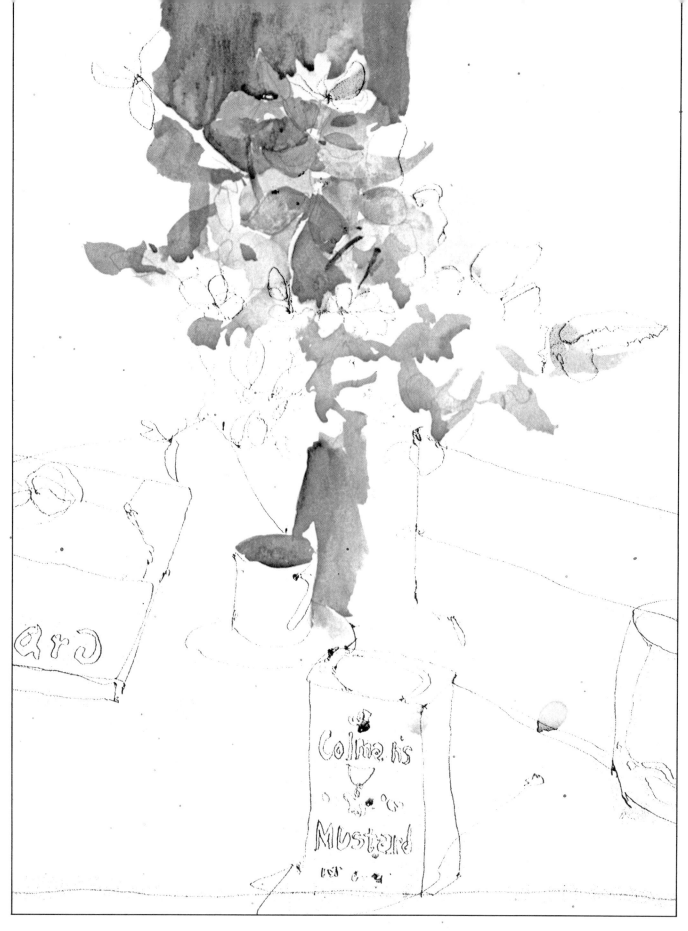

2 Still using my number 8 brush, I work mostly on the leaves, using cerulean blue and cadmium yellow pale as well as ultramarine blue and cadmium yellow for darker and warmer leaves. Notice that the values aren't too dark. I work my way around the flowers, trying to show fairly accurate shapes. Then I mix on the palette a very light wash of cerulean blue, alizarin crimson, and cadmium yellow pale, which I use to create a few shadow shapes in the flowers. Some greens are still wet, so I get blends between flowers and leaves. I work down to the vase, which is a green metal container that picks up quite a few reflections, particularly a blue one that I paint with cerulean blue. The basic color is sap green with a little alizarin crimson. I allow the leaf color to flow into the top of the coffee cup, where I put in some alizarin crimson, ultramarine blue, and cadmium yellow pale.

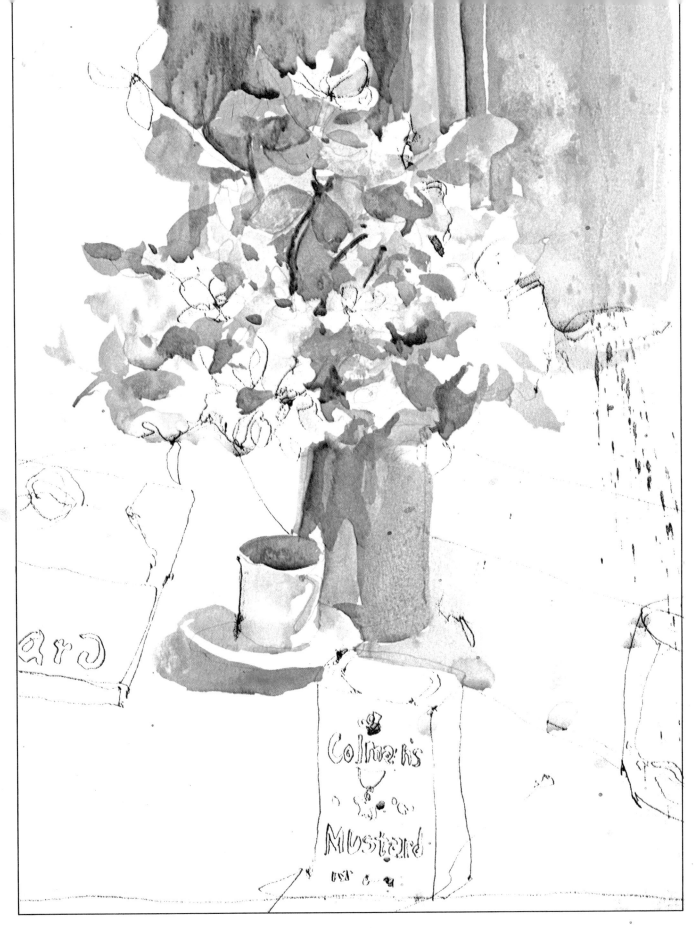

3 Here I use more green, working around the flower shapes, but the colors are essentially the same. I blot often to get value changes while the leaves are still wet, and continue working very slowly, still using my number 8 brush. It's important to go slowly in this middle stage of the painting. My values are still fairly high in key. I put in some stems with burnt sienna and a little cerulean blue. I also work on the brown wall behind the flowers with burnt sienna, cadmium red light, and a little sap green. I work more into the vase, still using quite a bit of the cerulean blue and cadmium yellow pale. For the cast shadow under the saucer of the coffee cup I use cadmium red light, raw sienna, and sap green. I also add grass outside the window with the green combination I've been using, and I blot to lighten values.

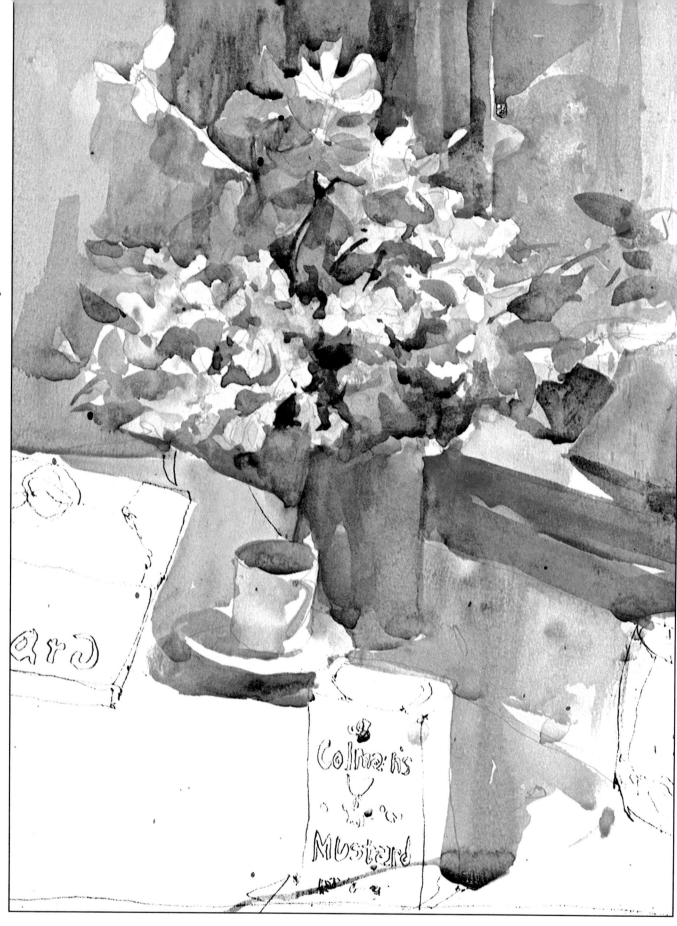

4 In this step I try to give the painting more strength. Notice the strong red in the windowsill to the right of the vase. It's almost pure cadmium red light. Working wet-in-wet, I next add raw sienna. The sill is painted to form a cast shadow under the blue-gray envelope. But the wash is too light, so I stop and let it dry before adding an overwash. I paint in the envelope with ultramarine blue and alizarin crimson. Its cast shadow, painted earlier in this step, is still wet, so there is a blend. I add a line wash to show the bottom boundary of the envelope; my colors are cerulean blue and raw sienna with a bit of alizarin crimson mixed on the palette. I next work on the tabletop using a light, but intense, wash of alizarin crimson and cerulean blue with cadmium yellow pale. Then I add more yellow and alizarin crimson to the paper wet-in-wet. My brush for the table as well as some background areas is a number 9 round sable.

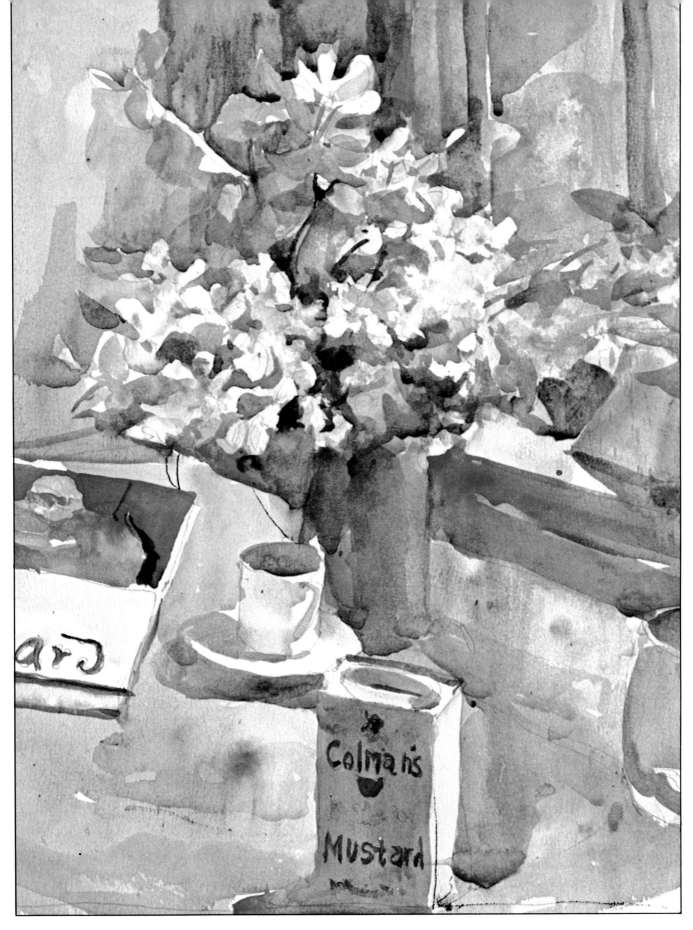

5 I finish the tabletop and wall with the same colors mentioned in the preceding steps. You'll notice some splotches of red. I don't mind these mistakes, which, I think, add something to the painting. The mustard container is washed in with cadmium yellow, raw sienna, and sap green. I don't use much green, since I want a yellow here. The raw sienna and green are meant to create a darker value, but not a major color change. I allow the container to dry before adding the lettering in cadmium red light and other details in raw sienna and cerulean blue. The book is a collection of paintings by Pierre Bonnard. A favorite of mine, he is one of the great colorists, and the book jacket vibrates with reds and oranges with little bits of blue and green. For these I use cadmium red light and cadmium orange with a little raw sienna. The lettering is raw umber, and the ends of the book are cadmium red light and cerulean blue.

Demonstration 10

COMPACT FORMS

The subject of this demonstration is slightly different from the others I've done so far. I'm not sure it works very well, but I think it's important to try different approaches. The most obviously unusual thing about this composition is the blue iris sticking out of the bouquet. Although it wouldn't win any prizes at a flower show, this particular flower is, I think, so paintable that one could forget about the overall effect of the arrangement. The iris is a lovely flower to paint, with its subtle coloring and interesting shapes. I do not include the bottom of the vase in the composition because I want to concentrate more on the flowers. Although this is a bit unusual, I do enjoy trying it out.

In this demonstration I'd like you to look at a couple of things rather closely. Note the way I blend the petals of the flowers with the stems. Blending can be a bit tricky. Try not to fuss with or correct your blends. Instead, let them dry and see how they turn out. This is the only way to learn what you're doing wrong. If the blend is out of control, you're using too much water; so use less water and more paint. Also try waiting a minute to let the flowers dry a bit before adding the stem. If you're not getting a blend, you're waiting too long before adding the stem or you're using too much paint and not enough water.

I'd also like you to note the way I lift out color to make lighter values, particularly in step 2. When I lift out color, I don't scrub! I merely touch the paper lightly with the tip of the brush and allow it to absorb the color. If you have trouble with this, you're working the brush into the wash too much, or perhaps your brush is too wet.

I'm working on 140 lb. cold-pressed paper, 13 × 16 in (33 × 41 cm). After completing my drawing, I start right out with the purple iris as I begin the painting. I use my number 8 round sable brush throughout the painting.

Brush
No. 8 round sable

Palette
Alizarin crimson
Cadmium red light
Cadmium orange
Cadmium yellow
Cadmium yellow pale
Sap green
Cerulean blue
Ultramarine blue
Raw sienna
Ivory black

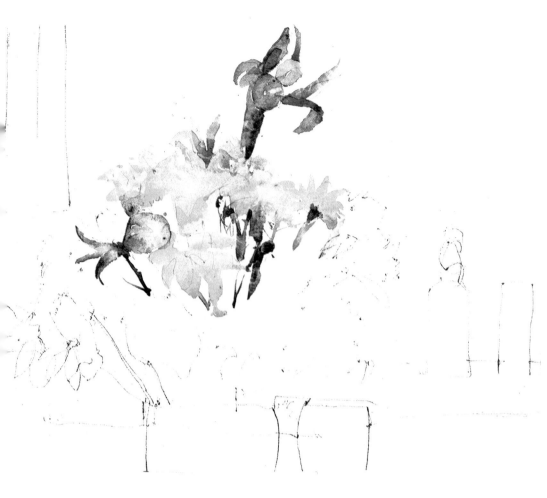

1

I make a purple mixture of ultramarine blue and alizarin crimson, hoping to complete the big iris at the top as much as possible with my first wash without counting on overwashes to suggest value changes. I work down and to the left without lifting my brush, then around and into the lower petal at the center and the two petals on the right, adding cadmium yellow pale. The green is sap green and cadmium yellow light, and I paint the stem while the petals are still damp, giving a blend where the two areas meet. The light blue at the bottom of the stem is cerulean. I suggest another iris and begin painting the yellow flowers with cadmium yellow, massing in a fairly large section, showing some of the petal shapes around the borders. While these are still wet, I paint the stems with sap green and cadmium yellow, and add a touch of cadmium red in the lower section of the stems to warm the green. I draw in more delicate stems using the same green combination and then go back into some of the yellow flowers with another yellow wash to darken certain areas where I get a blend.

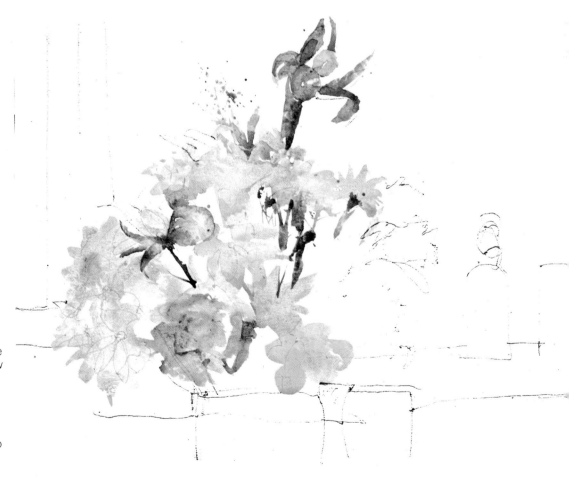

2

A lot is happening in this step. I add more yellow flowers and another iris, using the same colors, darkening here and there, lifting out color and creating lighter values, and leaving small bits of white paper to prevent complete blending. I add dark purple to the iris in the center and then draw the purple down and begin the stem. Using sap green and cadmium yellow, I show the delicate shape of the stem. I paint in first more of the yellow flowers with cadmium yellow and then the other stem, near the top of the vase, with my green combination which now has an added touch of red.

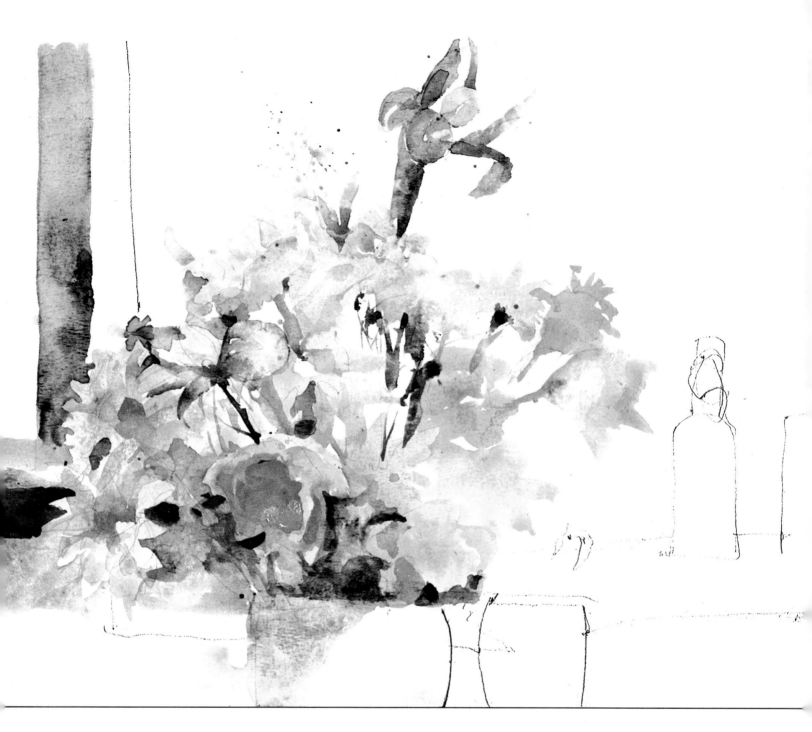

3

I continue to add yellow flowers. When I want a hard edge and a definite value difference within the flowers, I make sure that the area I just painted is dry. I begin making my cadmium yellow stronger, using very little water, and I place some raw sienna wet-in-wet in places that will help describe the construction of a flower. Then I add a green made up of ultramarine blue and cadmium yellow to the flower in the lower section that is in shadow, and I paint more flowers at the right. Now notice the difference in values and colors within the total flower mass. The top section has picked up color from damp stems, and the lower section is much richer with a good charge of strong cadmium yellow. Other yellow areas are light, since it's important to work for variety in both value and color. It's definitely time to get on with the background, since the flowers are almost finished, even though there is not really much detail in them yet. Later I can judge what details are needed to finish the painting. I started the painting with a fairly dark value in the form of the iris. The darker values I later added are made up of several colors. Some suggest a rather neutral green and others are warm gray-greens, which move toward a slightly cooler bluish-gray near the window frame. I've kept these darks from getting too dark because I don't want a big black hole down there. I want a dark that's relatively darker than the flowers but no darker than that. The accents around the flowers are also not really dark. As I put in the vase, I begin with the shadow side, instead of starting with an overall light wash and then adding overwashes to develop my shadow. I let it dry for a few moments and then draw the shadow out into the light. I follow this with a very light wash of alizarin crimson and cerulean blue for the light side of the vase, leaving white paper along the upper border of the vase shadow to retain a hard edge. I then allow everything to dry.

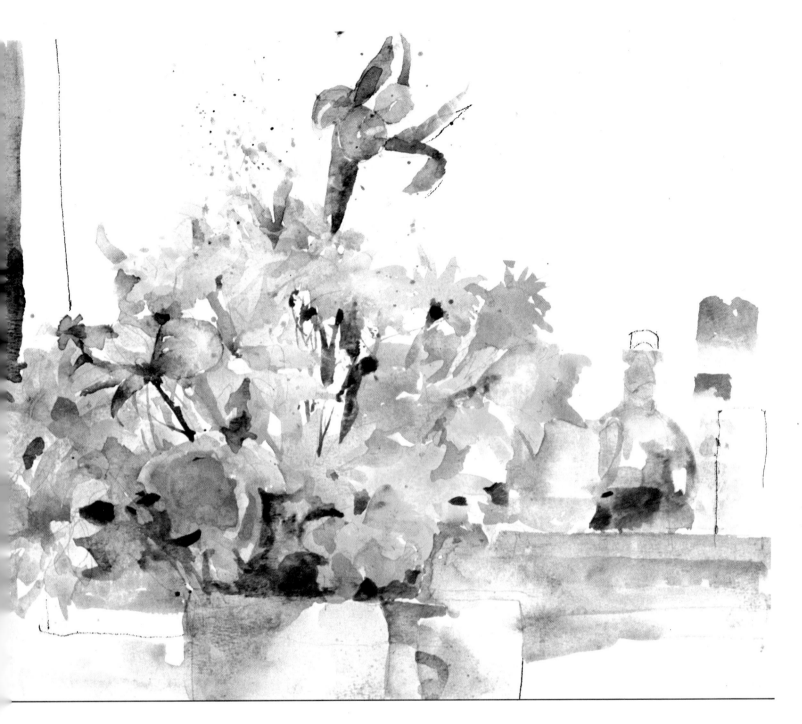

4

It's time to finish the painting, and I start with the lower section of the window frame. I paint the whole thing, including areas that will be covered later by darker overwashes. I use alizarin crimson and cerulean blue with a bit of raw sienna, starting at the right and working to the left, adding more raw sienna as I go. I paint around the cup to the right of the vase. Next I add a light wash of alizarin crimson and cerulean blue to the cup, leaving a white rim along the top. A darker version of the same colors is painted to show the cup's shadow. I next paint the shadow section of the window frame, using the same colors I used in the light section, and then the remaining objects. The cooler grays are alizarin crimson and cerulean blue, and the greens are cerulean blue and cadmium yellow pale. The orange trim on the spray can is cadmium orange with a bit of cerulean blue added.

Demonstration 11

RADIATING FORMS

Brushes
No. 6 round sable
No. 8 round sable
No. 10 round sable

Palette
Alizarin crimson
Cadmium red light
Cadmium orange
Cadmium yellow
Cadmium yellow pale
Sap green
Hooker's green dark
Cerulean blue
Ultramarine blue
Ivory black

I'm painting my favorite flower for this demonstration. I guess I'd paint daisies for every demonstration if I could. They are fun to paint; they are fresh and straightforward; and they are not the least bit overbearing, so they complement any color scheme and composition. As you can see, the flowers are only a part of the composition in this demonstration painting. Daisies fit in well with the kitchen objects that I also like to paint so much. Probably the most important thing to remember when painting radiating forms such as those in daisies is that you must think of the overall mass of the flower and not the individual petals. If you just squint your eyes, you'll be okay.

Notice that I stick with relatively light values as I work around the flowers. Don't be fooled by what seems to be a very dark value; make it a lighter value than you think it should be. You can always go back and darken it. When I emphasize a dark value, I just lay in a spot of the darker value. It's a good idea never to paint a large area with a solid dark value, since a relatively small dark-value area will make a middle tone seem much darker than it really is. During the course of this painting, I switch back and forth between the number 10 brush and the number 8 brush, depending on the size of the area I'm working on. Also, as you can see, I use a limited palette throughout. A lot of colors are just not necessary. I can get the effect of lots of colors by using just a few in a variety of ways.

I'm working on 140 lb. cold-pressed paper, 16 × 13 in (41 × 33 cm). I begin the painting by drawing in my preliminary sketch with a number 2 office pencil. I use a minimum of line, since I want to keep the drawing as light and simple as possible.

1

Beginning with the dark, hard-edged green in the top center, I paint my greens, spotting them around the top of the daisy. I do not use one continuous stroke, as I don't want to begin by isolating the flower. I start with sap green; then, as I go over the top of the daisy, I add a touch of cadmium yellow and a little cadmium red light. Alizarin crimson would also work, since I often interchange the two reds in a case like this. The soft edge on the left side of the petal can be done in two ways. You can dampen a section of the flower first with clear water, where you want a soft edge, and then paint the green right up to the dampened area. This leaves a blurred edge. Or you can paint the green first; then when you get to the area where you want a soft edge, clean and shake your brush, and draw it from inside the flower out into the green. For either method, have a tissue ready for blotting. As I continue the painting around the flower, I use cerulean blue, sap green, cadmium yellow pale, and, on the right side of the flower, alizarin crimson and cerulean blue.

2

The area behind the top daisy is the color of heather, which gives me a nice chance to get away from green, and for this I use alizarin crimson with sap green and cadmium yellow pale. Notice the spatter work here, as well as the short jabbing strokes. The cast shadow from the flowers is cerulean blue, alizarin crimson, and a touch of cadmium yellow. To add background, I dampen the paper and then paint in cerulean blue. I add a dark green-yellow center to the daisy on the left, which bleeds into the wet background. I continue to dampen sections of the flowers with clear water for a very light shadow wash and paint the darker values into the dampened areas. I paint the vase ultramarine blue, alizarin crimson, and yellow ochre wet-in-wet; the same colors appear in the background and in the cast shadow. Then I paint the carton of cream and the jar at the left, using the same colors and the same values, carefully retaining the light-struck sections on the top of the jar and on the cream carton by reserving the white of the paper.

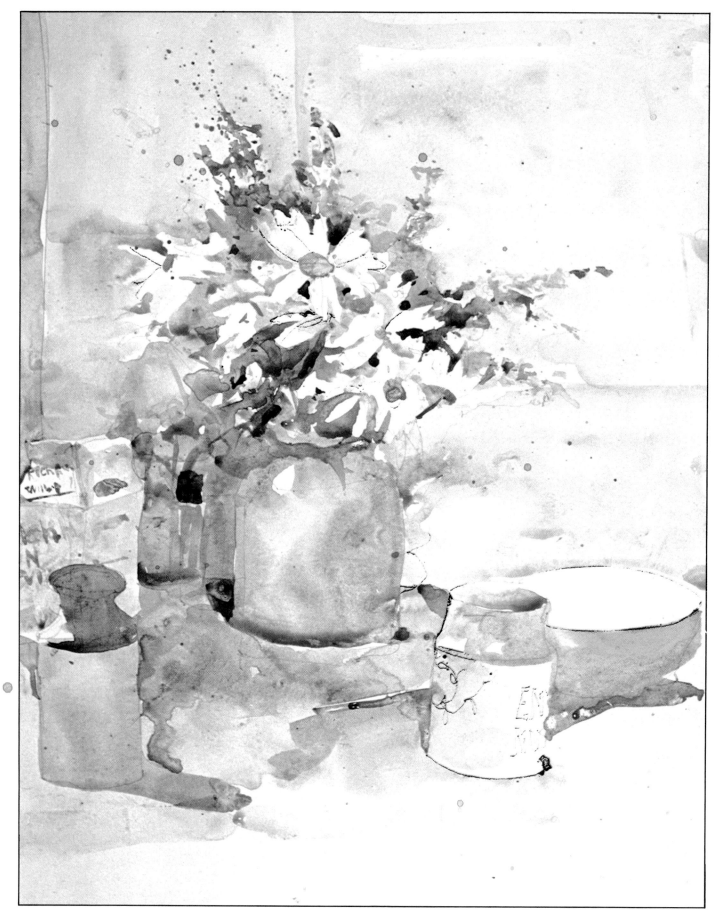

3 Still using ultramarine blue, yellow ochre, and alizarin crimson, I do a very light background wash. Next I paint the top on the jar in the left foreground, using Hooker's green dark and cadmium red light. Notice that the cast shadow by the vase doesn't have the same local color as the adjacent wall. I should have added more yellow ochre to the cast shadow so that it would relate better to its surroundings. The yellow bowl on the right is cadmium yellow on the right side, but when I get closer to the top of the mustard jar I switch to yellow ochre. I also pick up a bit of ultramarine blue, alizarin crimson, and yellow ochre.

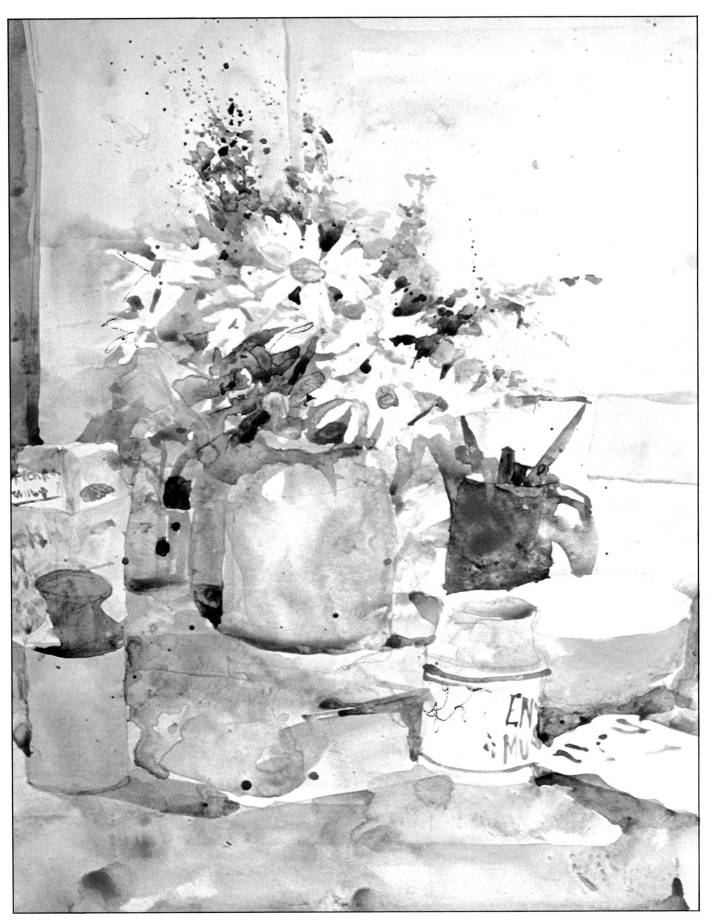

4 In this final step I add a dark blue mug containing some pens and a pencil. I paint the mug with ultramarine blue, alizarin crimson, and yellow ochre, and while it is still wet, I add the pencil, using cadmium orange and a little yellow ochre. The pens are ivory black. I continue painting the tabletop with a mixture of ultramarine blue, yellow ochre, and alizarin crimson. Then with a number 6 round sable I render the lettering on the mustard jar. As you can see, I use a limited palette throughout this painting. It is not necessary to work with a lot of colors. I can get the effect of lots of colors by using just a few colors in a variety of ways.

MASSED FORMS

For this demonstration I'm painting white narcissus, which are flowers that I particularly like to paint because of their simplicity. I don't need a lot of detail, and these flowers fit comfortably into simple surroundings.

Because you are working here with a white flower against a colored background, you will encounter a problem that will arise again and again as you paint flowers. Since you're reserving the white of the flower, you'll paint around that white with shadows and background. But you have to decide the order in which you'll paint the shadows in the flowers and the background, and the speed with which you'll paint each. You can paint the shadows of the flowers first and then add the background, or paint the background completely around the white silhouette before adding the shadows. I do both in this demonstration; but with either approach, you have to decide how fast you will work. Try two different methods. First paint the shadow sections of the flower and then immediately add the background. You'll have to be careful about the shadow shapes in the background because the sections of the flowers that are dry will have a hard edge where the background connects with them. But when the background connects with the newly painted shadow sections, you'll get a soft edge. The second method is to wait longer between each application of shadow and background value. Here you will notice that although the shadow washes are almost completely dry when you begin working in the background, background tone can still seep in. But this can give the flower life and form—a fortunate accident. But timing is critical.

I'm working, as I most often do, on 140-lb. cold-pressed paper, 16 × 13 in (41 × 33 cm). After making my usual modified contour drawing, I start right out with a background wash in the upper left corner, and this outlines the shapes of my white flowers.

Brush
No. 8 round sable

Palette
Alizarin crimson
Cadmium red light
Cadmium orange
Cadmium yellow
Cadmium yellow pale
Sap green
Cerulean blue
Ultramarine blue
Raw sienna

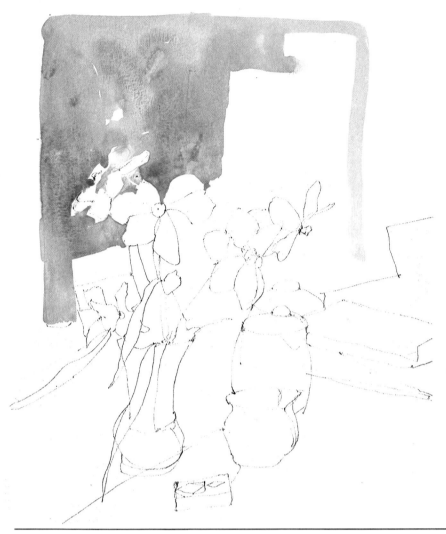

1

Working wet-in-wet, I add colors but do very little actual painting with my brush. However, I am very careful about the shapes and boundaries of the flowers and objects. My initial wash is cerulean blue and alizarin crimson mixed with a bit of raw sienna. I allow some of this background to flow into a section of the flower at top left and then add a bit of cadmium yellow pale in the center. I blot this area very lightly with my tissue to keep things under control.

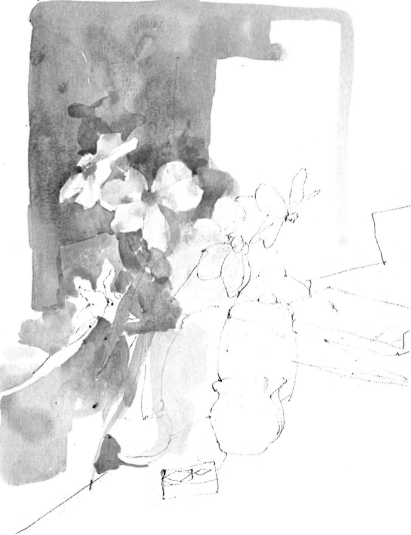

2

I now work in more flowers, completing one and beginning two others; I am very careful with the boundaries of the completed flowers and try hard to show the conformation of the flowers using light and shade. I'm using cerulean blue, alizarin crimson, and a bit of cadmium yellow for the flowers. Note that the edges around the flowers are fairly hard. This is because I allow the shadow sections to dry before adding my background—my second solution to the problem of shadows and background. Also note the green that seeps into the petal in the lower left section of the finished flower—the accident I mentioned in the introduction to this demonstration.

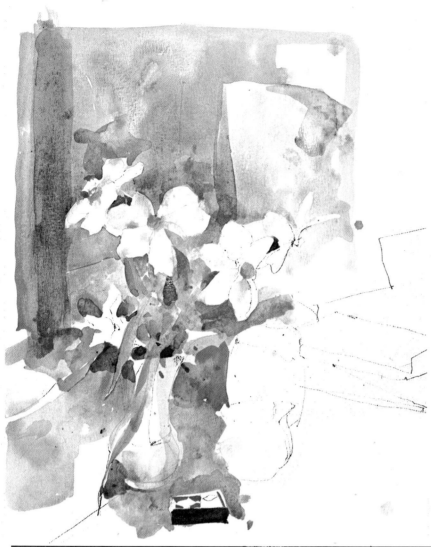

3

Here I paint some of my edges very distinctly and leave others unstated. The flower in the left area is the only one I isolate with hard edges. Also, I only spot darks around the vase, balancing values while trying to keep air and atmosphere around it. These darks are cadmium red, raw sienna, and cadmium orange. Working wet-in-wet in the tabletop, I apply unmixed colors directly to the paper, creating very definite color changes. Next to the darks around the vase I add alizarin crimson and cerulean blue, allowing the various sections to run together. I now add the window frame to the left of the flowers using cadmium orange and raw sienna, painting this wash over a section of the cool background which I did in an earlier step. I allow this to dry before adding another darker value to show the shadow section of the window frame, where I use alizarin crimson and ultramarine blue with a touch of raw sienna. I'm eager to make the flowers come into focus, but I'm liable to put in too many dark accents. The leaves are a cool delicate mixture of cerulean blue and cadmium yellow light, with sap green and cadmium red light for the dark areas.

4

I now concentrate on other objects in the painting, leaving the flowers temporarily. I add a small blue pitcher and a light-colored container with blue designs. I concentrate on keeping the edges in the light fairly firm, while I almost completely lose the shadow sides. The wash which describes the shadow on the jar carries on out to the right. Some sections of the pitcher are quite refined above the cast shadow, but then the boundary is again lost, and I leave some sections untouched to suggest highlights. While the pitcher is still damp, I add darker shadow sections using the same colors but less water. Neither the first wash nor the cast shadow is complete when I add these shadows, so there is a good blend between the cast shadow and the shadow wash on the pitcher.

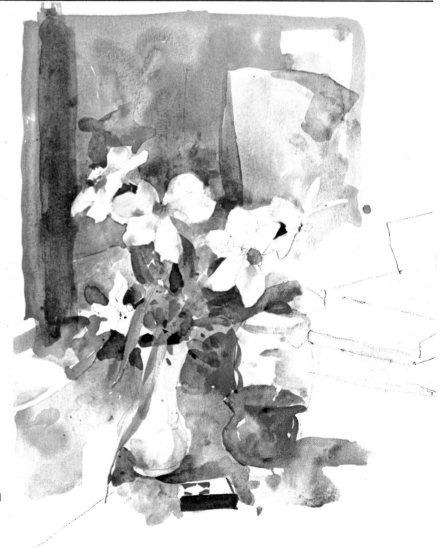

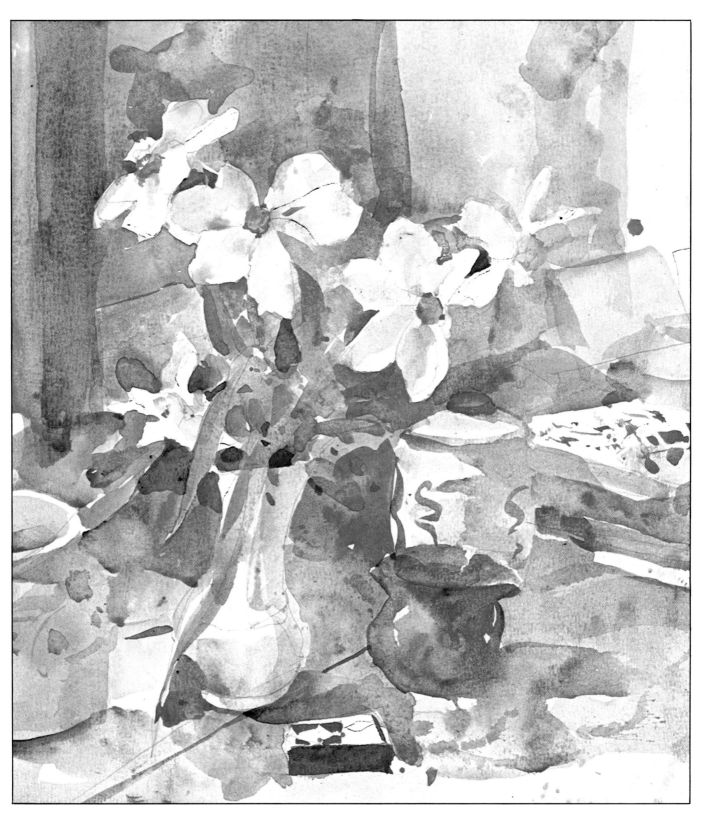

5

I finish the various areas around the flowers and objects. If you compare this final step with step 4, you'll note that I really haven't gone back and done much refining. I also haven't added many dark accents. I try to get the sense of reality through controlling edges rather than through accenting darks. Note that on the white jar I combine the shadow on the jar with the books. The only real separation is in the blue book, where there is some contrast. In the final step I concentrate on combining rather than separating areas. For example, the values in the gray jar in the left foreground are very close to the light strip of tabletop, which in turn is almost the same value as the vase holding the flowers. This leads the eye in from the left side of the picture. In the same way the cast shadow to the right of the vase leads over the top of the matchbox and connects with the small pitcher.

Demonstration 13

FLOWERS OUTDOORS

I'm painting asters for this project. Since I'm painting close up, I'm really forced to zero in on my subject and understand how this particular flower is made. This is one of the advantages of painting a close-up study of something. It requires that you look very carefully.

The aster is a difficult flower to paint because of its numerous individual petals. In an effort to be accurate, I run the risk of getting too definite and hard. So here I'll be concentrating on catching the character of the flower accurately without making it look like it's been cut out and pasted down on my paper.

Notice that I'm quite spontaneous with my washes in the beginning. Some of the flowers get painted with light overwashes either intentionally or by mistake. But I don't want the flowers to look stiff, so I don't worry about this early stage because I know that when I surround the flowers with dark greens near the end, the white flowers will come into focus and will still look white contrasted with the green. I'm also careful to only spot the dark accents around the flowers without outlining them or isolating them. Also, I limit any really dark areas to a small size so that there are no big masses of dark color. And I vary the character of the flowers' edges as well as the values surrounding them.

This is a small painting, only 8 × 16 in (20 × 41 cm). I'm working on 140 lb. cold-pressed paper, and I begin with a rather brief drawing.

Brush
No. 8 round sable

Palette
Alizarin crimson
Cadmium orange
Cadmium yellow
Cadmium yellow pale
Yellow ochre
Cerulean blue
Phthalo blue
Ultramarine blue

1

I begin by painting my light wash of alizarin crimson and cadmium yellow pale over some of the flowers I've drawn but work around others that are out in the light. While this wash is still wet, I add more alizarin crimson to the puddle on the palette and drop in this stronger color wet-in-wet. I then add cadmium yellow and yellow ochre to suggest a center section. Next I mix a light wash of cerulean blue, alizarin crimson, cadmium yellow pale, and a little phthalo blue and cover almost the whole picture area with it. I work around some of the flowers, leaving white paper. I then add wet-in-wet more of the individual colors I started with, first shaking my brush to remove excess water.

2

Before now I couldn't get into too much trouble. But now I must be more careful, since I'm using such dark values. If I make a mistake and paint over important white flowers with dark greens, I will have problems, since greens are hard to remove. I allow the earlier washes to dry before adding this background of middle darks: ultramarine blue, phthalo blue, cadmium orange, cadmium yellow, and alizarin crimson. Some of this darker wash will stand for white flowers in shadow. There are mostly cool grays in the center area. I use yellow above the flowers and to the right, where I have leaves. I don't want too much green in those areas where flowers in shadow are to be positioned. I paint this darker wash very slowly, trying to show the proper boundaries of the lighter flowers in the foreground.

3

Next I add more darks, trying to get some good dark accents around the flowers without isolating them. I use the same wet-in-wet approach, first wetting an area and then dropping color into the dampened section I wish to darken. I want good color, so I use a pure wash of ultramarine blue on the upper left area. But I never make continuous dark outlines. Then I show some of the asters in shadow below the flowers out in the light. Notice that I start with a dark middle value here, since I don't want too much contrast in the shadow section. Then I go back and add four darker accents just below the flowers in the light.

4

By this stage I'm using patches of overwash. I wait for each previous wash to dry before adding the next one. I try to make the color as rich as possible in these overwashes, taking care not to disturb underwashes with my brush. I just gently lay down the color—and I do no scrubbing! I also avoid grays in my overwash, as two or three overwashes will create the feeling of gray. I'm using the same colors in the darker background section, with more cadmium orange and cadmium yellow for the center parts of the flowers. I'm still concentrating on letting the flowers breathe, so I often leave lighter underwashes adjacent to the lighter flowers.

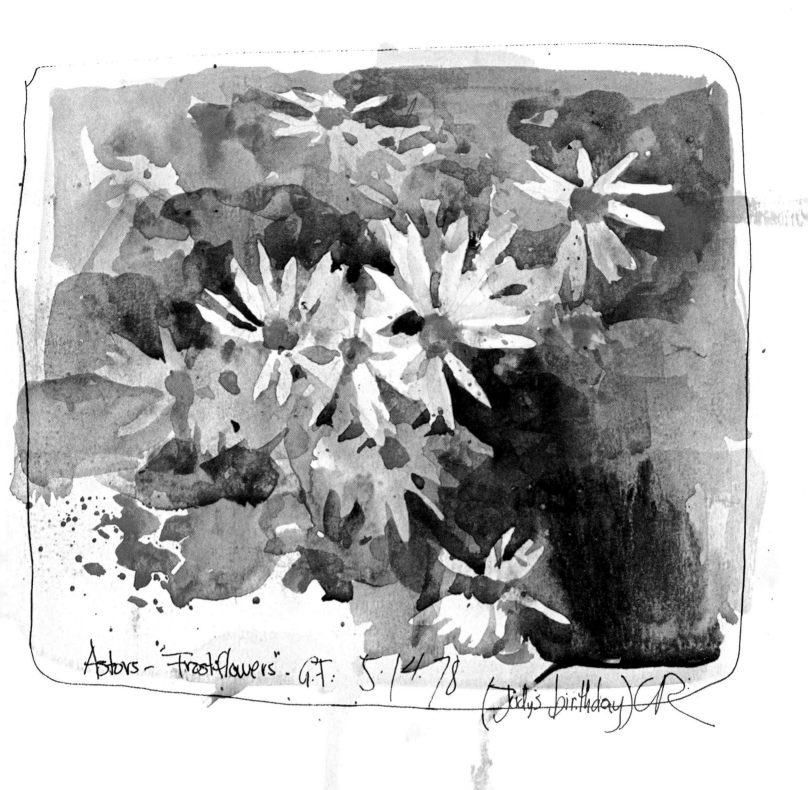

Astors – "Frostflowers". G.T. 5.14.78

(Judy's birthday) CR

5

I finish painting the background and pick out more light flowers. Note that in this final step I bring many vague areas into focus with darker background washes. White flowers that were overpainted look like white flowers when surrounded by darker greens. Also in this final step I continue to work wet-in-wet. For the large dark in the lower right area, I first dampen the paper with an overwash of clear water and then drop in ultramarine blue and cadmium yellow. I don't direct this dark with my brush after delivering the paint; rather, I let it take its own course wet-in-wet. In an attempt to keep strong color, I add some pure cerulean blue in the upper right of the picture and some cadmium orange in the lower left.

Demonstration 14

FLOWERS IN LANDSCAPE

Brushes
No. 8 round sable
No. 9 round sable
No. 12 round sable

Palette
Alizarin crimson
Cadmium red light
Cadmium orange
Cadmium yellow
Cadmium yellow pale
Sap green
Cerulean blue
Ultramarine blue

I'm working outdoors in strong sunlight painting lilacs in a white enamel container. As I begin the drawing, I actually outline my shadows and cast shadows. Naturally since I'm painting outside, these will change a lot before I finish, and I might not stick with the drawing that I begin with. But I think it's important to tie them together in the beginning because of the changing light.

The changing light is the big problem here. For this reason, notice that I actually start with darks, working from dark to light in many places. This is really more the procedure I would follow if I were painting an oil, but it is the method I often use if I know my light will change. If I work from light to dark with successive washes, everything will be different by the time I get my shadows in.

I start the demonstration by sketching my subject on a sheet of 140 lb. cold-pressed paper, 16 × 13 in (41 × 33 cm).

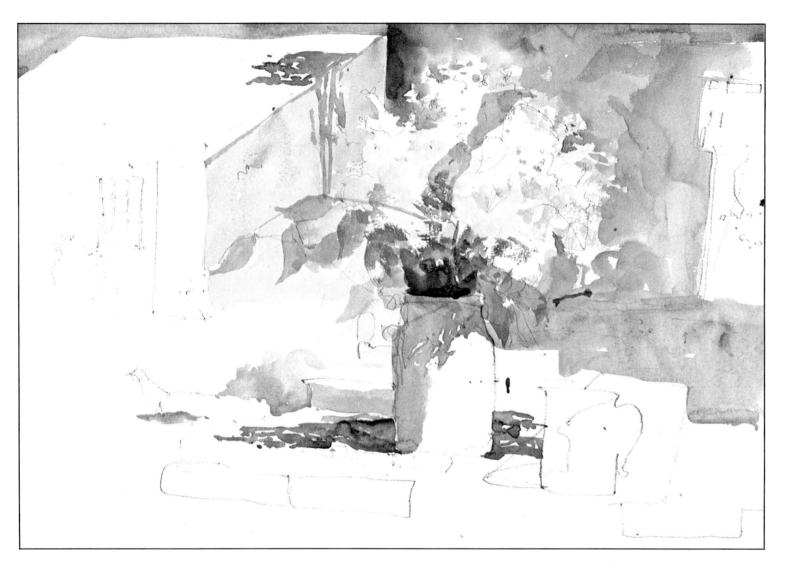

1

I start out with the shadow of the white container, using cerulean blue and ultramarine blue, with alizarin crimson added in the area to the left. Hard edges in the top of the vase describe shadows cast by leaves. I work the shadow wash down the left side of the vase, letting it flow both out to make the soft edge and into the bouquet and the table. Next I paint the leaves, using cadmium yellow pale and cadmium yellow mixed with cerulean blue in the lighter greens. The darker greens are sap green mixed with cadmium yellow and a little cadmium red light. I use these same combinations in the background greens. I also use strong color and fairly dark values in the cast shadow on the table: alizarin crimson, cadmium orange, and ultramarine blue. The side of the studio on the right is a very light wash of cadmium orange, cerulean blue, and alizarin crimson, which I mix on the palette. However, you can see where I add cerulean blue directly to the paper, working wet-in-wet. For the very light tones in the lilacs I use cerulean blue, alizarin crimson, and a little cadmium yellow pale. I also use a little drybrush around the flowers.

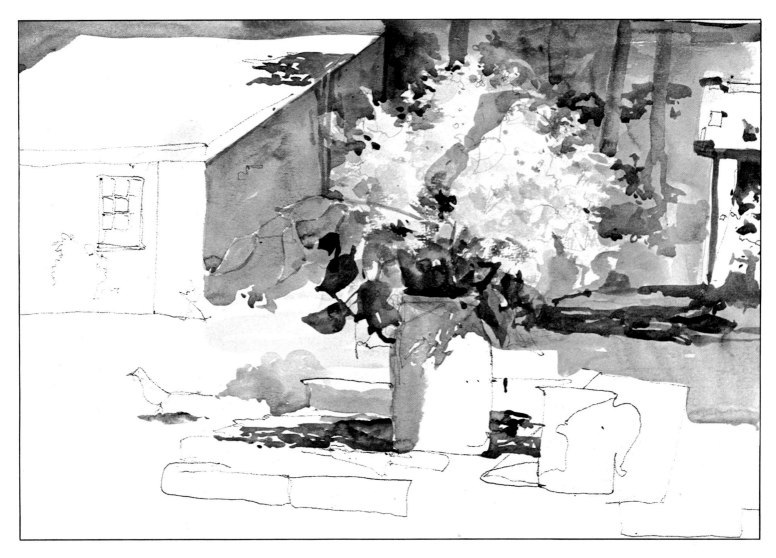

2

In this step I add more darks around the flowers: ultramarine blue, sap green, and cadmium yellow. For the studio I use alizarin crimson, ultramarine blue, and cerulean blue. I am also still using some drybrush around the flowers. So far I am working with my number 8, my number 9, and my number 12 round sable brushes, using the bigger brushes solely in the background. The tighter work, such as the drybrush, is all done with the number 8 brush. The danger in this step is that I might put in too many darks. My best course is to put in only enough darks to assure a good value range, waiting until later to add those darks that I'll need to finish the painting.

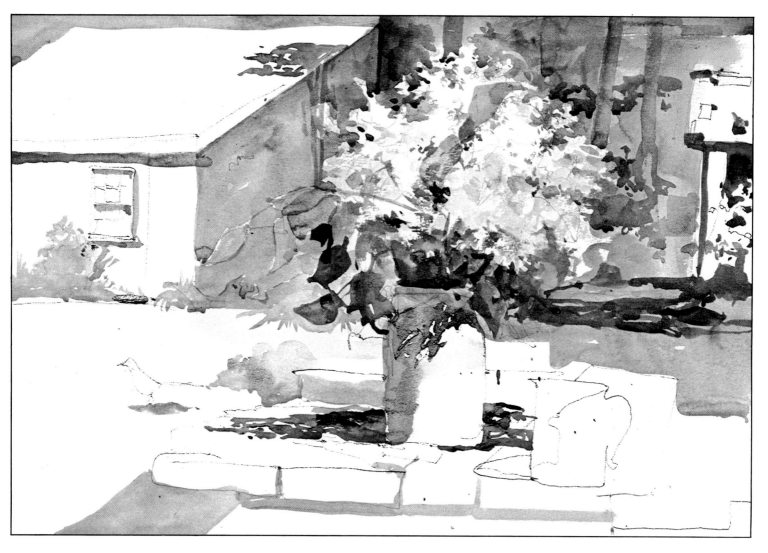

3

I'm still using my number 8 brush as I work in very light drybrush in the flowers. I paint with only alizarin crimson. I mix the paint and water on the palette to get the light value and then blot the brush to get it sufficiently dry. I must be very careful to avoid going too dark in the white flowers. Drybrush works best for me in light areas such as this. In this kind of painting darker drybrush would be out of place. When you're adding darks at this stage, think more of color than of value. Color should become more and more intense as you get toward the end of the painting. On the right I use alizarin crimson, diluted only with water, and some strong ultramarine blue in the tree. Then I drop in cadmium orange wet-in-wet. I also use alizarin crimson and ultramarine blue around the window and alizarin crimson and cadmium orange along the roof line.

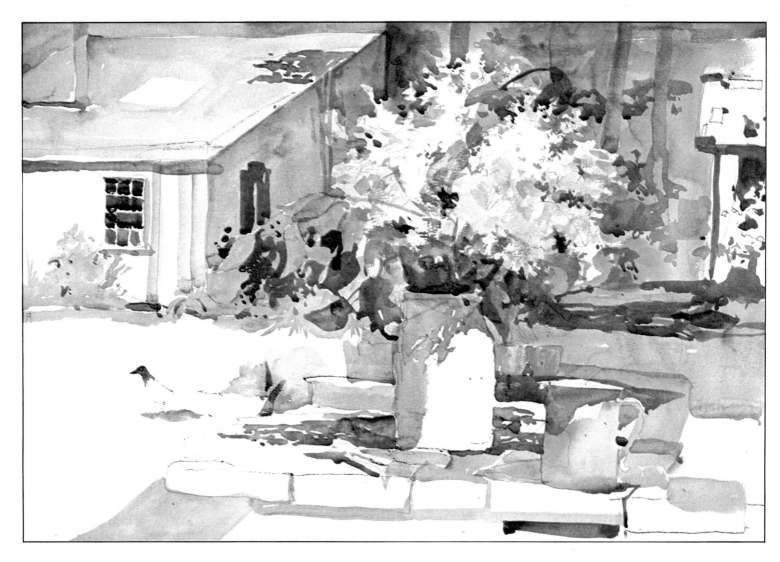

4

In this step I add more darks and work on the studio at the left. I do very little to the flowers but concentrate on the surroundings. For the table I start with darker accents and then add lighter washes when the darker values dry. Before adding the lights, I paint the shadow on the coffee cup first with ultramarine blue, alizarin crimson, and cadmium orange, carrying these colors out into the table. Note the color changes as I work out from the cup to the table. I start with more blue and less of the other colors, but as I paint to the right, I add more orange and alizarin crimson. I use alizarin crimson, ultramarine blue, and orange in the windows of the studio. The orange accent is cadmium orange and cadmium red light.

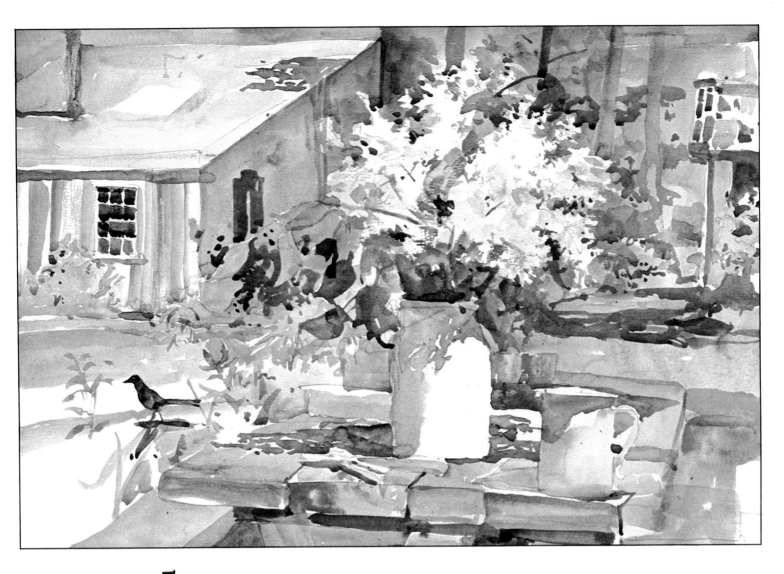

5

Next I add my friend the blackbird. I drew him in my preliminary sketch, and he stayed around the whole time I have been painting. Alizarin crimson, ultramarine blue, cadmium yellow, and cadmium orange are my colors for the tabletop which I paint next. I use the same colors throughout the table but vary the quantity of individual colors in each section. Actually, I paint each slat of the table separately and allow it to dry before adding an adjoining slat. My main emphasis throughout has been on color. I've tried to keep overwashes to a minimum, aiming for my darks with the first wash. I've also concentrated on using more intense color in the necessary overwashes.

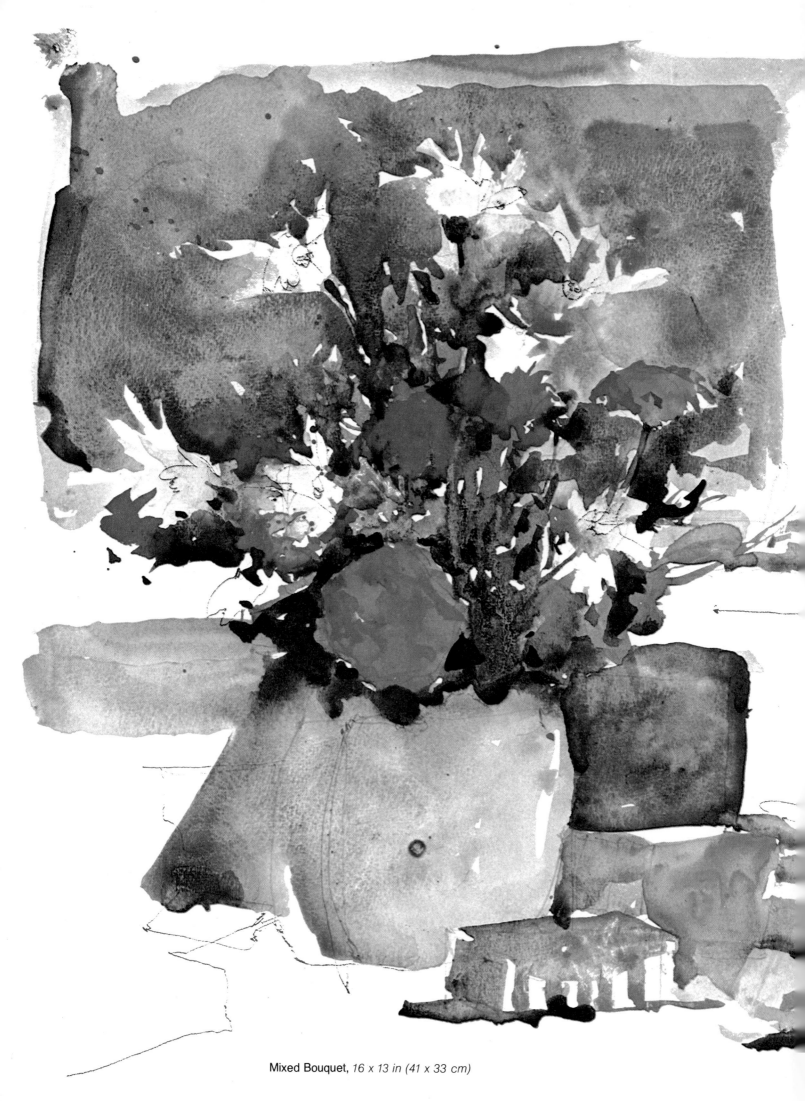

Mixed Bouquet, *16 x 13 in (41 x 33 cm)*

LIGHTING

Demonstration 15

SIDE LIGHTING

As you will see in this demonstration, the problems of side lighting are not really unique, since this is probably the most common form of lighting that painters use. However, it's most important to keep the accuracy of local color in each flower or other object. Remember that local color is the overall value of a particular area in relation to other areas. As a rule, you'll find much more value contrast in light objects, whereas there is less apparent value contrast within darker objects. This project will mainly be concerned with the problems of retaining local color. You'll see here that even though a definite and fairly strong light shines on the still life, the overall feeling is more one of local color than of light and shade. The colors are important here because they are intense in the purple and the red flowers. Color in light areas, though important, tends to be more subtle than it is in darker areas, where color should be rich and vibrant. It's easier to be extravagant with color in darks but more difficult to do so in the lights. The best solution to color problems is to limit your palette and use the same colors but in different ratios.

I'm working on 140 lb. cold-pressed paper, 16 × 13 in (41 × 33 cm). I use a continuous line in the drawing not only to give me a general idea of the flowers that I'll be painting but also to suggest the entire composition. Notice that I draw right out to the borders of the picture that I've established with a pencil line. The drawing is actually more concerned with the composition than with the individual flowers. This is an important point, since I've found that one tends to get too involved with the object and often ends up with the question, "What do I do with this section of the background?" The subject is often the easiest part of the painting. Many more problems seem to occur when one is executing the surrounding areas.

Brushes
No. 8 round sable
No. 10 round sable

Palette
Alizarin crimson
Cadmium red
Cadmium orange
Cadmium yellow
Cadmium yellow pale
Yellow ochre
Sap green
Cerulean blue
Ultramarine blue
Raw sienna

1

These relatively dark flowers are painted with ultramarine blue and alizarin crimson. I'm more interested in the overall local color than in light and shade. I try to establish this by painting the flowers in the same value. But for variety I blot some areas for lighter values and then restate some of the darks. I don't paint any greens at first, but work around the top of the daisy. Then using alizarin crimson, ultramarine blue, and cadmium yellow, I wash in a very light value for the shadow side of the daisy. While this is still wet I continue with my purple and achieve a soft edge along the shadow side, continuing along the bottom to describe the shape. Where there is wet shadow color, I get a soft edge. But I will need definite descriptive shapes when I get to the firmer edge on the light side of the form. When the purples are dry, I add my greens, mixing ultramarine blue, cadmium yellow, and sap green on my palette. I don't want a washed out green, but I don't want a dark heavy green that will weigh down my flowers, which are about the same value as the leaves. I add a touch of red to the lower left area to tie it in with the red flowers that I'll add later.

2

I continue with the cadmium red I began previously, still holding the local color of the flowers even though a definite light shines on the bouquet. You shouldn't look too hard for light and shade on a relatively dark, richly colored area. It's more important to get the correct value and color of the overall flower. If you try too hard to show its form, you'll lose the essence of the flower. I start right out with a fairly dark value, then blot for my lighter values. I add more greens, which combine with the reds for a softer edge in a shadow area. These darker greens are a mixture of green I mixed in step 1 and cadmium red light, which I mix directly on the paper since I want a transition from green to red. Finally, using alizarin crimson, ultramarine blue, and yellow ochre, I add the shadow section at the top of the vase.

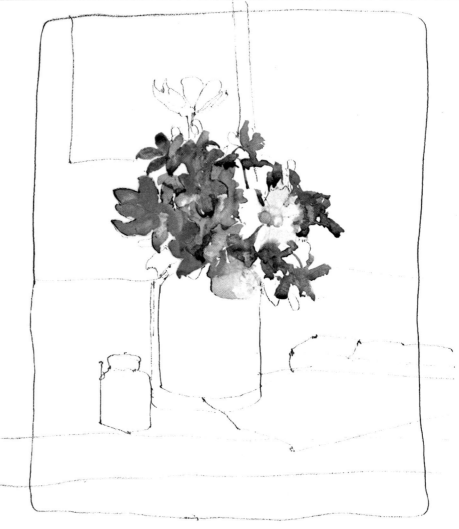

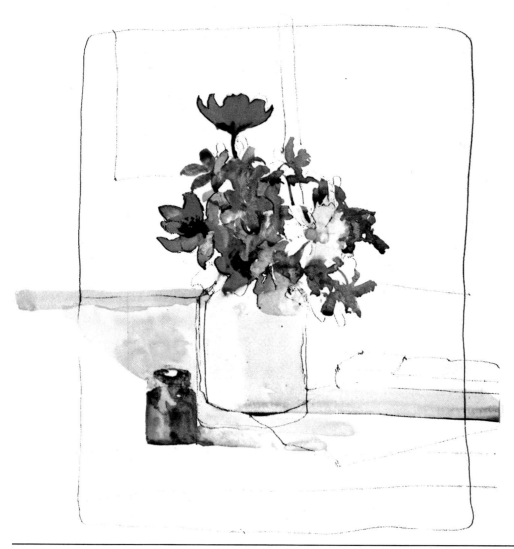

3

Now I show definite light and dark as I paint the vase. But remember the vase is still a fairly light object, so form is more important than color. I paint the whole vase with a fairly light wash of cool gray mixed on the palette. I leave a section of white as a highlight in the upper left section. I then add a second overwash so that there is a slight blend between light and shadow. This shadow wash is carried out into a cast shadow by using the same values and colors as well as the same stroke. When all this is dry I add a mixture of alizarin crimson and cadmium yellow pale to the left of the vase. The colors change, but since both are about the same values, there isn't a problem. This wash dries almost completely before I add the ink bottle with sap green and cadmium red mixed on the paper. But some of the tabletop etches into the bottle. I add the dark bottle top using ultramarine blue, alizarin crimson, and some of the green mixture from the bottle, getting a blend between bottle and bottletop.

4

Next I add more of the tabletop. I paint around the paper and put a light wash over the drafting triangle. Each section has a slightly different color feeling, which is important. Sometimes I do more mixing on the palette to create a more neutral color, such as that in the foreground. In other sections I mix more on the paper suggesting individual colors, such as you can see in the table section to the left of the vase. I now add the pencil using cadmium orange and cadmium yellow, with a bit of raw sienna for the darker point. All these colors are added wet-in-wet. Now I paint in the cast shadow of the pencil with cerulean blue. Most of the pencil is dry before I add the cast shadow; the only real blend is at the pencil point. I paint the watercolor box with ultramarine blue and a touch of cadmium orange. The whole box is painted with the same value and allowed to dry before the shadows are painted in. I try to make these shadows describe the contours of the box; the same colors appear in both the shadow and the light areas.

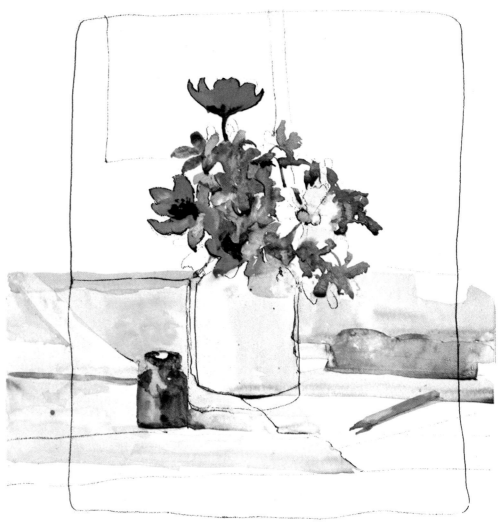

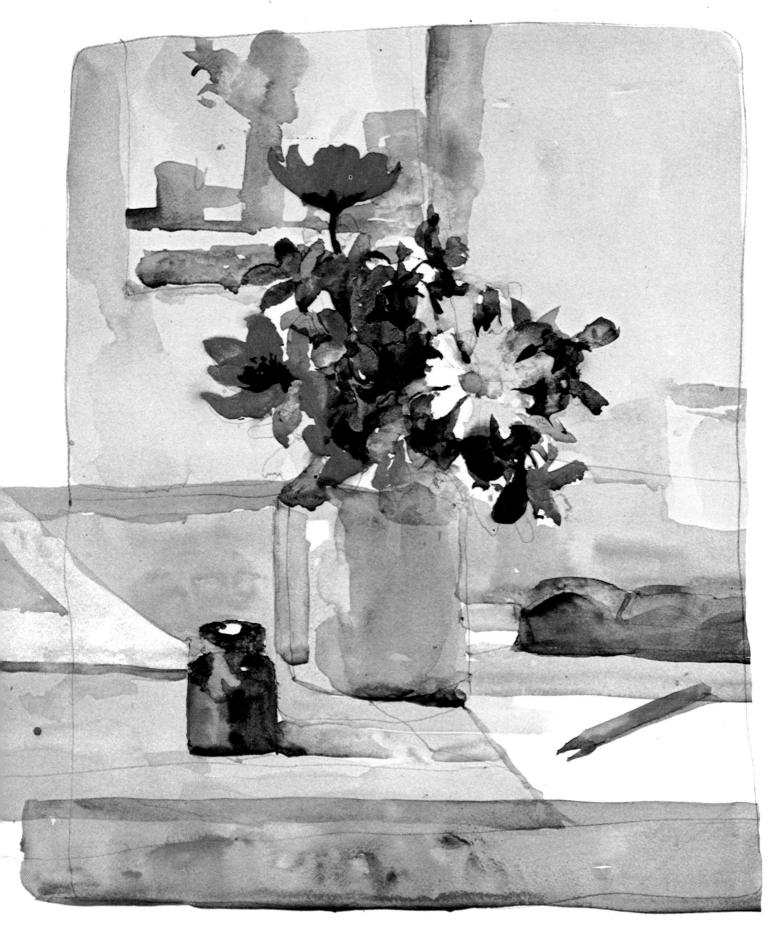

5 In the last step I paint a little background color around the white container to the right of the vase. Finally, I add a suggestion of a painting on the wall and a darker strip of foreground table edge. I continue to use the same colors. I mix the darker foreground strip on the paper and add a bit of practically all the colors used throughout. Note the lights and shades in this painting. Most of the lights are achieved by blotting rather than by first painting the light sides and then painting the shadow sides. Always try for good local color, good value patterns, and rich color, especially in the darker values. If you get these, no one will complain that your painting lacks light and shade.

Demonstration 16

BACK LIGHTING

Brushes
No. 6 round sable
No. 8 round sable
No. 9 round sable

Palette
Alizarin crimson
Cadmium red light
Cadmium orange
Cadmium yellow
Cadmium yellow pale
Yellow ochre
Sap green
Hooker's green dark
Phthalo blue
Ultramarine blue
Raw sienna

Here I'm painting zinnias, the last flowers in my garden as winter approaches. I'm painting with back lighting, as I have done in several other demonstrations. I particularly like it because it simplifies the flowers into large masses, and I can concentrate on color changes rather than value changes. I'm painting indoors with my light coming from a window behind my subject. This will create the same difficulties that I would have if I were painting outdoors. Shadows and cast shadows will change very fast as the light changes. Therefore, I've found it best to put in the shadows and cast shadows fairly early in the painting and then try not to change them.. But it's a great temptation to alter a shadow pattern later in the painting, especially if the pattern seems better than the one I have on paper.

As you paint shadows and cast shadows, keep them as consistent in value as possible and avoid having shadows within shadows. In fact, if you're a beginner, it's best to have just one value representing shadows since nothing will detract from a painting more than complicated shadow values.

Almost any color will work for both light and shadow if you vary the amount of water you use. Naturally some colors such as cadmium yellow, yellow ochre, cadmium orange, and cerulean blue come out of the tube at a light value. Only by mixing such light-value colors as these with other colors can you get a darker value. But with other darker-value colors, I often find that students tend to use too many different colors to achieve lights and darks, when they could get good value changes simply by adding or subtracting water.

I'm working on a piece of 140 lb. cold-pressed paper 16 × 13 in (41 × 33 cm). I've done a relatively careful drawing using a contour line. Notice that I'm already thinking of masses in this drawing. Very little detail is used, and I concentrate on large shapes instead.

1

I start by establishing some of the light color values in the flowers in the upper left, using the yellows and oranges I mentioned in the introduction. Notice the colors are quite washed out; I've used a little too much water. Generally you'll note that I use rich color in these first washes. Remember, nothing looks as exciting when it's dry. I held back here for fear the alizarin crimson and cadmium orange would look too wild. Working down into the yellow flowers I use cadmium yellow with a touch of the colors I used in the flowers above. As I paint I indicate the stems of some of the flowers using the same colors I used in the blossoms. While the stems are still wet I suggest green using raw sienna and ultramarine blue. I don't fill in these stems. I just paint some sections, trying to keep the change from stem to flower gradual and subtle. Note the blend where the yellow flowers meet the red ones. I'm working rather quickly trying to separate and define some areas and blur others. As I work in areas other than the flowers you can see such color mixtures as alizarin crimson and cerulean blue in the lower right-hand section. I do some mixing on the palette but most on the paper, and as I mix on the palette, I make sure that I retain individual colors.

2

In this step I establish some cast shadow patterns on the table, add darker values to the flowers, and work on some of the objects around the flowers. Since I want to get the areas that are going to change done early, I start with the flowers and use some darker versions of the same colors that I used in the light sections. I use raw sienna mixed with cadmium yellow and a little cadmium orange for the darker values in the yellow flowers. At the same time I add some dark greens, using sap green with a little cadmium red for the darker leaf areas. I also add a touch of ultramarine blue with cadmium yellow. Notice that these greens blend with some of the flowers. The colors in the vase are the same as in my yellow flowers—cadmium yellow, raw sienna, cerulean blue, and alizarin crimson. I put a light wash over the vase, then allow it to dry before adding the darker values. I never use raw sienna in my lights, only in the darks, so the cadmium yellow is the only yellow in the light wash on the vase. Before painting the vase, I paint in the small container sitting just in front of it with a cool gray mixture of alizarin crimson, ultramarine blue, and cadmium yellow. This dries almost completely before I do the vase and cast shadow. The cast shadow has the same colors as the small container. Notice that some of the warm cast shadow color bleeds up into a section of the container that is still damp. Most of this shadow is fairly light, but I put in warmer values on the right side wet-in-wet with alizarin crimson, ultramarine blue, and yellow ochre. These darker colors reach up into the container. I paint the other objects with the same combination of grays that I've already mentioned. You can see here that the palette is fairly limited.

3

Now I almost complete the flowers and add the rest of the window casings. However, some things have gotten dry before I can get back to work on them. But if this happens, all is not lost. Just relax and think about what you've done so far and what you'd like to do now. In this case I use clear water and dampen the flower area. I don't scrub the water into the paper. I just wash it on lightly and let it sit for a moment. Now with my alizarin crimson, cerulean blue, and yellow ochre, I work into the center, showing the shadows in a white flower. There isn't a soft edge between the new and old washes, but no one will notice. I carry my shadow wash to the left, showing some of the hard edges as well as the soft ones that happened with the wet-in-wet. Now I add some cadmium yellow, cadmium red, and cadmium orange to show some of the other flowers. Notice that these new sections of color are richer than my first light washes. I think they look a lot better, and I wish I'd started out with stronger color.

4

Using a light green wash of cerulean blue and cadmium yellow light, I add the grass that's seen through the window behind the flowers, painting around the flowers and the window casings. Notice that I leave some white paper to suggest lightstruck areas, but not too much. I don't want the painting to look jumpy. Also you'll lose the effect of sunlight if there are too many bits and pieces of paper showing. Don't squander your white. Make it count by creating careful shapes, making sure that the white paper describes the object on which it lies. I also work on the window frame and some of the other objects and add a watercolor brush. The yellow-browns in the objects on the right are done with yellow ochre, with a bit of my cerulean blue and alizarin crimson combination. I paint the cast shadow and the paint brush with alizarin crimson and yellow ochre but switch to ultramarine for my blue. Notice that the brush isn't a solid dark color. I leave sections which dry lighter. Try to get in the habit of leaving things alone. Your watercolors will be a lot fresher.

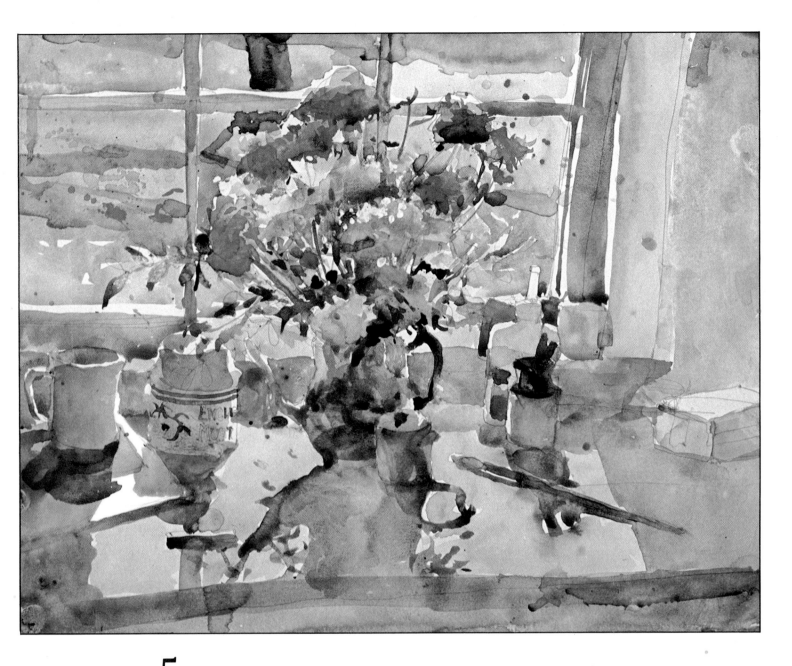

5

The final step is a matter of just a few finishing touches. I put in the cast shadow on the right using raw sienna with alizarin crimson and cerulean blue. The cast shadow on the left is done with the same colors, but I use more of the blue and the alizarin and less of the raw sienna. Next I put a very light but warm wash on the light-struck table, using alizarin crimson, cadmium orange, cadmium yellow, and cerulean blue. The right side has more orange, as I use it alone wet-in-wet after diluting it on the palette with water. I finish the job with some details in the objects on the table, a matchbox, and a tree in the background.

TOP LIGHTING

I'm painting a bouquet of irises, daffodils, and daisies in my studio, and the light is coming mainly from an overhead skylight. Although the light is from above, it's quite diffused, and I don't have the obvious shadows and cast shadows that I would have with a spotlight shining down on the flowers.

Diffused lighting like this is particularly good when working with flowers, just as strong light and shade are very good for figure and portrait painting. In the latter we want to capture the structure of the subject, and light and shade are the best ways to do this. Structure isn't nearly as important, however, in flowers. In fact, too much interest in light and shade will probably make your flowers look harsh.

I begin with my usual kind of sketch, drawing with a number 2 pencil on cold-pressed paper, 16 × 13 in (41 × 33 cm). The drawing is quite sparse, since I'm interested mainly in getting in the big shapes. When I start to paint, I begin directly with the yellow daffodils, which I later surround with dark greens to give the yellow flowers the correct shape. Notice that the stove in the background creates a very dark contrast with the flowers. This is a good exercise in painting a dark object without making it look like a black hole.

Brushes
No. 8 round sable
No. 12 round sable

Palette
Alizarin crimson
Cadmium red light
Cadmium orange
Cadmium yellow
Cadmium yellow pale
Sap green
Cerulean blue
Phthalo blue
Ultramarine blue
Raw sienna
Burnt sienna
Ivory black

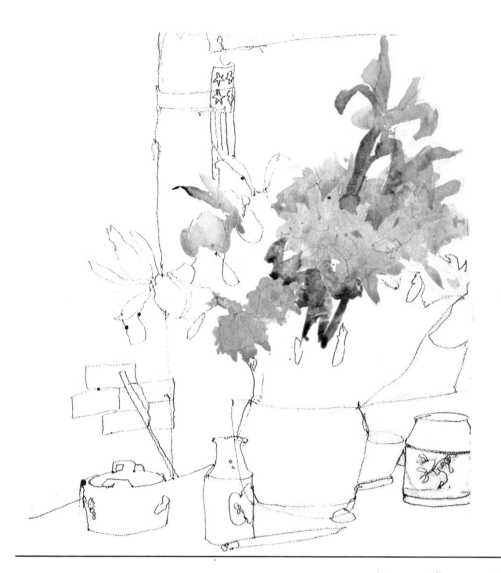

1

Starting with my number 8 brush, I paint the daffodils with cadmium yellow, cadmium orange, and a little cadmium yellow pale. I make an effort to show some of the shapes of the flowers, but I know that I'll be surrounding them with darker greens and can correct the shapes later. I start green stems and leaves with ultramarine blue and cadmium yellow and paint in an iris with phthalo blue and alizarin crimson. Then I put in more daffodils below the green stems, this time adding raw sienna to the original mixture, which makes for rich color. The new stems are sap green and ultramarine blue with cadmium yellow. While the stems are still damp, I paint in more irises, but I don't want either the stems or the irises to be too dark. Even though the irises are high in key, I'm careful with the shapes. I might not finish with darker values behind the irises, and perhaps I won't be able to correct.

2

I mass in most of the daffodils and daisies in this step, working broadly, thinking about outside shapes, and trying to keep the color as rich as possible. I use a lot of cadmium yellow with small amounts of cadmium orange and wait a few moments before adding the greens. There is some blending, but the flowers tend to keep their outside shapes. Note also some white paper showing between the stems. When working on the iris in step 1, I used fairly light washes first and allowed them to dry before going back with darker washes. Phthalo blue or cerulean blue mixed with alizarin crimson makes the cleanest light purple washes, so I alternate between the two blues. Here I'm using phthalo blue for both light and dark washes. The vase contains the same colors as the irises, but I add a little cadmium yellow pale wet-in-wet on the right. Some green from the leaves that haven't dried yet drifts down into the vase. I carry the vase over into the table, using vase colors with an added touch of cadmium yellow and raw sienna.

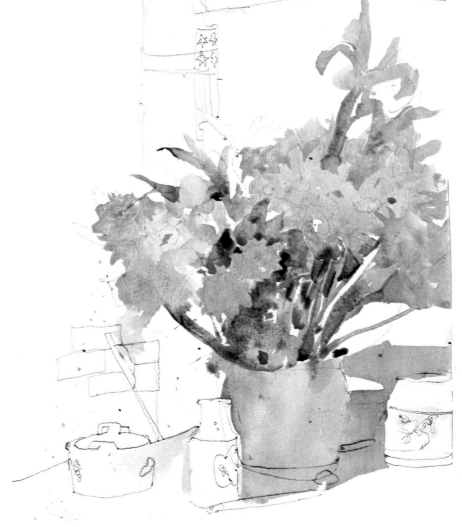

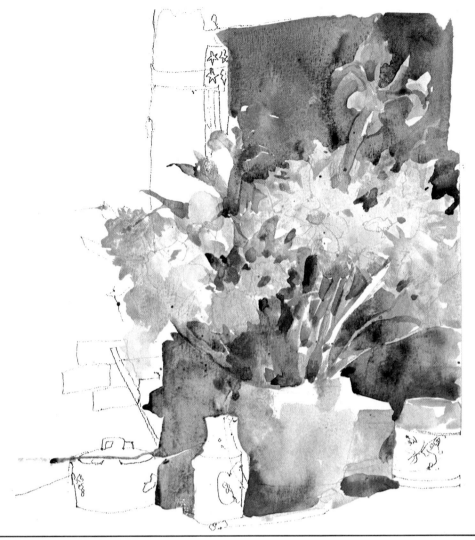

3

Here I add more darks surrounding the flowers. The cool dark mass above the flowers is my stove—mostly ultramarine blue, burnt sienna, and ivory black, with some alizarin crimson. I work carefully around the irises that have dried by this time, keeping the dark values a bit lighter around the flowers. You can see the same colors below the flowers, but with more alizarin crimson. I work carefully around the stems in some places but allow the greens to merge with the background color in others. I add more color to the vase and quickly work in more background to achieve a blended edge. I add more alizarin crimson to the vase, this time working wet-in-wet after first putting on an overwash of ultramarine blue and alizarin crimson. The darks painted wet-in-wet below the vase are burnt sienna, cadmium red light, sap green, and raw sienna. I use lots of pigment in these dark, warm colors so that the blend won't get out of control.

4

Although I don't change the painting much in this step, I darken the stove. This may not seem particularly important, yet it is very important. The stove is actually very dark and creates a very strong contrast between the flowers and itself. The trick here is not to make it too dark all over. I first dampen the paper with clear water, working only in the stove, and I'm careful to work around the flowers. I want them to stay dry. Next I mix on the palette some ultramarine blue and burnt sienna with a medium amount of water and work this combination into the stove wet-in-wet. I then drop some more ultramarine blue into the wet wash. My darkest values appear slightly away from the flowers, except on the far right where I do have a very dark value next to a light flower.

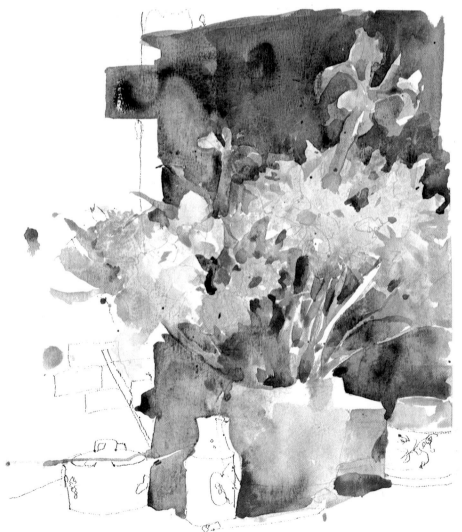

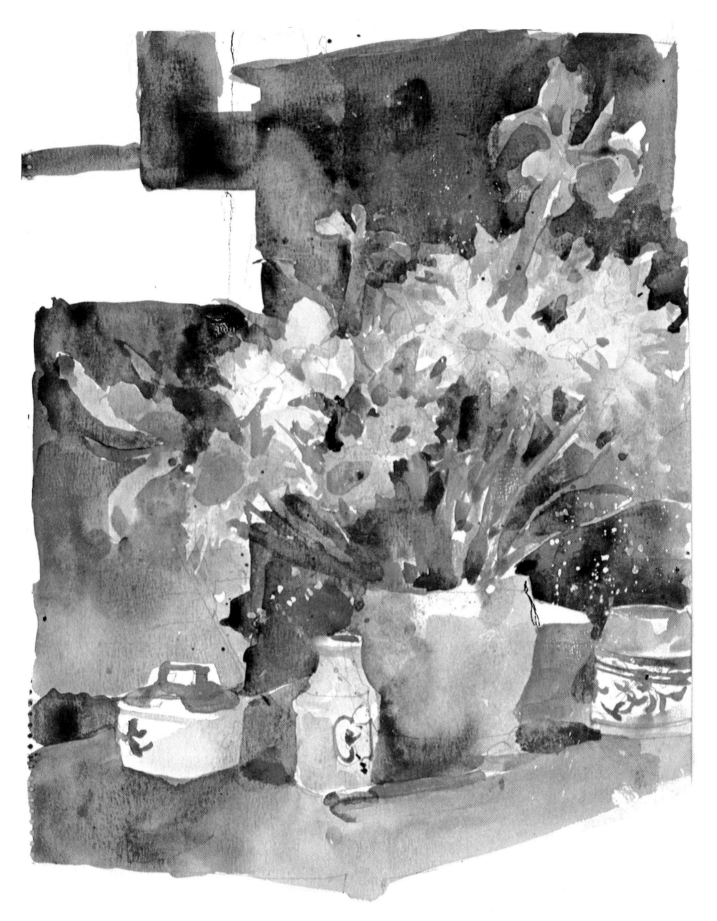

5 I finish the painting by adding the tabletop, again working wet-in-wet, with light washes of sap green, ultramarine blue, raw sienna, cadmium orange, and alizarin crimson. But I don't mix all these colors together at the same time; rather, I make the wash and then work around the objects, trying to keep variations in color. Then, while the table is still wet, I go back to the darker colors—the sap green, the ultramarine blue, the alizarin crimson—and drop them in wet-in-wet, as you can see particularly on the left. I allow the paint, the water, and the paper to do the work with no help from me once the paint has been delivered. When the table is dry, I make light washes on the objects using alizarin crimson, cerulean blue, cadmium orange, and cadmium yellow pale. Finally, I add the designs on the objects after the light washes I put on them are dry.

DIFFUSED LIGHTING

Since I'm painting in diffused light here, I'll be thinking mainly of local color and local value rather than form. (If you need to refresh your memory, go back to the discussion of local color in Chapter 4 on "Values.") Painting in diffused light is good practice, since it doesn't lend itself to breaking up sections of your subject into light and shade in order to show form. In fact, every painting should probably start out as a work done in diffused light, with the focus on local color and value. You should think about achieving form through light and shade only toward the end of the painting.

This painting is a good example of a very light mass contrasted with a very dark mass, and attempt to keep this contrast balanced. The stove is very dark, although I paint it much lighter than it actually is. But trying to keep it from being a dark hole in the painting gives me an opportunity to use many colors, since dark areas are the place to use color.

I begin with one of my rather minimal drawings on 140 lb. cold-pressed paper, 12 × 16 in (30 × 41 cm). But you shouldn't necessarily follow my example here. Do as much or little drawing as you feel comfortable with. When I begin painting, I start out with my number 8 round sable brush, but I switch to my number 9 and number 12 brushes when I get to the stove, since I want to keep this area loose and open.

Brushes
No. 8 round sable
No. 9 round sable
No. 12 round sable

Palette
Alizarin crimson
Cadmium red light
Cadmium orange
Cadmium yellow
Cadmium yellow pale
Sap green
Hooker's green dark
Cerulean blue
Ultramarine blue
Raw sienna
Burnt umber
Burnt sienna
Ivory black

1

Starting out with my number 8 round sable brush, I mass in some purple lilacs using cerulean blue, ultramarine blue, and alizarin crimson. I concentrate on the overall shapes and use some spatter work to bring out the delicate nature of the flowers. To give the flowers some texture and value variety, I blot with a tissue. I now work rather quickly, adding some green leaves using cadmium yellow pale, cadmium yellow, cerulean blue, and ultramarine blue. I also use sap green and Hooker's green dark along with some ivory black mixed with cadmium yellow pale in the darker sections just above the vase, continuing the wash right down into the vase and onto the stove. In the light sections of the white lilacs I use some cadmium yellow pale, but my principal colors are alizarin crimson and cerulean blue diluted with lots of water so I won't go too dark. I use the same colors in the vase and tabletop, as well as cadmium orange mixed with cerulean blue for the light grays in the vase and tabletop.

2

In this step I'm still using all the same colors and my number 8 brush. I apply more very light washes for the white flowers and add a bit of cadmium yellow pale in the upper section after I paint the first wash of cerulean blue and alizarin crimson. Then I pin down some of the light flowers in the center section using my darker greens, but I don't put in very dark greens right up against the lilacs in this center section. The arc-shaped bail is ivory black, which goes down to the alizarin crimson and burnt sienna of the handle. I also add some stems, using sap green, ultramarine blue, and cerulean blue mixed with cadmium yellow pale, and then turn to the upper right area, contrasting it with the white flowers. The frame of the painting behind the flowers is cadmium red light, raw sienna, and cadmium orange. The blues are mainly cerulean and ultramarine with a touch of cadmium orange. The brown is burnt umber. I'm using a lot of spatter work and blotting with my tissue. I want to keep things alive and spontaneous.

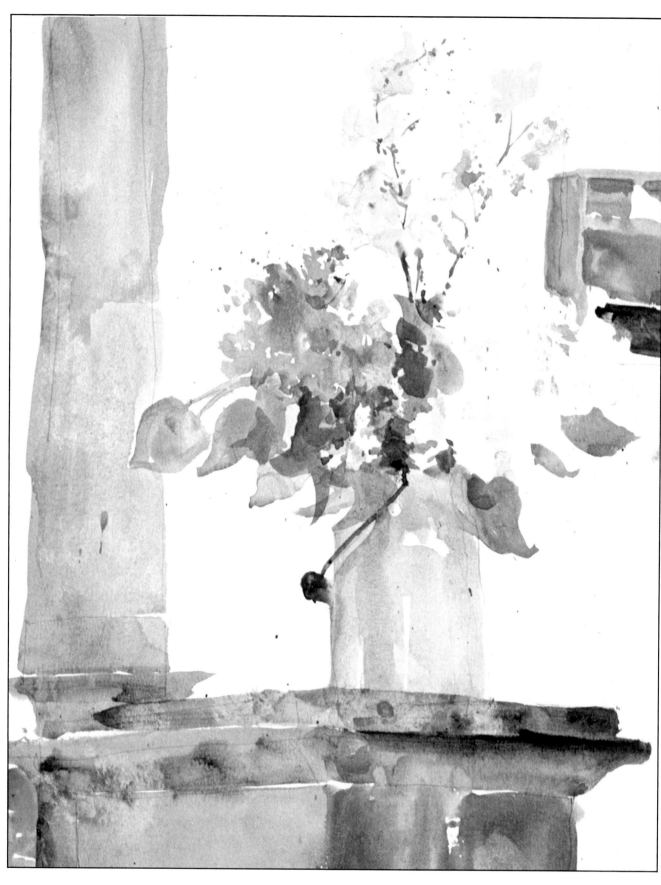

3 Next, switching to my number 9 and number 12 brushes, I concentrate on the stove, a very dark object which, if painted as dark as it really is, would create a problem, since I want to keep the flowers very light. Also, a heavy dark at the bottom of the painting would completely dominate the picture. So I leave some white paper between washes to help show the conformation of the stove. This black stove gives me a chance to try lots of different colors: ivory black and burnt sienna mixed with alizarin crimson, ultramarine blue, raw sienna, and cadmium orange. I do a lot of mixing on the paper, working wet-in-wet. Remember that dark areas are the places to use color. You can get away with almost anything except the more opaque, light-value colors such as yellow ochre or cadmium yellow pale. I add the stovepipe using alizarin crimson, cadmium yellow, cadmium orange, cadmium red light, and cerulean blue.

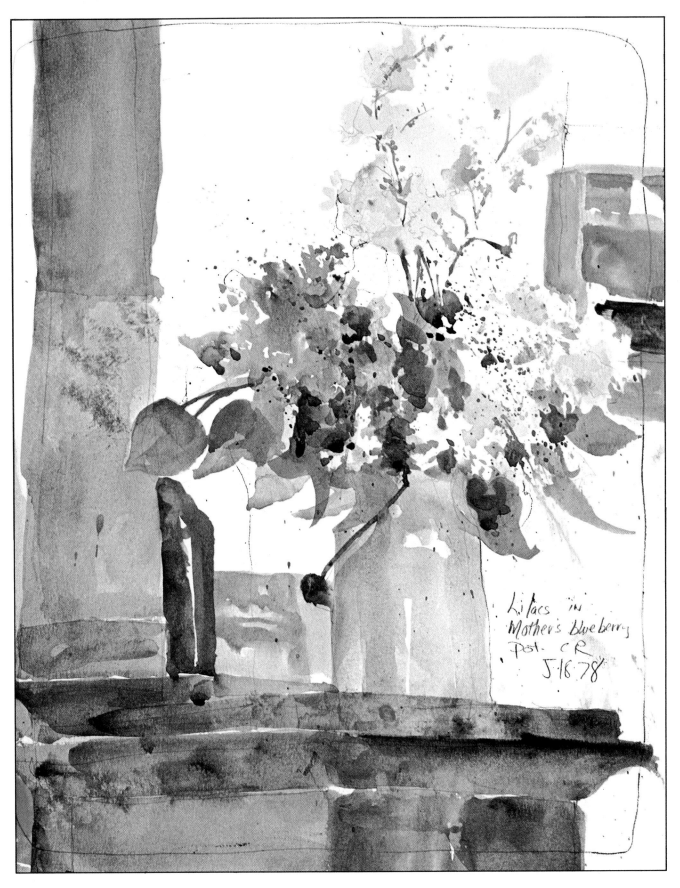

Lilacs in
Mother's blueberry
pot. CR
5·18·78

4 You'll notice that I keep the stove fairly light. I add a few darker values, but the stove I painted is still much lighter than the stove I'm looking at. I've saved the very subtle tones on the white flowers for last. I'm very careful not to work too hard here, and I switch to some spatter work when I think I might be overworking things. But I'm also careful not to get carried away with the spatter work, since a picture can be ruined easily if one splashes too much.

Bibliography

Blake, Wendon. *Acrylic Watercolor Painting.* New York, Watson-Guptill, 1970.

Brandt, Rex. *Watercolor Landscape.* New York, Reinhold, 1963.

DeReyna, Rudy. *Painting in Opaque Watercolor.* New York, Watson-Guptill, 1967.

Guptill, Arthur L. *Watercolor Painting Step-by-Step.* Edited by Susan Meyer. New York, Watson-Guptill, 1967.

Hoopes, Donelson F. *American Watercolor Painting.* New York, Watson-Guptill, 1977.

———— *Sargent Watercolors.* New York, Watson-Guptill, 1976.

———— *Winslow Homer Watercolors.* New York, Watson-Guptill, 1969.

Kaupelis, Robert. *Learning to Draw.* New York, Watson-Guptill, 1966.

Kautsky, Ted. *Ways with Watercolor,* 2nd ed. New York, Reinhold, 1963.

Kent, Norman. *100 Watercolor Techniques.* Edited by Susan Meyer. New York, Watson-Guptill, 1968.

Meyer, Susan. *40 Watercolorists and How They Work.* New York, Watson-Guptill, 1977.

Pellew, John C. *Painting in Watercolor.* New York, Watson-Guptill, 1970.

Szabo, Zoltan. *Creative Watercolor Techniques.* New York, Watson-Guptill, 1974.

———— *Zoltan Szabo Paints Landscapes.* New York, Watson-Guptill, 1977.

Wilkinson, Gerald. *Turner's Early Sketchbooks.* New York, Watson-Guptill, 1972.

Index

Edited by Connie Buckley
Designed by Bob Fillie
Production by Ellen Greene
Set in 11 Point Helvetica